BEC 4

Proceedings of the Fourth British Egyptology Congress
University of Manchester, 7-9 September 2018

Edited by
Carl Graves

Egypt Exploration Society
2020

LONDON

Exclusive distribution outside of North America and Mexico by
Bloomsbury Publishing ● www.bloomsbury.com

BRITISH LIBRARY CATALOGUING PUBLICATION DATA
A catalogue record for this book is available from the British Library

ISBN 978 0 85698 243 9

Printed in Great Britain
Typeset by Jan Geisbusch

Printed by Hobbs the Printers Ltd
Brunel Road, Totton SO40 3WX, UK

Contents

Foreword

The 4th British Egyptology Congress (BEC) was held in September 2018 at the University of Manchester. The KNH Centre for Biomedical Egyptology hosted the Congress with assistance from Manchester Ancient Egypt Society and Ancient Egypt Magazine on behalf of the Egypt Exploration Society.

The last BEC had been held at the British Museum in 2010 and so the fourth instalment represented somewhat of a resurrection in the platform, allowing scholars from around the world to present their latest and ongoing research to peers.

Almost 200 delegates attended the Congress coming from across the UK, Egypt, Europe, North America and even as far away as Australia. Over three days, 82 papers were presented including four keynote speeches from the organising committee institutions. Papers covered the full spectrum of Egyptology, archaeology, museology, and the history of travel along the Nile. Being hosted by the KNH Centre, there was an unsurprising flavour for biomedical research, and the latest findings from several Manchester-based projects were presented including histories of mummy dissection, Manchester Museum's own collection of Egyptian mummies, and a discussion about dislocations in the Edwin Smith Papyrus.

Delegates were welcomed to the Congress with an introductory keynote lecture provided by Dr Christian Greco, Director of the Museo Egizio in Turin. Dr Greco stressed the importance for museums to attract broader audiences by actively engaging with often overlooked groups within the community. The lecture set the tone for the Congress, which had a distinctly inclusive feel with researchers of all backgrounds and affiliations enthusiastically discussing their ideas, something that BEC has always been known for.

The 13 papers included in this volume are representative of the wide variety of ongoing research discussed during the 4th BEC. They reflect the ongoing studies of the authors and it is hoped that providing a publication platform for presenters will stimulate further dialogue and investigation. We expect to hear further updates from these projects at future BECs!

The Congress could not have been possible without the hard work and dedication of the Manchester organising committee, and the Egypt Exploration Society is particularly grateful to Prof Rosalie David, Prof Anthony Freemont, Dr Jenefer Metcalfe, Sarah Griffiths, Peter Philips, and

Dr Campbell Price for overseeing its planning. Our appreciation is also owed to all those volunteers that offered their time to running the event as well as all of the delegates and presenters during the Congress. The organising committee would also like to thank the supporters of the Egypt Exploration Society and the KNH Centre for their financial contribution toward the fourth British Egyptology Congress. We look forward to seeing BEC continue to grow in 2020 at Durham University.

Dr Carl Graves Prof Rosalie David
London, December 2019 Manchester, December 2019

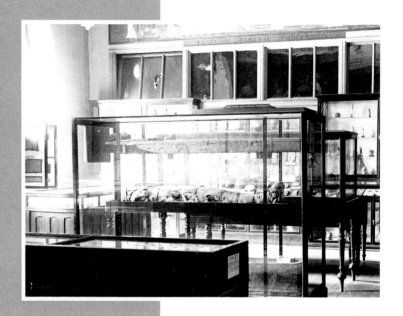

The collectors and collection in the McManus Art Galleries and Museum, Dundee: Rev. Colin Campbell, the Egypt Exploration Fund, Sir James Caird and Thomas Wise

Averil Anderson
The McManus Museum and Art Galleries, Dundee

The museum was founded in 1867 as the Albert Institute for Science and Literature and Victoria Art Galleries, the name was changed in the 1980s in favour of the local councillor Maurice McManus. It recently celebrated its 150th year and remains the original 'Victoria & Albert' in Dundee. Recently modernised, the McManus Museum continues to be one of the most popular visitor attractions in the city.

The Egyptian display in the 'Dundee and the World' gallery is a small one but covers the early Pharaonic to the Roman Period. Highlights from the collection include:

- false door of Inseneferuishetef (1914-204-26 = 1966-222), Dahshur, limestone; 5th Dynasty; excavations of Jacques de Morgan, 1894; presented by Sir James Key Caird
- canopic jar (1976-680), limestone; Middle Kingdom
- coffin and cartonnage mummy-case (1914-204-1), probably from mouth of Fayyum; 22nd Dynasty; given by Sir James Key Caird
- stela of Merri (1966-224), Dendara; early First Intermediate Period; excavated by W. M. Flinders Petrie, 1898; donated by the Egypt Exploration Fund
- mummy mask (1914-204-36), Roman Period; given by Sir James Key Caird
- coffin lid (1914-204-41), Qaw el-Kebir, limestone, Ptolemaic Period; donated by Sir James Key Caird
- jewellery (gold earring with carnelian and green stone, 1963-298-1), Benha; early Ptolemaic Period

From this list it can be seen that the Museum has the same problem of many collections in that the provenance of a number of objects has been lost, although this can on occasion be resolved by using archival research. In addition, several objects were assigned new numbers after their original

ones had become lost – thus 1914-204-26, the false door of Inseneferuishetef, received a new number in the 1960s, becoming 1966-222, under which it appears in Porter and Moss (1974–81). However, ongoing research has now reunited it with its original number, which is also the case with an increasing number of pieces.

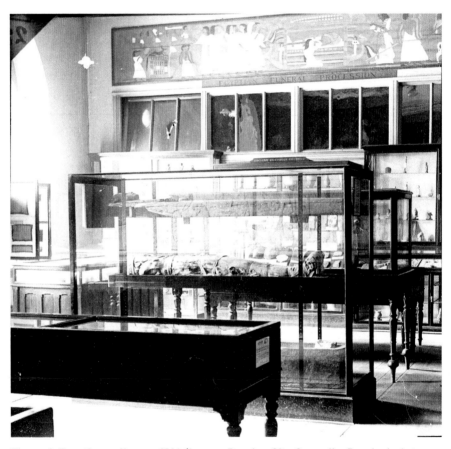

Figure 1: Egyptian gallery c. 1914 (Image: Dundee City Council - Dundee's Art Galleries and Museums).

Main Donors and Contributors

The Egypt Exploration Fund/Society (founded 1882)

The Egypt Exploration Fund (EEF) was founded by Amelia Edwards in 1882, having been greatly affected by her visit to Egypt in 1876: 'Such is the fate of

every Egyptian monument, great or small [...] every day, more inscriptions are mutilated, more tombs are rifled, more paintings and sculptures are defaced' (Edwards 1877). Funding for the EEF was by means of subscriptions and donations, to which end Amelia undertook extensive lecture tours, which included a visit to Dundee, where she gave an Armitstead Lecture in May 1889. These had been endowed by George Armitstead, born in Riga, Latvia, to a Yorkshire father and a Russian Jewish mother. After an education at the German universities of Wiesbaden and Heidelberg, he settled in Dundee to develop his father's trading firm of George Armitstead & Co. and married the eldest daughter of Edward Baxter of Kincaldrum, an influential textile family. Growing his business into a worldwide shipping and trading empire, he became extremely wealthy and prominent, having homes in both London and Perthshire. However, he had an ongoing interest in Dundee, for which the City of Dundee made him an honorary burgess (freeman).

He gave money to a wide range of activities such as the Dundee Poor Houses, the St. John's Ambulance Association, the Industrial Schools for disadvantaged children, the Sailors' Home, the Victoria Hospital, the Dundee Royal Infirmary and University College Dundee, and established a Dundee Working Men's Club in South Tay Street. When this began to lose popular support, he wound it up and put the funds into the Armitstead Illustrated Lectures, which still continue today. This reflected the civic duty behind many of the 'great and good' of Dundee: to improve the lives of its citizens.

The subject of Amelia's lecture is unknown, but it can be imagined that it conveyed the plight of the monuments, the current work of the EEF and what more could be done with donations from the people of Dundee. An article in the local newspaper, *The Courier and Argus* described the event (11 May 1889):

> *after a very interesting lecture in the Armitstead course by Miss Amelia Edwards, Hon Secretary of the EEF, the Rev. Colin Campbell agreed to act as local honorary secretary for Dundee, and was successful in inducing a number of his friends to become subscribers. In addition to the satisfaction of assisting what is perhaps, from a religious and historical point of view, the most important archaeological exploration ever undertaken, and obtaining for themselves the yearly publications of The Society, Mr Campbell stated that there was a possibility of securing for the Dundee Museum gifts of rare and most valuable specimens of the art, architectural and domestic of that oldest of civilisations.*

Campbell was thus to raise funds for the Egypt Exploration Fund locally, which would help fund the society's excavations in Egypt and in return for these donations the EEF would share out some of the antiquities that had been found to the various funders, depending on their contribution.

Rev. Dr. Colin Campbell (1848-1931)

Colin Campbell had been involved from early in his career in Dundee society and with those desirous of improving the lives of the local population. As such, the following letter from Amelia must have been most welcome (quoted in *The Courier and Argus*, 11 May 1889):

> *The Larches, near Bristol, May 1st 1889*
> *Gentleman – I have the pleasure to inform you that a selection of antiquities for your museum will be forwarded from London in a few days. The President and Committee of the Egypt Exploration Fund have much pleasure in offering this selection for your acceptance. I wish to add that this donation is presented in recognition of the Rev. Colin Campbell's valuable services as our local Honorary secretary in Dundee. - I am, &c., Amelia B Edwards.*

Campbell spent many years researching the collection in Dundee and he continued to actively seek out more donations. An article in *The Courier* notes:

> *Valuable Donations to Dundee Museum – Antiquities from Egypt*
> *The Archaeological sections of Dundee Museum has just been enriched by one of the most valuable and interesting acquisitions it has ever made. This has been received from the Egypt Exploration Fund mainly owing to the influence of the local secretary of that society, the Rev. Dr. Campbell, who is an accomplished and enthusiastic Egyptologist. Several times during recent years similar donations have been received from this energetic society, these including one of the most interesting objects that the Museum possesses – an outer and inner mummy case which contained the body of a woman, and was found in the Necropolis of Ha-Kanensu (Heracleopolis Magna, the modern Ahnas-el-Medinet or Hennassieh, in nome XX of the Ancient Egyptian geography, the biblical Hanes, Is.30-4). The elaborate hieroglyphic inscription on the inner case executed in the*

characteristic Egyptian polychromatic manner still effective after more than 2000 years, was translated by the Rev. Colin Campbell [not in the McManus Museum collection].

Continuing, we hear that objects are further explained by having some of the hieroglyphic figures reproduced in facsimile (*The Courier*, 12 December 1898):

The antiquities in stone are from Dendereh, and were discovered last winter (1897-98) by the party working there, of whom the Rev. Norman de Garis Davies, BD (Glasgow University), was an active member. They are all funereal tablets (corresponding to our gravestones), and were found either in the outer corridors of a Mastaba or in pit tombs.

Amongst the pieces received in this group was the stela of Merri (1966-224), on it he is depicted holding a staff and *ḥrp*-sceptre. The inscription reads:

An offering which the King gives to Anubis upon his hill, who is within the burial, the Lord of the sacred land, for funerary offerings for the hereditary chief he who is over the secrets of the divine ordinances the chief priest, the revered one before the great god, Merri.

Campbell's work on the collection included making wax casts of scarabs, writing monographs and translating a variety of texts; this continued even when he was no longer active on the Museum Committee. Several of these endeavours are still part of the McManus Art Gallery and Museum's collection and are now accessioned in their own right (figs 2 and 3).

Campbell retired from the ministry in 1904, his departure being noted in the *Dundee Free Library Report* for that year (1904: 8):

Regarding the Egyptian collection in the West Museum Hall, which was also augmented by interesting acquisitions in 1904, the Committee reported last year how greatly they were indebted to one of their number, the Rev. Dr. Colin Campbell, through whose influence the large and educative Egyptian collection was obtained. He devoted much time and arduous labour to its acquirement, and to the translation of the hieroglyphics, which made the objects so intelligible and interesting to visitors. They regret to report that these highly appreciated services are no longer available, the failure of Dr. Campbell's health having compelled him to resign his charge

Canopic Jar (Museum Coll^n)
Columns Reading from right to left

① Saith Nephthys: I conceal the secret thing, and protect (make protection) over

② the Hapi that is within me. The protection of the Osiris Ptah-meri-Uah-ab-Ra.

(3) Son (?) of Psamthek is the protection of the Osiris Ptah-meri-Uah-ab-Ra

④ triumphant, for the Osiris Ptah-
← (5) meri-Uah-ab-Ra, triumphant,
The same is Hapi-

The name of the deceased was Ptah-meri-Uah-ab-Ra, and he was called after King Uah-ab-Ra (XXVI Dynasty), fourth King of Dynasty XXVI (about 589–570 B.C) King Hophra of Jeremiah XLIV:30

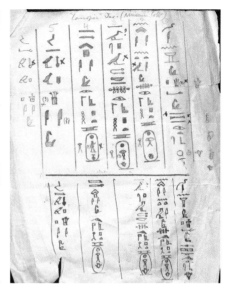

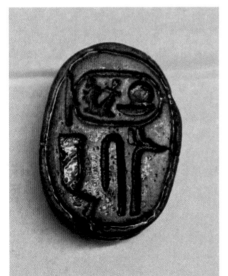

Figure 2a-c: Canopic jar, 1976-679-1, translation (left), general description (above), copy of inscription (right) (Images: Dundee City Council - Dundee's Art Galleries and Museums).

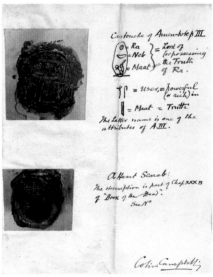

Figure 3a-b: Scarab, 1975-488-1 (left) and translation (right) (Images: Dundee City Council - Dundee's Art Galleries and Museums).

and reside abroad. The Committee felt it to be their duty to enter in their minutes a grateful acknowledgement of Dr. Campbell's long, arduous, and most able services to the Museum, and the intellectual work of the Libraries generally.

He then travelled to Egypt for his health. This allowed him to visit the country for the first time and to experience the land that had captured his imagination. An article in *The Courier* dated 6 February 1908 describes his exploits:

The Rev. Colin Campbell, Minister of The Parish of Dundee, who is well known for his researches in Egypt, was in residence in Luxor during the past two winter seasons, and while there made careful examination of several of the Theban tombs.

While doing so, Campbell found many 'visitors were interested in his translations', and as the burial chamber of Sennefer (TT96A) 'was not sufficiently dealt with in any other guide books', he published a brochure covering it (Campbell 1908).

Dr. Campbell says the tomb is remarkable for the beauty and freshness of its colouring, as well as its religious symbolism, which does not always admit an easy interpretation. Sen-nofer (Good Brother) was one of several of that name who filled high office at Thebes in the 18th Dynasty [...] The work is characterised by the literary grace and charm of Dr. Campbell.

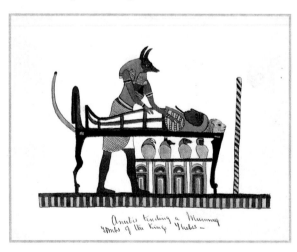

Figure 4: Anubis tending a mummy, watercolour by Rev. Dr. Colin Campbell, 1848-1931 (Image: Dundee City Council - Dundee's Art Galleries and Museums).

Campbell left a few Egyptological objects with the Museum, including two small watercolours of Egyptian scenes (figs 4 and 5), perhaps painted as smaller pieces or as drafts for larger works, such as his life-size tomb paintings now part of the collection of the Hunterian Museum, Glasgow. His principal gift was, however, his enduring enthusiasm and dedication to Egyptology and to his adopted home of Dundee.

The Annual Reports

The Museum's annual reports provide insights into the growth of the Egyptian collection (*Dundee Free Library Report* 1892: 6):

The Archaeological Section also continues to increase, and during the year received some most interesting additions. Among these were important and valuable gifts from the Egypt Exploration Fund, including a fine mummy case (outer and inner) in splendid preservation, and elaborately decorated with beautiful hieroglyphics. This was found in the Necropolis of Ha-Khenensu Heracleopolis Magna, the modern Ahnas-el-Medinet, or Hanassieh, in Nome XX. of the ancient Egyptian geography, the Biblical 'Hanes', Isaiah xxx.4. This, and a large number of smaller objects illustrative of Archaeological Egyptian Art, were received per a member of your Committee, Rev. Dr. Colin Campbell, who is a local secretary for the Exploration Fund, and who kindly wrote a full translation of the hieroglyphical history of the female whose mummy was contained in

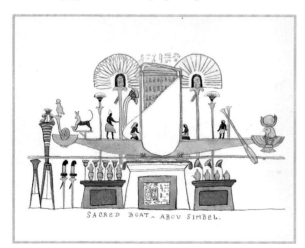

SACRED BOAT AT ABOU SIMBEL.

Figure 5: Sacred Boat at Abou Simbel, watercolour by Rev. Dr. Colin Campbell, 1848–1931 (Image: Dundee City Council - Dundee's Art Galleries and Museums).

the case. This was printed and placed alongside, making the exhibit much more interesting. Another valuable Egyptian art specimen was received through another member of the Committee, Ex Bailie Stephenson, from the Egypt Transit Society. This was a large granite slab, with incised inscription and figures, from the Great Temple of Bubastis, lower Egypt, built by Osorkon II, 22nd Dynasty, 950BC. To Dr. Campbell and Ex Bailie Stephenson the Committee have recorded in their minutes their grateful thanks.

Campbell's donations as Local Secretary to the EEF meant that the Albert Institute received the EEF's annual memoirs along with the objects. These were separated several years ago when the libraries and museums divided, some were reunited with the objects in the museum in 2013. It was most rewarding to find in these some objects staring out across time from these pages, having previously lost their provenance. Their journey to the collection can thus be reconstructed once again, for example a Third

Figure 6: Cartonnage, 1976-1708, on display c. 1914.

Figure 7: Stela of Iy from Dendera, 1966-223 (Images: Dundee City Council - Dundee's Art Galleries and Museums).

Intermediate Period coffin (1976-1170 and 1975-531), a cartonnage mummy case (1976-1708) and a mummy (1978-2146), which can now be re-assigned to Édouard Naville's work at Ahnas el-Medina (Naville 1894a: 11–13).

Unfortunately, the provenance for other objects remains lost. For example, 1975-132, a bracelet of gold and semi-precious stones probably dating to the New Kingdom, is probably from the EEF, to judge from surviving distribution lists. Another example is the cartonnage mummy-mask (c. 1st century AD; 1976-1008), probably from the Fayyum, and possibly also from the EEF or the collection of Sir James Caird (for whom see below). In 1895, the Report states (*Dundee Free Library Report* 1895: 8):

The Egyptian [sic] Exploration Fund has again presented valuable objects and volumes descriptive of their very successful archaeological work, per a member of your Committee - Rev. Dr. Colin Campbell, Local Secretary to the Egypt Society; and the Committee are also greatly obliged to that gentleman for lending for exhibition his copy of the reproduction of the Codex Vaticanus. Only 100 copies of this celebrated manuscript of the fourth century were taken, and of these few are to be found in Great Britain.

More EEF objects are reported in 1898 (*Dundee Free Library Report* 1898: 14):

The Egypt Exploration Fund made what is probably the most valuable gift of many received from them, - five stone funereal tablets, nine fire burnt clay vases, three clay food vessels, two small alabaster vases, quantities of beads, amulets, scarabei, &c, all found during excavations last winter at Dendereh. A Member of your Committee, Rev. Dr. Colin Campbell, through whose kind influence, as corresponding secretary, so valuable a gift was obtained, made a transliteration and translation of the hieroglyphic inscriptions on the tablets, which has been published in small pamphlet form, copies placed beside the tablets, and is also sold at a merely nominal price. To Dr. Campbell, for this and former valuable assistance, the warm thanks of the citizens are due.

Dr. Thomas Wise (1802-1889)

In 1843, Wise was on leave from the Indian Medical Service and travelled back to Europe via Egypt. He left on 10 February 1843 on the steamer India

to Suez. He carried with him 13 volumes of publications of the Asiatic Society of Bengal to present to the Mohammad Ali Pasha. He undertook the journey from Suez to Cairo by horse-drawn wagon across the desert and then a paddle steamer down the Nile to the Mahmoudiyah Canal on to Alexandria and then the Mediterranean (Johnston 2016). Wise did not record exactly how and where he obtained the objects he collected in Egypt, though he does write of several that they came 'from tombs'. Many are amulets and reflect his interest in the prevention and treatment of illness and disease.

Colin Campbell and Wise may have met sometime before Wise donated his collection to the University of Dundee in 1884, in order to assess the objects, or the University may have requested Campbell to view them at a later date. The latter is perhaps more likely as wooden shabti 1993-375-8 was described in 1903. Campbell made wax impressions from some of Wise's scarabs, then translated and described the objects. The collection was catalogued as Campbell's until Laura Adam of the University of Dundee reinstated Wise's name whilst researching her 1994 Wise exhibition. Material from Wise's collection includes two shabtis (1993-375-8, -10), and various amulets (including 1993-375-15 [papyrus sceptre], -4 [Anubis], -13 [Shu], -2 [Bes], -7 [Uraeus], -1 [Wadjet-eye], and -17 [heart]).

Figure 8: Shabti, 1993-375-8 (Image: Dundee City Council - Dundee's Art Galleries and Museums).

Sir James Key Caird (1837–1916)

James Caird was born in Dundee on 24 July 1837, his father being Edward Caird (1806-1889), who founded the firm of Caird (Dundee) Ltd in 1832. The business at Ashton and Craigie Works was one of the first textile manufacturers to weave cloth composed of jute. As jute became increasingly popular, the business prospered. Caird married Sophie, daughter of George Gray, a solicitor from Perthshire. Tragically, she died aged 38 in 1882, after only 9 years of marriage, and their daughter died aged 14. After this, Caird devoted himself to philanthropic causes.

In 1914, Caird was approached by Ernest Shackleton for funding for his Antarctic Expedition. Caird, who was well travelled and a linguist, had no interest in polar exploration but he was impressed by Shackleton's energy and determination. He sent Shackleton a cheque for £24,000, expressing his hope that others would follow suit. Later, an area of the Weddell Sea was named Caird Coast after him (Dundee Yearbook 1916: 55)

Caird was apparently a friend of W. M. Flinders Petrie, although it has not been possible to confirm this via archival research. Their friendship is noted in the Annual Report of the Albert Institute of 1914, which also mentions the British School of Archaeology in Egypt. Caird's donations to the museum are mentioned in his obituary from the Dundee Yearbook, having given 98 Egyptian objects (Dundee Yearbook 1916: 55):

In 1907, when on tour through Egypt, he secured a large number of Egyptological specimens, which he retained for a considerable time, but ultimately handed over to the Museum in 1913. These specimens formed the nucleus of the new Egyptian Section founded in that year. They include a complete example of an encased mummy, dating from 900 BC and numerous examples of bronze, pottery and mummy cases of great interest and antiquity.

Perhaps the most interesting of his gifts was a fragment of limestone (1977-534-1), with a low relief image of Princess Neferure, the daughter of Hatshepsut and Thutmose II. It came to the Albert Institute after Caird's death in 1916 and is on display in the 'Dundee and the World' gallery in the case dedicated to him, close to the Egyptology case in the same gallery. It is unclear how the relief came to Caird but was presumably acquired from a Luxor antiquities dealer.

The fragment comes from the Amun sanctuary of the memorial temple of Hatshepsut at Deir el-Bahari, at the top of the southern wall (Porter and Moss 1972: 365–66[132]). It was copied *in situ* by Champollion and Rosellini in 1828/29; however, it was not present in 1894 when Naville noted 'these scenes have been much defaced since the time of Lepsius' (1894b: 27), while in 1899

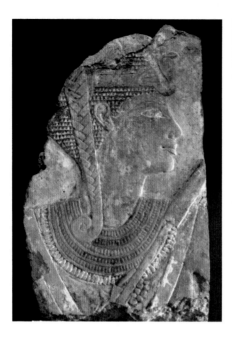

Figure 9: Limestone relief depicting Princess Neferure, 1977-534-1 (Image: Dundee City Council – Dundee's Art Galleries and Museums).

Margaret Benson and Janet Gourlay state that 'the quaint portrait of this princess […] was preserved until lately at Deir el-Bahari' (1899: 169). A letter written on 21 December 1962 by Kenneth Kitchen, then resident at Chicago House, Luxor, to J. D. Boyd (Curator at Dundee Art Galleries and Museum) reads:

Dear Mr Boyd,
This is just a short line to say that a couple of days ago I had the pleasure of actually taking the full-size pencil rubbing of Princess Neferure's head up to the temple of Deir el Bahri, of climbing a ladder and of putting the rubbing into the relevant hole in the wall in which it fitted exactly, as earlier postulated! So you can now be absolutely sure that the Dundee head really is the Princess Neferure from Deir el Bahri temple, c.1490BC. (It would be nice to put a cast of the Dundee piece in the wall at Deir el Bahri).
I'm also dropping a line to the Editor of the Journal of Egyptian Archaeology to mention the success of the 'fit'. A small Polish expedition working at Deir el Bahri were quite thrilled when they got to know about Neferure.
All best wishes (& the Season's greetings),
Yours sincerely,
Kenneth A. Kitchen

Kitchen's resulting paper adds (1963: 38):

> *At one stroke this fact adds very greatly to the interest and importance of the Dundee fragment and restores to the knowledge of Egyptologists the only known surviving 'portrait' in low relief of the famous but curiously ephemeral daughter of the redoubtable Queen Hatshepsut and ward of her favourite Sennemut, builder of the temple from which this fragment comes.*

Another Neferure fragment (W1376), possibly from the Deir el-Bahari temple, was identified in 2018 by Ken Griffin in the collection at Swansea University.

The false door of Inseneferuishtef (Porter and Moss 1974-81: 891) had been found at Dahshur by Jacques de Morgan in 1894, but also found its way into Caird's collection. Cyril Aldred of the Royal Scottish Museum (now National Museum of Scotland) described it in a letter dated 3 June 1955 to J. D. Boyd (curator at Dundee Art Galleries and Museum):

> *False door in limestone, baring traces of colour, and bearing funerary prayers to Anubis in favour of In-Sneferu-ishtef, Deputy Inspector of Gardens of the Palace.*

He also made the following comments on the potential origin of the piece in 1955:

> *Two explanations are possible. It was pilfered from the site and sold eventually to someone who gave it to Dundee; or, more probable, it was sold over the counter at the sale-room of the Cairo Museum. At one time such business was transacted and second and third-rate material disposed of in this way. As your door was obviously in poor condition even when it was found I expect that it was considered undesirable to retain it.*

Other items from the Caird collection include a Third Intermediate Period coffin (1914-204-1), a bronze Sekhmet (1976-1346), a Late Period granite statue (1914-204-4-1), a Roman Period coffin (1976-1170), and a Roman Period mask (1914-204-37a).

The Late Period granite statue depicting a wealthy man and his wife seated, was described by Campbell as follows:

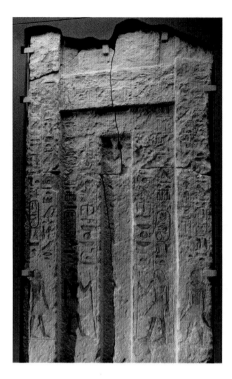

Figure 10: False door of Inseneferuishtef, 1914-204-26. (Image: Dundee City Council - Dundee's Art Galleries and Museums)

Opposite page:
Figure 11 (right): Bronze Sekhmet, 1976-1346.
Figure 12 (far right): Late Period granite statue, 1914-204-4-1.
(Images: Dundee City Council – Dundee's Art Galleries and Museums).

The wife is seated on her husband's right and has her left arm around him. Inscriptions were originally on back and sides of the seat but they are almost entirely effaced. They seem to give the usual formulas for funeral offerings, the names cannot be read, a very few signs being legible.

RHS - 'Nekht em heb (perhaps the name of the woman), born of the mistress of the house, Sen....'.

LHS – 'Guardian Lord, Zet-het-hor, triumphant, born of the mistress of the house, Auf(?)-aa'.

Unfortunately, the current state of the stone makes it impossible to verify this translation, despite further investigation.

Concluding remarks

This brief history of the Egyptology collection in the McManus Art Galleries and Museum, Dundee, aimed to introduce the collectors and researchers,

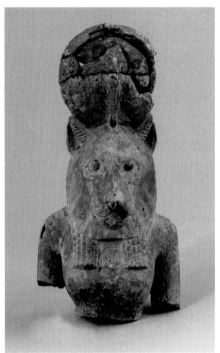
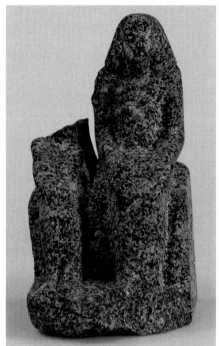

that contributed to the city's collections. As always, the work of researching collections is ongoing and the author would like to acknowledge the work of all the team at the Dundee Art Galleries and Museums, without whose support, guidance and access to the collection none of this would be possible.

Bibliography

Benson, M. and Gourlay, J. A. 1899. The Temple of Mut in Asher. London: John Murray.

Campbell, C. 1908. The 'Gardener's Tomb' (Sen-nofer's) at Thebes. Glasgow: J. MacLehose & Sons.

Edwards, A. B. 1877. A Thousand Miles Up the Nile. London: Parkway.

Free Library Committee. 1893. Dundee Free Library Report of 1892. Dundee: D.C. Thomson.

Free Library Committee. 1895-96. Dundee Free Library Report of 1895. Dundee: D.C. Thomson.

Free Library Committee. 1899. Dundee Free Library Report of 1898. Dundee: D.C. Thomson.

Free Library Committee. 1906. Dundee Free Library Report of 1904-05. Dundee: D.C. Thomson.

Johnston, H. 2016. The Life of Thomas Alexander Wise (1802-1889). Unpublished manuscript.

Kitchen, K. A. 1963. 'A Long-Lost Portrait of Princess Neferurē' from Deir el-Bahri', Journal of Egyptian Archaeology 49: 38–40.

Naville, É. 1894a. Ahnas El-Medineh (Heracleopolis Magna): With Chapters on Mendes, the Nome of Thoth and Leontopolis. London: The Egypt Exploration Fund.

Naville, É. 1894b. The Temple of Deir el Bahari: Its plan, Its Founders, and Its First Explorers. Introductory Memoir. London: The Egypt Exploration Fund.

Porter, B. and Moss, R. L. B. 1972. Topographical Bibliography of Ancient Egyptian Hieroglyphic Texts, Reliefs, and Paintings, II: Theban Temples (2nd ed.). Oxford: Griffith Institute.

Porter, B. and Moss, R. L. B. 1974–81. Topographical Bibliography of Ancient Egyptian Hieroglyphic Texts, Reliefs, and Paintings, III: Memphis (2nd ed.). Oxford: Griffith Institute.

Various authors. 1916. Dundee Yearbook Obituaries. Dundee: John Leng & Co.

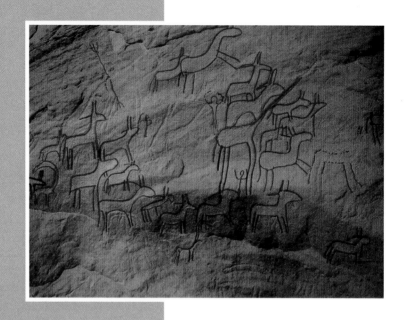

Competition, conflict and control: suggestions of motive in the use of petroglyphs recorded from the Kom Ombo Basin

Gordon Dicks
Independent researcher

1. Topographical overview

The Kom Ombo Basin [KOB] is located approximately 150 km south of the Qena bend, with Middle Egypt's broad floodplain to its north and the first cataract at Aswan 50 km to the south. It is a unique, isolated floodplain environment and a habitat supporting past and present human and animal occupiers of nomadic or migrating seasonal visitors (Peters 1990). The development of the Kom Ombo wadi system, created during periods of altering climatic conditions, holds much data in the form of petroglyphs left by human visitors through multiple millennia up to the present day.

The Kom Ombo wadi system fans out into the volcanic, mineral rich mountains to the east, which contain known gold mining sites such as Dungash and Samut (Klemm and Klemm 2013: 228, 238), both approximately 380 m above sea level. This paper discusses petroglyph material from Wadis Midrik and Bezeh in the northern section of the system. Wadi Midrik is to the south of Wadi Barramiya, which intersects with water courses falling into both the Kom Ombo and Edfu Basins. South of Wadi Bezeh, a wadi group comprising Sha'it, Muweilhat, and Sibrit (Judd 2009: 140, map 9) extends the Kom Ombo system into its central eastern section. The majority of petroglyphs occur on Nubian sandstone but also occur in the volcanic series, which are often intruded by dykes and quartz veins at significant locations throughout the Egyptian Eastern Desert.

1.1 Wadi Midrik

The petroglyphs incorporated in this paper, are located in a short narrow Nubian sandstone section of the wadi approximately 7km in length. Clusters of pharaonic inscriptions are also present in the wadi course and occur across the region (Rothe et al. 2008: 329-43). The eastern end of the section is approximately 40 m higher than the western end and intersects with an established camel road running roughly north south

following the elevated sandstone outcrops to the east. The undulating rugged floor is unsuitable for a 4 x 4 vehicle. The wadi floor varies in width from less than 10 m up to 80 m at intersections with side gullies and smaller wadi junctions. Time limitations due to day visitation did not allow for a fuller survey of these areas or the higher ground between the intertwined systems. Both Wadi Midrik and Wadi Bezeh displayed dried alluvial sediment from seasonal rains at low lying points in their respected water courses during February 2017.

1.2 Wadi Bezeh

Positioned to the south of Wadi Midrik, Wadi Bezeh, in contrast, has a wider smoother undulating floor easily accessible by a 4 x 4 vehicle. The investigated petroglyph sites are located in a 13 km section and appear to be spaced at longer intervals than in Wadi Midrik. Similarly, clusters of pharaonic inscriptions and petroglyphs occur at the same

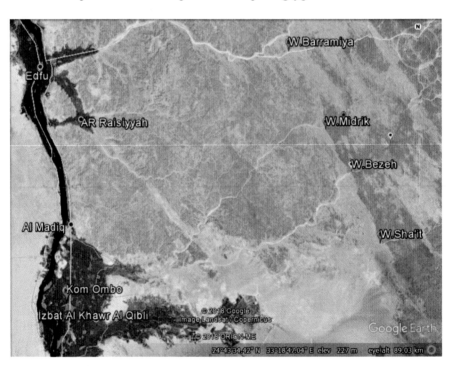

Figure 1: Satellite image showing the area discussed in this paper. (Image: Google Earth)

locations (Rothe et al. 2008: 247-79). Unlike the Wadi Midrik section, the longer Wadi Bezeh section could not be surveyed to its full length. The remaining section extends for approximately 9 km to the north-east before a major confluence with Wadi Dungash, which rises east into the volcanic series.

2. Method used in assignment of the petroglyphs

Due to day visitation status, creating a photographic record was the only practical option available to analyse the petroglyphs from the visited sites. Chronological analysis of the petroglyphs from these two wadis has been cross referenced from the following published surveys:

A. The general analysis of Egyptian petroglyphs by Cervicek (1986), extending from Wadi Halfa up to the Qena bend and into the eastern and western deserts. His chronology is divided into six horizons, the earliest of which includes spirals and geometric patterns which at present seem absent from the El-Kab data. The table (Cervicek 1986: 117) does not include giraffe, elephant and ibex motifs in the early chronological horizons.

B. From El-Kab (Nekheb), a table was compiled and published by Huyge (2002: 195) of seven time periods .The close proximity of this eastern Nile site to the western early elite settlement at Hierakonpolis (Nekhen) gives its petroglyph data significance when social, religious or political developments are evidenced in the archaeological record, most notably from decoration on vessels, cloth, and animal burials associated to elite burial sites such as HK6. If such developmental 'markers' can be identified within the archaeology, such as the association of an elite burial with a specific animal, then the possibility might be suggested that this relationship continues further afield into the eastern desert in the function of petroglyphs. The earliest motifs include giraffe, bull, and a stick 'orant' figures, but not elephant.

C. The individual petroglyph analysis from the Bi'r Minayh Survey (BMS) by Farkas and Horvath (Luft 2010: 68-169), provides data from a site approximately 100 km from the river between the Nile and Red Sea, which has a similar elevation to the mining areas at Dungash and Samut. The long-held view of this site's importance was highlighted by Luft (2010: xi) and evidenced by accompanying clusters of pharaonic inscriptions (Rothe et al. 2008: 47-81) relating to commissioned groups likely engaged in mineral extraction and processing activity as assessed from the geological element of the survey by Kleb and Török (2010: 21-4). The presence of water all

year round supports herds of sheep and goats belonging to local Bedouin as well as occupation from limited licenced mining activity. Petroglyphs with geometric patterns occur a short distance from the area but do not have a dominant presence at the well site, whereas several examples of elephant and giraffe do occur. The majority of ass and ibex are positioned high above the wadi floor.

3. Motifs

3.1 Ass (equus africanus asinus)

When collating the photographic material, it seemed striking that so many depictions of ass-like quadrupeds occurred in these two wadis. This identification is due to the proportion of the torso to head, ears and neck with the legs. Petroglyph scenes on rock panels including ass often also included armed men, with or without dogs, or just dogs and no human figures; these are logically interpreted as hunting scenes. However, as some panels include ass but lack dogs or humans, such depictions may also suggest that the animals were valued for more than just food. An appendage, which might be interpreted as a mane, was often present and in differing styles. Drawing from the data at El-Kab and Bi'r Minayh, the earlier assigned style of ass depiction possessed general characteristics of, a head-down stance with a thin lined neck and body. The depictions are fully pecked and not cross hatched in this data.

Association of this animal with elite burials is evidenced at the north cemetery of Abydos where ten adult wild ass (possibly examples of the now extinct Nubian ass, *Equus africanus africanus*); six male, four unknown were deposited in a high status building (Rossel 2008).

At the elite burial site of HK6 at Hierakonpolis two adult wild ass and a potential domesticated foal have been discovered in a Naqada III archaeological context (Friedman 2018). This may further suggest that ass held an elevated status at this time.

3.2 Giraffe-types

The petroglyphs assigned as giraffes fall into the two categories described by Judd, as A-type realistic and B-type diagrammatical (2009: 12). The occurrence of this motif was largely confined to a few notable sites from both wadis representing both A- and B-types. Judd

also details other examples such as tail-up which are not separated in this data (Judd 2009: 13).

The presence of gerenuk (*Litocranius walleri*) motifs at some of the same sites as giraffe was noted. These depictions are identified by having exaggerated forward curving antlers, present only with males, and long necks. The B-type giraffe, in comparison, are depicted with fully pecked unnaturally proportioned narrow extended limbs, neck and tails. The patina was similar between the gerenuk and giraffe, at several sites. At other sites the giraffe had an earlier palimpsest shared with ibex. Whilst ibex occur in the osteological archaeological records of the area (see Petrie 1901: 46), the giraffe, gerenuk and dibatag (*Ammodorcas clarkei*), to date do not and therefore their identification has to be assumed as evidence of presence, rather than proven as a resident or visitor in Pre-dynastic times. More specific data has not yet been incorporated into the data due to the specialisation and rarity of the image where horns are straight up, twisted (kudu, addax), in a loop (ornamental / manipulated) or incurved (hartebeest).

3.3 Elephant (Loxodonta africana)

Issues regarding ear and trunk position, outline only or fully pecked, cross-hatched body, association with mountains, snakes and elite funerary accompaniment all help provide substance when isolating specific types and specific archaeological context and can therefore assist in a chronological analysis (Hendrickx 2004: 147). Along with petroglyphs and decorated artefacts, the elite HK6 area has provided examples of elephant burials; including one buried with a high-status woven blanket (see Drewsen in this volume).

3.4 'Orant' figures

The data analysed here is limited to figures not in direct association with boats, with one or both arms raised. Some exhibit a steatopygous form, others are more slender at the hips and with differing headdresses, stance and costume. Sexing of some figures is difficult and reliant on archaeological finds of figurines or painted pottery images of similar style for guidance. The main cross referencing for this data is with material from El-Kab and analysis by Cervicek (1986), as few examples are recorded in the Bi'r Minayh survey. However, significant petroglyph examples are present in outlying sites beyond the survey area.

25

4. The panels

4.1 Petroglyph panels (Wadi Bezeh) – east- to south-facing (position: 24, 48', 59, 00"N 33, 41', 51, 65"E, west side of wadi)

The petroglyphs present on three boulders are clear and distinct, in isolation, and palimpsest. Weathering has been minimised by position in a narrow section away from wind and flash flood hazards. The sandstone surface is in places exceptionally well metalled to a bronze sheen.

The front boulder displays a general collection of quadrupeds with horns facing forward and rearwards. The problem of accurate identification is discussed in greater detail by Judd (2009: 11-26). For example, where horns are to the front, dorcas, dibitag and gerenuk might be considered; however, when other traits such as body shape, length of horn, ears, tail length and limb proportions allow specific natural physiological attributes to be incorporated, the process of species assignment can be improved. Where less detail is in a scene, such as the top right of the boulder, it is of interest that several types of horn orientation on the animals present relate to a single unarmed human figure.

4.1.1 Asses

On the lower part of the panel, a group of asses, with appendages, look south, their heads are erect and their stance alert. Above, a larger example with lighter patina faces east. A darker patinated example, following right, faces south, with its head held horizontal to its back. The next examples are in palimpsest; the earlier image has its head low while the later one has its head-up. A similar scenario is present on the boulder behind including the older image having its head-down. Whilst these images could be an alternative animal, the trend, if repeated elsewhere gives confidence in noting its possible significance as a chronological marker.

4.1.2 'Orant' figures

These evenly proportioned figures occur on the rear boulder, surrounded by a pair of similar boats with lighter patina which are occupied by plumed figures with arms raised. Three or four successive groups have produced an 'orant' assemblage. The darkest patinated lower group have incurved arms, similar to the 'D ware' associated with Naqada II, as do several of

the upper group. The steatophygous hipped figures have a trend of shape
to the left. This mixture of posture includes fully and partially incurved
armed members and outward facing hands. One figure in a group has one
arm up and one on the hip. A solitary sleek figure of similar proportion
is positioned to the left of the group with a plume and both arms down,
possibly male. The presence of the boats, not in palimpsest, poses some
questions regarding the association with the figures, such as control,
shamanic or votive relationship to a possible female spiritual authority
associated with the area. One observation is the adaptation of the stern
of the boat on the right of the figures reflecting the steering of a possible
pharaonic vessel. This suggestion is supported by the lighter patinated
boat to the upper right of the boulder with a similar steering oar. Such
adaptations, when compared to an example at El-Kab of the stern of a
'sickle' boat being converted to a more square-hulled design, suggests a
usurpation while the possibility of a connection to the decoration of Tomb
100 at Hierakonpolis is commented upon by Huyge (2014: 93-102). This
motive might be supported by the placement of the boat over a B-type
giraffe, with a flayed tail. Similar 'orant' figures are present in Horizon
2 (Cervicek 1980: 117) and Naqada II from El-Kab. The steatophygous
hipped figures, often in clay or ceramic, decline in the archaeological
record during the late Naqada II to early Naqada III periods from the elite
burial areas north of the KOB, seemingly replaced by slender male and
female figures with lowered arms, in material such as ivory in increasingly
ostentatious elite graves and assemblages, such as U-J at Abydos, Tomb
100 and the Main Deposit at Hierakonpolis (Hikade 2004: 182).

Figure 2: Left, ass with head-up stance on the left before an ass with head-
down stance and ibex. Right, 'orant' figures at the rear in relation to several
boats. (Images by the author)

4.2 Obscured boulder 7 km west of 4.1 (Wadi Bezeh) (position: 24, 45', 32, 90"N 33, 36', 41, 87"E, south side of wadi)

To contrast the data from the area regarding figures, this north-east facing panel on a low-lying split sandstone boulder at the western mouth of the wadi section depicts figures in very different relationship and association. No animals are present and only a few points of palimpsest occur giving guidance to what image pre-dates the other. Patina is similar but certain figures are distinctly darker.

The main female figure on the left is being assailed by a smaller oval-headed, plumed 'hunter' figure, dressed in a tailed garment, firing an arrow from a short bow with one hand on a hip and a dog in outline behind. The larger, open-breasted, female figure is slim at the hips and appears to be in a dress. The presence of plumes or horns suggests rank or a deity, possibly both. The posture of the raised arms is curved in with hands pointing out. To the right, several 'orant' figures with plumes and tails are mixed with 'hunters' holding short bows. The lower, darker patinated 'orant' figure has a fully incurved arm posture compared to the possibly male figure above, which has a similar posture to the female figure and of similar patina and working. The panel also has several unfinished figures of similar patina and working. The lower, larger etched figure is of a later date to the adjacent 'hunter' due to the palimpsest evident at the figure's feet. Plumes added to the 'hunter' are 'spikes' compared to the headdress of the larger figure, which are similar to the female figure. All 'hunters' are aligned in the same manner with bows to the right. All 'orant' figures face front and have no accompanying bundle to one side.

Figure 3: Left, Hunter with dog shooting a plumed female 'orant' figure. Right, 'orant' and hunter figures. (Images by the author)

4.3 Large boulder, close to 4.1 – east-facing (Position: 24, 48', 56, 62" N 33, 41', 51, 40"E, west side of wadi)

4.3.1 Elephant

The central elephant motifs on the well-metalled sandstone surface face in both directions. The depicted style of the fully pecked examples (Cervicek 1974: figs 29, 30, 505) have raised ears, short tusks (possibly female), long downward trunk, clubbed feet as well as one smaller male example which is sexually excited and animated. The smaller examples have a rougher executed surface.

4.3.2 Various figures

Two faint figures can be seen above the elephant on the left. One figure has arms in an incurved 'orant' pose. Other animal motifs on the boulder with a similar patina are ibex (or other backward sweeping horned quadrupeds) and gerenuk. Between the two central elephants, a later figure reuses the elephant's trunk as a staff with one hand on a hip. No 'hunters' are present on the boulder.

4.3.3 Asses

An example of the head-down style is present with similar patinated and pecked examples of ibex, a possible dog as well as the excited male elephant.

Figure 4: Left: large boulder dominated by elephant, gerenuk, gazelle, and ibex. Centre: earlier images of similar patina (black), later alterations and additions (blue), with independent forms (red). Right: ass with head-up stance in relation to earlier images. (Images by the author)

The groupings of later asses are mostly with appendages and in animated poses. What is striking is the association of these asses to the animal motifs they are with in palimpsest. There is a synchronism in direction of the asses to the direction of the earlier animal motif, whether elephant, gerenuk and perhaps the earlier head-down ass.

4.4 Large panel – south-east facing (Wadi Bezeh) (position: just south of panel 4.3, west side of wadi)

4.4.1 Giraffe

The centre of this panel has several large B-type giraffes. The elongated limbs and neck appear similar enough to suggest they were executed at a similar period. The heads have horns. Faint ibex are present in earlier palimpsest to the giraffe. Gerenuks are of a similar patina, frequency and direction.

4.4.2 Human figures

Three small figures are present of a later patina to the giraffe. On the left of the panel, in front of an ass, a stick figure holds a long bow / staff with one hand and the other hand is placed on the hip. A second slim 'orant' figure is placed in front of an earlier gerenuk. The third figure has been placed between the legs of the largest giraffe and in front of a head-up ass, with arms raised in a squarer pose.

4.4.3 Ass

The earliest forms of ass with head-down posture are to the left of the panel. A small, well-executed ass, with a head-up posture has been placed above the back of a gerenuk on the right at a later date. Later asses are placed in groups facing the same direction as the earlier motifs. Most have appendages and all have a head-up pose. The ass group stacked above the largest giraffe has a similar patina and pecked appearance to its body and part of the neck. The later head-up asses are in later palimpsest to giraffe, ibex, gerenuk and head-down ass.

4.5 B-type giraffe panel – west- and north-facing (Wadi Midrik) (position: 24, 51', 18, 00" N 33, 34', 56, 00", south side of wadi)

Multiple similar images, facing north and west, dominate the boulder. A mixed size group occurs on the west face of the boulder. The giraffe images have a

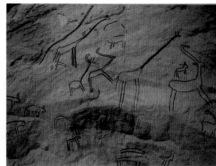
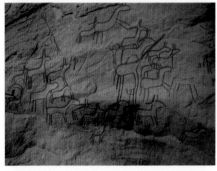

Figure 5: Top left: giraffe, gerenuk, ibex, oryx, and ass panel. Top right: earlier images (black) of giraffe, ass, and ibex. Right: later images (blue) and final examples (red). (Images by the author)

Figure 6: Central giraffe with ass across its neck. (Image by the author)

hammer and crescent shaped head without distinct horns. Their tails do not divide. In the centre at the top of the boulder, a solitary ass has been placed across the neck of one of the giraffes. A similar example of palimpsest is depicted at el-Hosh (Cervicek 1974: fig. 149). The ass has an exaggerated round muzzle, a long tail and appendage from its ears to its back; its hoofs are clubbed, showing a patina that is lighter than the darker colour of the entire giraffe group. The shape of the images, in part, seems to follow the contours of the rock.

4.6 B-type giraffe boulder – west- and north-facing (Wadi Midrik) (position: 24, 52', 07, 00"N 33, 35, 45', 36"E, east side of wadi, 2 km north of 4.5)

The shape of the large boulder is used to compliment the B-type giraffe form on the west face. The north-facing side of the boulder depicts boats, cutting across the earlier B-type giraffe necks.

A large north-facing panel above the boulder has figures with plumes, bows, tails, and associate animals, including dogs, ibex, ostrich and ass of similar patina. Giraffe and gerenuk are absent. A larger, single-plumed figure is identified by palimpsest as being of a later date (Lankester 2013: 101).

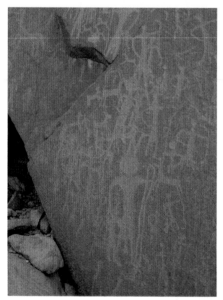

Figure 7: Top left: large pointed boulder with large early giraffe and later ass, boats, and figure images. Top right: north-western face consisting of giraffe with later boats over heads and neck. Left: hunters in a large panel with dogs and bows. A larger plumed figure is in final palimpsest. (Images by the author)

5. Site comparisons

The subject data from Wadi Midrik and Wadi Bezeh is compared, on the
bar chart, with published data immediately north from Wadi Barramiya and
south from the wadi system, described by Judd (2009: 140, map 9) as 'zone
5' which comprises Wadi Muweilat, Sha'it and Sabrit. To suggest relevance
to early state formation the El-Kab chronology has been used.

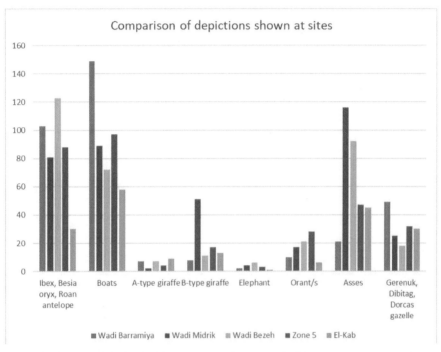

Wadi	Petroglyph sites	Approximate distance of distribution (km)
El-Kab	4	1
Barramiya	39	40
Midrik	34	7
Bezeh	17	13
Zone 5	48	35

Figure 8: Number of depictions recorded in survey area.

5.1 Giraffe

In general A- and B-type giraffes have a frequency, if combined, similar to 'orant' figures not incorporated with boats from the same region. The exception to this is the increase in occurrence of the B-type form, in Wadi Midrik. Some giraffe examples occur in the wadi together with boats, figures and animals. The palimpsest generally indicates that the giraffe is consistently of an earlier time period than other images, if present on the same panel. The examples from El-Kab indicate a higher occurrence on a west-facing surface and decline in use during Huyge's period II (2002: 195), roughly equivalent to Naqada II. A-type examples continue to occur in solitary images, or in direct palimpsest with elephant, as in Wadi Barramiya (Morrow et al. 2010: fig. BAR-2 GP1229).

5.2 Elephant

The low occurrence of elephant is consistent with the other wadis and El-Kab. The fully pecked examples from Wadi Bezeh are different to the outline style of the elephant image from El-Kab. The raised ears are a closer match to earlier pottery motif style, associated with Naqada I pottery, but without an outlined body and parallel tusks. One outlined example from Wadi Minayh, T010, has some similarity, but is not in association with other motifs such as ass (Luft 2010: 129).

5.3 'Orants'

These figures, with one or both arms raised, have differing headdresses or plumes or none at all. The sex of the figures can be ambiguous. However, if the figures are of steatopygous appearance an assumption of female has been made. A small increase in occurrence seems to be present south of Wadi Barramiya, where there is also an increase in boat occurrence, often include an 'orant' figure within the hull. Similar examples of the styles present at El-Kab are present in all wadis in the data.

5.4 Antelopes and gazelle

In general, the data is consistent in the area regarding quadrupeds with horns facing forward and backward. The lack of certain identified species from the archaeological record gives caution when suggestion of motive

and meaning for a potentially absent animal is considered on image alone. Analysis of El-Kab is hindered by the number of sites it currently has published, which hopefully will extend into Wadi Hillal to provide a more comprehensive appraisal.

6. Comparison of data from Bi'r Minayh to El-Kab.

6.1 Background

During the late 1990s and early 2000s, several archaeological and topographical surveys took place in the Eastern Desert. The effect of the differing efforts and publications led to areas being divided, where topographically it would appear sites were better understood as a group or cluster. Pharaonic inscriptions from the Egyptian Eastern Desert were unified in the publication by Rothe et al. (2008), which also noted petroglyph occurrence. The petroglyph survey publication by Judd (2009: 140, map 9), assigns the area encompassing Bi'r Minayh as zone 2, which includes the southern wadi system branch of the Quft basin.

6.2 Asses

From the data at El-Kab, asses start to appear in the Naqada II period. Generally, the earlier fully pecked images have a head-down posture and a thinner neck and body. The ass motifs occur on the east face of 'Vulture Rock' (Huyge 2002: 200, fig. 5). Images do not seem to be deliberately placed over each other. At Bi'r Minayh, the asses assigned chronologically to Naqada II are found in two contexts, with a few being found along the wadi sides. However, the majority are 35 m above wadi floor level, around a sandstone rock shelter area called 'Field V'. The upper site ass petroglyphs face in all directions except west and contain one example of an ass being placed above the back of an ibex (V20/6). At El-Kab, the peak period of use is in Naqada II, though at Bi'r Minayh a slight increase occurs from Naqada II-III.

6.3 Giraffe

The giraffe figures of Bi'r Minayh are limited to just five small faint examples executed on the hard, Precambrian outcrops of the wadi. No examples of either A- or B-type are present above the wadi floor. One clear example of a

B-type is located at MOO4/2 (Luft 2010: 86); it has been assigned to Naqada I and is part of a group including an ostrich or bustard and possibly an ass or dog. The images face south-east. In comparison to El-Kab, there is no diversity of tail types at Bi'r Minayh. However, a few kilometres to the west, several B-type examples have been recorded with divided tails and appear to have been modified by the addition of a lasso held by controlling smaller figures of a later date (Rohl 2000: 95, fig. 7).

6.4 Elephant

Only one outlined east-facing example, with long tusks (probably male), is present in the data from El-Kab. It is directly beneath an ibex, with similar patina, assigned to the Naqada III or Early Dynastic period (Huyge 2002: 195). The ears are raised and the stance set squarely.

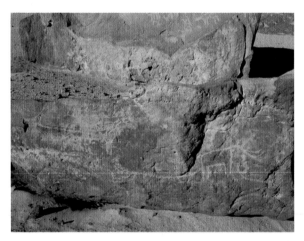

Figure 9: Possibly altered earlier elephant image, showing it tethered to a figure. (Image by the author)

At Bi'r Minayh (BMS T010), the large outlined elephant with raised ears stands alone 1 km west of the well, facing south. 3.5 km west of the well, an outlined example is present, with a curled-in trunk, possibly re-pecked with a controlling figure, on the northern side of the wadi facing south (Rohl 2000: 90; see fig. 9). An outlined elephant head with ears in, tusks upward and a curled-in trunk, facing north-west, is present above the Bi'r in Area E, with multiple pharaonic inscriptions (BMS E003/2). This style is closer to that present on a late Naqada II-Naqada III pottery decoration on a standard, from Naqada (Petrie 1895: pl. LVXII). An east facing example of a faint outlined elephant has tusks that rise behind the head, perhaps in a form mimicking

exaggerated ibex depictions (BMS R041) (Luft 2010: 105). Approximately 7.3 km south-west of the Bi'r similar depictions are present of fully pecked 'ears in' and outlined 'ears up' styles (Morrow and Morrow 2002: 172, a; 175, m).

6.5 'Orants'

No breakdown of the 50 anthropomorphic figures in the data from El-Kab is currently available (Huyge 2002: 197). This research has therefore relied upon private photos in order to provide detail of groups of 'orants' similar to the five published examples from Bi'r Minayh, as well as those from the chart by Huyge (2002: 195). Of these five, two examples are close to or in a boat. A Naqada II example with both arms raised faces west in Area F while another assigned to Naqada III in Area I faces south-east. No steatopygous figures are present at Bi'r Minayh. However, a false bundle might be attached to one figure. The 'orant' figures at El-Kab face to the south and east, as do the boat images.

7. Why is this important?

In describing the late Naqada II period, Midant-Reyes commented: 'as these new social and economic structures were evolving, an ideological system was being created' (2000: 207). The data discussed in this paper suggests relevance to the Naqada periods in the following ways:

• Significant use of B-type giraffe images at El-Kab, dated to the earliest period, is consistent with its occurrence in the KOB, where examples of ibex are dated to earlier periods by studying palimpsests. Association of authority is suggested during pharaonic periods by examples of a cartouche assigned most likely to Senwosret III at Toshka East (Simpson 1963: pl. xxiii.b) and a graffito of Amenhotep I in Shatt el-Rigal, Gebel el-Silsila (Petrie 1888: 15).

• Fully pecked elephant motifs from KOB differ from the open worked examples at El-Kab, Hierakonpolis and Bi'r Minayh, which do not occur in palimpsest with ass.

• Female steatopygous 'orant' figures are consistent with examples of Naqada II D-ware and El-Kab examples, but are not all proportionally larger to associate figures. The large, slim female 'orant' figure, of a likely Early Dynastic date, suggests a possible depiction of a deity in conflict with a new culture. Such an amalgamation of issues might be represented by the in-curved bull horns of the front facing Bat goddess heads, surrounding the king's serekh on the top of the Narmer palette (Midant-Reyes 2000: 244).

- Ass motifs show marked development at El-Kab, Bi'r Minayh and KOB. The use of later motifs (NQ2-3) in the KOB is significantly different to elephant, giraffe and gerenuk assigned to earlier periods (NQ1-2). A hunting or capture context does not therefore seem to be supported in certain tableaux.
- Significant similar 'hunter' figures show a strong association with wild ass in the KOB. They are depicted with larger proportions and with plumes, which suggests the possible emergence of a social elite specialised in the exploitation of wild ass within the region (Judd 2009: fig. 27).

8. Conclusions

Various factors can be suggested as drivers to the observed changes presented here. The course of the Nile at Gebel el-Silsila changed at some point, and a breach in the sandstone massif could have decreased the size of the KOB. Such geographical transformations, without doubt, would have had some influence on the inhabitants of the region during their yearly cycle.

The high status of the wild ass is indicated by its depiction on Early Dynastic palettes, ivory knives and their inclusion in the mortuary complexes associated with Narmer and Hor-Aha at Abydos. Thus, control over this animal resource seems to go hand in hand with the emergence of a new elite.

Finally, the proximity of wadi systems to mineral occurrences suggests the possibility of fluvial deposition where sufficient funnelling and sieving might have naturally occurred downstream of the ore-bearing seams, during wetter times or flash floods. Should such a relationship be substantiated, the potential for conflict and need of control would be of significant importance to the fortunes of any emerging or dominating elite and help formulate a cultural strategy to this end.

Acknowledgements

Supplementary data has been kindly provided by Joe Majer, Geoff Phillipson and Tony Judd and been incorporated into the analysis above. The author would like to thank Mahmoud Muhammed Ali, Nassar al-Ababda, Hussein Abbady, Mujihad Tohammy, Jean and Peter Dicks, Neville Green, Paul and Camilla Pearce, Lily Locock, Catherine Evans, Billy Gess, Marie Bryan, Cheryl Hanson, Jim Buckman, John Wyatt, Brigitte Balanda and the EES library, EGSMA Cairo, the Geological Society London, and the Natural History Museum library for their assistance in this research.

Bibliography

Cervicek, P. 1974. Felsbilder des Nord-Etbai, Oberägyptens und Unternubiens. Wiesbaden: Franz Steiner Verlag.

Cervicek, P. 1986. Rock Pictures of Upper Egypt and Nubia. Naples: Istituto Universitario Orientale.

Friedman, R. F. 2004. 'Elephants at Hierakonpolis', in S. Hendrickx et al. (eds), Egypt at Its Origins: Studies in Memory of Barbara Adams. Leuven: Peeters, 131-68.

Friedman, R. F. 2018. 'Exploring Ancient Nekhen', Thames Valley Ancient Egypt Society lecture, 7 July 2018.

Hikade, H. 2004. 'Urban development at Hierakonpolis and the stone industry', in S. Hendrickx et al. (eds), Egypt at Its Origins: Studies in Memory of Barbara Adams. Leuven: Peeters, 181-98.

Huyge, D. 2002. 'Cosmology, ideology and personal religious practice in Ancient Egyptian rock art', in R. Friedman (ed.), Egypt and Nubia: Gifts of the Desert, London: The British Museum Press, 192-206.

Huyge, D. 2014. 'The painted tomb, rock art and the recycling of Predynastic Egyptian imagery', Archeo-Nil 24: 93-102.

Judd, T. 2009. Rock Art of the Eastern Desert of Egypt. Oxford: BAR.

Kleb, B. and Török, Á. 2010. 'Geology of the Bi'r Minayh region', in U. Luft (ed.), Bi'r Minayh: Report on the Survey 1998-2004. Budapest: Archaeolingua, 21-4.

Klemm, R and Klemm, D. 2013. Gold and Gold Mining in Ancient Egypt and Nubia: Geoarchaeology of the Ancient Gold Mining Sites in the Egyptian and Sudanese Eastern Deserts. New York: Springer.

Lankester, F. 2013. Desert Boats: Predynastic and Pharaonic Era Rock-art in Egypt's Central Eastern Desert: Distribution, Dating and Interpretation. Oxford: BAR.

Luft, U. (ed.). 2010. Bi'r Minayh: Report on the Survey 1998-2004. Budapest: Archaeolingua.

Morrow, M., Judd, T., and Phillipson, G. 2010. Rock Art Topographical Survey. London: Bloomsbury Summer School.

Morrow, M. and Morrow, M. 2002. Desert RATS: Rock Art Topographical Survey in Egypt's Eastern Desert. London: Bloomsbury Summer School.

Midant-Reynes, B. 2000. The Prehistory of Egypt. Oxford: Blackwell Publishers.

Neer, W. V., Linseele, V., and Friedman, R. F. 2004. 'Animal burials and food offerings at the elite cemetery HK6 of Hierakonpolis', in S. Hendrickx et al. (eds), Egypt at Its Origins: Studies in Memory of Barbara Adams, Leuven: Peeters, 67-130.

Peters, J. 1990. 'Late Palaeolithic ungulate fauna and landscape in the plain of Kom Ombo', Sahara 3: 45-52.

Petrie, W. M. F. 1888. A Season in Egypt: 1887. London: Field & Tuer.

Petrie, W. M. F. 1896. Naqada and Ballas. London: Bernard Quaritch.

Petrie, W. M. F. 1901. Diospolis Parva: The Cemeteries at Abadiyeh and Hu, 1898-9. London: The Egypt Exploration Fund.

Rohl, D. 2000. The Followers of Horus: Eastern Desert Survey Report, I. Oxford: Institute for the Study of Interdisciplinary Sciences.

Rossel, S. et al. 2008. 'Domestication of the donkey: Timing, process, and indicators', Proceedings of the National Academy of Sciences 105(10): 3715-20.

Rothe, R., Miller, W. K., and Rapp, R. G. 2008. Pharaonic Inscriptions from the South Eastern Desert of Egypt. Winona Lake: Eisenbrauns.

Simpson, W. K. 1963. Heka-Nefer and the Dynastic Material from Toshka and Arminna. New Haven: The Peabody Museum of Natural History of Yale University.

The elephant's shroud

Anne Drewsen
Centre for Textile Research, Saxo Institute, University of Copenhagen

At some time during Naqada IIA-B (c. 3700 BC), the local ruler of Hierakonpolis was given or acquired an elephant that lived in Hierakonpolis as proof of the ruler's power in being able to control such a strong and wild animal. After the ruler died, the elephant was taken to the elite cemetery, and was given a meal of marsh plants after which it was sacrificed and carefully laid to rest on a piece of linen textile that was then wrapped around it. Much focus has been given to the analysis of the body of the elephant, but the elephant's linen shroud holds information of equal interest and will be the case study for this article.

Hierakonpolis

The site of Hierakonpolis has been excavated for over 30 years. It includes several unique features; one of these is the predynastic elite cemetery, HK6 (Friedman 2011: 67). Here bodies were laid out in burial complexes surrounding a central person, with other humans and animals buried around this central tomb. The burial complexes are fenced in, a feature not found anywhere else at this time (Friedman 2011: 69). Other unique features include superstructures over burials as well as pillared halls used for rituals, perhaps ancestor worship. Of the pillared halls, at least one had wooden frames with walls made from textile that was plastered and painted red and green (Friedman 2019). Animal burials in Naqada II are not unusual; cattle, dogs, and capriovids are found in some but not all cemeteries from the Naqada culture and far into Nubia (Wengrow 2006: 59). However, in HK6 not only are domesticated animals buried but also wild animals including baboons, crocodiles, hippopotamus, aurochs, ostrich, leopard, and two African elephants. Of the over 100 animals buried at HK6, only a few animals are buried shrouded in textile, namely the largest and most powerful animals, including the two elephants. Being buried shrouded in textile is a burial custom usually reserved for humans. However, these animals were apparently considered very special and therefore accorded a distinct burial (Friedman 2011: 72). One of the two elephants will be used

here as a case study, more specifically the elephant buried in Tomb 24 (fig. 1). Analysis shows that it is an African elephant, male, c. 10 years of age and that it was buried whole (Van Neer 2003: 11). The tomb has been robbed in the area of the head, and while this area is very disturbed, the rest of the body is found *in situ*. It seems that the elephant was buried with grave goods, including a ceramic vessel from Lower Egypt, an amethyst bead, an alabaster jar, malachite and even an ivory bracelet, although these may have been from layers above. However, the piece of textile is related to the elephant and it held considerable value both monetary and ritually. The remains of the textile were found on the sides of the burial pit, as well as on the top and under the remains of the elephant (Friedman 2003: 8-9; 2004: 138). As textile from the Predynastic Period is mostly found in fragments, this distribution of textile in relation to the burial pit is interesting because

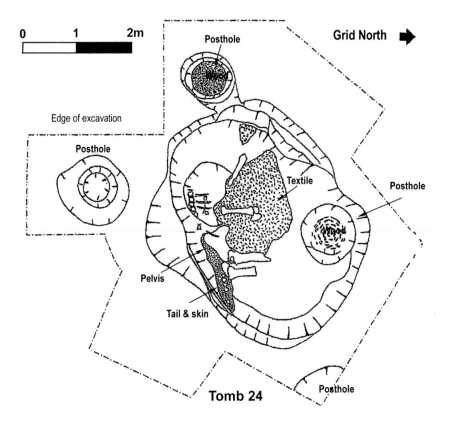

Figure 1: Tomb 24. (Image: Friedman 2003: 8-9)

it points to the textile completely shrouding the elephant, not just covering parts of it. The element of shrouding provides a possibility of estimating the size of the shroud and to use this estimate for further calculations.

Textile

What is known about textile production in ancient Egypt comes from iconography, such as the tomb paintings from the tomb of Khnumhotep (Tomb 3), and the model from the tomb of Khetya (No. 575) both at Beni Hasan, and from later texts (Vogelsang-Eastwood 1995: 28; Liverpool Museums 55.82.4). Early excavators had little interest in or understanding of textile and its production process. This is probably why the textile covering items in Tutankhamun's tomb was cut up and used as presents for visitors to the tomb (Jonker 2016: 46). Whereas pottery and flint are well researched and have a good frame of reference, textile has remained an invisible craft with little research done and scant recognition of the required tools, resulting in a lack of understanding or framework. One of the few researchers in early Egyptian textile is Jana Jones of Macquarie University, but unfortunately her good and valuable research has not prompted more scholars to look at textiles from these early periods, although that is now changing. The earliest textile found in Egypt is dated to c. 5000 BC and was found in the Fayoum (Jones 2008: 100). By Naqada II, textile is used in most burials in Hierakonpolis in at least the workers' cemetery, HK43, although it is more difficult to establish the norm in the elite cemetery, HK6, due to tomb robbers. It is in the workers' cemetery that one of the earliest attempts of mummification has been excavated, burial 85, a woman who had her hands and neck wrapped in finely woven textile, soaked in resin (Jones 2002: 13; 2008: 117). In Hierakonpolis, remains of linen were found in the settlement area (HK11), too, both in the form of woven textile and spun yarn (Jones 2008: 119). Even without a proper frame of reference, it is still possible to access some data and information. Looking at the finds recorded and the material researched, it is possible to evaluate the expertise of the crafts people working with the textile production process; the point to which material is standardised either in size, use or quality; or, depending on the find place, the organisation of the work force as well as the time frame. Working with the elephant's shroud as a case study, some of this information can be accessed.

All textiles dating to the Predynastic Period that have been tested have proven to be linen, and linen comes from the flax plant, *Linum usitatissimum*

45

(Jones 2008: 105). The *chaîne opératoire* for transforming the plant into textile is complex and has been well described by Andersson Strand (2012). To summarize: The plant requires particular growing conditions as it has shallow roots. To grow to the height needed, it should be cultivated in fertile, well-drained soil, with good preparation of the soil, crop rotation and regular watering, for example in the form of slow-moving water or rain. These quite specific growing conditions indicate that the people cultivating flax were aware of how to handle it. Once ripe, the flax should be harvested by pulling the plant with the roots, so bacteria cannot move into the stalks during subsequent stages. Expectations are that from 6 tonnes of flax harvested from a 1-ha-field, only 250 kg are suitable for use in textile production. Descriptions of how to extract the usable fibre bundles from the flax plant exist only from later periods in Egypt, but due to the properties of the plant, the process would necessarily be quite similar regardless of the time period. Extraction of the usable material from the flax stalks was done by either drying the stalks in the sun or soaking them for 10 to 20 days to soften the outer woody layer of the stalks. The stalks could then be broken using a mallet and remains of the woody layer scraped off with a sword-like object in a process called scuthing. Finally, the flax is combed to remove the last part of the woody layer (Andersson Strand 2012: 24-8). Jones notes that the spun yarn found in Hierakonpolis has no remains of stalks in it, so the textile workers were aware of the processes required (REF).

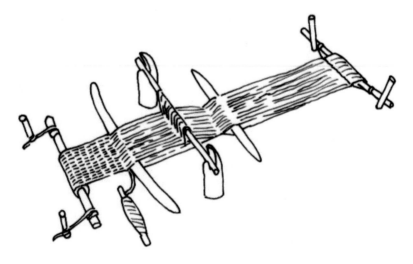

Figure 2: Horizontal loom. (Image: Andersson Strand 2012: 35)

The only textile tools registered from prehistoric Egypt so far are spindle whorls (Jones 2008: 111). A spindle whorl is a small weight that keeps the thread taut while it is being spun. In general, the lighter the whorl, the thinner the thread one can spin, and spindle whorls down to three of four grams are quite common. The Viking Centre in Denmark has made several tests to calculate the time required for an experienced spinner to produce a linen thread with a spindle whorl which is roughly similar to the ones used in Egypt. Although the tests have not been carried out with exact replicas of Egyptian tools, they can be used to give a rough estimate of the time and effort needed to produce the shroud. Jones notes that the spun yearn in Hierakonpolis is spun very hard and very evenly, the hallmark signs of experienced spinners (Jones 2001: 13). No remains of looms have been found from this early stage, but the image of an early loom can be seen on a bowl from the Badari Period currently in the Petrie Museum (Brunton and Caton-Thompson 1928: 51; UC9547). The loom depicted is most likely a ground loom or horizontal loom that lies straight on the ground, where tension of the threads is provided by pegs securing the loom to the ground (fig. 2) (Jones 2008: 112; Andersson Strand 2012: 34-5). Horizontal looms are usually worked by one person, therefore the width of the textile is determined by the reach of one person sitting down, i.e. c. 100-130 cm (Vogelsang-Eastwood 1993: 6).

If the above information is combined, it is possible to estimate the time used for producing the elephant's shroud. The size of an adult elephant

Figure 3: The elephant's shroud, 14 x magnification. (Image: Friedman 2008: 8-9).

shows that the shroud would have to fit c. 5 m over the back of the elephant (covering both sides), and c. 4 m from nose to hind leg which would equal a piece of linen of 20 m² (Friedman 2004: 158). The linen fragments found in the tomb are well-preserved and show a thread count of 20:10, or 20 threads one way in a centimetre, 10 threads in the other (fig. 3) (Jones 2008: 121). This is equal to 3,000 m per square metre, equalling 60,000 m of thread used for 20 m². An average of the spinning test from the Viking Centre shows that an experienced spinner can spin 56 m thread per hour on average (Ejstrud 2011: 62), suggesting c. 1,071 hours of spinning the thread for the shroud, not including preparation of the flax. The tests also show that an experienced weaver can produce c. 5 cm textile per hour. Considering the size of the shroud and assuming a maximum textile width of 100-130 cm, we may estimate that the shroud would have consisted of 4 pieces of textile, each 5 m long, equivalent to 100 hours per piece of textile, or 400 hours of weaving.

However, all textiles from this period are fragmentary so the above calculation of 4 pieces of 5 m each is a conservative estimate. It is impossible to know if the shroud consisted of smaller pieces, sown together. The question of how many pieces the shroud consisted of is interesting in relation to calculating the time used to produce the shroud, as even setting up a loom is time consuming. As there are no remains to indicate what type of loom was used, we cannot estimate the time it would have taken to set up the loom, respectively the grand total of production time. For comparison, the equivalent time used for setting up the loom on a warp-weighted (standing) loom gives an overall idea of the time used for setting up the loom for one piece of textile. First the yarn must be cut to form the warp, which is the taut yarn used as basis: 2.40 hours for each piece of textile. Attaching the warp to the frame of the loom and securing it so that it can take the weight of both textile and loom weights: 1.30 hours. Tying every other yarn in the warp to form heddles so that it is possible to lift the threads in their turn, which will make the weaving quicker: 10.40 hours. This would add up to 14.50 hours for one piece of textile in total (Ejstrud 2011: 67). As these estimates are for a vertical loom, they cannot be straightforwardly applied to the calculation for a horizontal loom. They do, however, demonstrate that further time needs to be added to the calculation.

The total of the above calculations is 1,071 hours of spinning and 400 hours of weaving, which makes a grand total of 1,471 hours. If this is divided by 8 working hours per day for one person working every day, it equals 6 months of production time for the elephant's shroud. This does not

include the preparation of the flax, the setting up of the loom, nor does it include sowing the pieces together to form the shroud. All these parts of the process would have to be added. The conclusion is that textile production is extremely time-consuming. This fact is backed up by all tests done as well as early textual evidence from e.g. the Ur III texts, which show calculations not dissimilar to the above (Andersson Strand and Cybulska 2013: 116-17). Overall, the elephant's shroud is just one of many pieces of textile used for funerary purposes, ritual purposes, clothing, or to provide the basis for walls that have been plastered and painted, as seen in the pillared halls in HK6. For the elephant's shroud alone it meant taking a person out of food production to produce this piece of linen for purely ritual purposes with no monetary gain, which suggests a very wealthy society. Looking at the skeletal remains from the workers' cemetery, these show no signs of severe malnutrition, so it does not seem that they were not fed properly, despite some of the workforce being employed in textile production (Zabecki 2008: 355).

Tools of the trade

With this amount of textile production, it would be natural to find a large number of textile tools, and for this early period it would be expected to find spindle whorls. However, in the early excavation reports only a few spindle whorls are described, although to produce this amount of material there would have been spinners working full-time to provide enough yarn, and the few spindle whorls found would not have been enough (Jones 2008: 112). In 2016, a reinvestigation of finds at Hierakonpolis sought to uncover whether there were any spindle whorls in the magazines. Since textile is an invisible craft, and the tools are not easily recognized, spindle whorls are often described as fishing-net weights, tokens or simply 'pierced discs'. In the magazines at Hierakonpolis, several 'pierced discs' were found and c. 150 items were subsequently re-registered as possible spindle whorls. While these all show signs of potentially being spindle whorls, they are in varying stages of manufacture and levels of use. They are made from potsherds, either rough ware or fine ware such as black-topped redware, and many are broken which may be the reason that they were left behind. Surprisingly, the find place for many of them was the ritual area of Hierakonpolis, HK29A.

While the elite cemetery HK6 is one of several unique elements of Hierakonpolis in the Naqada II Period, other parts, such as the settlement area, production areas (such as brewery and pottery), and a workers'

cemetery, HK43, are no less unique (Wengrow 2006: 75). Archaeologically, Hierakonpolis is exceptional as it shows a slice of society during the Naqada Period that is rarely seen at any other site. Research has shown signs of urbanisation and an estimated population of up to 5,000-10,000 people, which would make Hierakonpolis an extensive settlement for this time (Campagno 2011: 1230). Of these elements, the earliest ritual structure, HK29A, is particularly impressive. HK29A is an oval walled courtyard 45 m long and 13 m wide. This area is part of a larger ceremonial and administrative centre spread out over 1 ha of land, sectioned off by a palisade of wood. This includes the remains of workshops to produce fine flint tools, semi-precious beads, and stone vessels (Friedman 2009: 91-3). It was in this structure and its close vicinity that the majority of the 150 possible spindle whorls were found, in what was a communal working area related to a ritual structure. This find place is interesting for many reasons, from understanding the organisation of labour to when the idea of temple administration emerged and whether ritual material was produced here. It certainly points to textile production not simply being a household industry but a very important part of society.

The discovery of spindle whorls in a communal working space also gives rise to questions about quality and control. Jones found evidence of three distinct qualities of linen in Naqada II: fine, medium-coarse, and coarse. The qualities used for burials are the same throughout the workers' cemetery, and particularly in the burials with the wrapping of hands and neck area, a fine gauze-like fabric for the wrapping and a coarse fabric on the outside. The uniform use of the qualities points toward a specialised funerary industry sharing a common understanding of ways to treat the deceased. The division into three distinct qualities also points to a standardisation, which is only possible with a centralised or formal control of the production (Jones 2008: 117, 119). This control is further evidenced in Naqada III, whence small ivory labels have been found in relation to grave goods, and probably once attached to these, in royal tombs at Abydos. The labels show the first signs of a hieroglyphic writing system most likely used in administration (Wengrow 2006: 200). They have been interpreted in some instances as being tied to bundles of textile (Jones 2008: 89).

Conclusion

Evidence of spun yarn and linen reveals a very high degree of specialisation, which means that spinners and weavers would have had been trained and

experienced. Although there was household manufacture, major production was carried out in large-scale specialist workshops, such as within the ritual structure, HK29A. Standardisation of fabric sizes cannot be estimated, though the quality can be demonstrated. This is evidence of formal or centralised control. As for the time frame, the elephant's shroud took at least 6 months to produce, which both points at a large number of people employed in the production, but also a society able to take this amount of people out of food production.

Acknowledgements

The author would like to thank Dr. Renée Friedman for her hospitality at Hierakonpolis, and to Associate Professor Eva Andersson Strand (Centre for Textile Research, UCPH) for her advice and support.

Bibliography

Andersson Strand, E. 2012. 'The textile chaîne opératoire: using a multidisciplinary approach to textile archaeology with a focus on the Ancient Near East', Paléorient 38(1-2): 21-40.

Andersson Strand, E. and Cybulska M. 2013. 'Textile production, tools and technology – How to make textiles visible on the basis of an interpretation of an Ur III Text', in H. Koefoed, M.-L. Nosch, E. Andersson-Strand (eds), Textile Production and Consumption in the Ancient Near East: Archaeology, Epigraphy, Iconography. Oxford: Oxbow, 113-27.

Brunton, G. and Caton-Thomson, G. 1928. The Badarian Civilisation and Prehistoric Remains near Badari. London: British School of Archaeology in Egypt & Egypt Research Account.

Campagno, M. 2011. 'Kinship, concentration of population and the emergence of the state in the Nile Valley', in R. F. Friedman and L. McNamara (eds), Egypt at Its Origins: Studies in Memory of Barbara Adams. Leuven: Peeters, 1229-36.

Ejstrud, B., Andresen, S., Appel, A., Gjerlevsen, S., and Thomsen, B. 2011. From Flax to Linen: Experiments with Flax at Ribe Viking Center. Esbjerg: Maritime Archaeology Programme. Available at: https://www.ribevikingecenter.dk/media/10424/Flaxreport.pdf [last accessed 26 September 2019].

Friedman, R. F. 2003. 'Excavating an elephant', Nekhen News 15: 8-9.

Friedman, R. F. 2004. 'Elephants at Hierakonpolis', in S. Hendrickx et al. (eds), Egypt at Its Origins: Studies in Memory of Barbara Adams. Leuven: Peeters, 131-68.

Friedman, R. F. 2009. 'Hierakonpolis locality HK29A: The predynastic ceremonial center revisited', Journal of the American Research Center in Egypt 45: 79-103.

Friedman, R. F. 2011. 'The early royal cemetery at Hierakonpolis: An overview', in F. Raffaele, M. Nuzzolo, and I. Incordino (eds), Recent Discoveries and Latest Researches in Egyptology. Proceedings of the First Neapolitan Congress of Egyptology, Naples, June 18–20, 2008. Wiesbaden: Harrassowitz, 67–86.

Friedman, R. F. 2019. HK6: The Elite Predynastic and Early Dynastic Cemetery. Available at: http://www.hierakonpolis-online.org/index.php/explore-the-predynastic-cemeteries/hk6-elite-cemetery [last accessed 31 January 2019].

Jones, J. 2001. 'Bound for eternity: Examination of the textiles from HK43', Nekhen News 13: 13-14.

Jones, J. 2002. 'Funerary textiles of the rich and the poor', Nekhen News 14: 13.

Jones, J. 2008. 'Pre- and early dynastic textiles: technology, specialisation and administration during the process of state formation', in B. Midant-Reynes and Y. Tristant (eds), Egypt at Its Origins 2. Leuven: Peeters, 99-132.

Jonker, Z. 2016. Secrecy and Transformation: The Practice of Wrapping in Tutankhamun's Burial in a Comparative Perspective. Unpublished MA thesis, Royal Library, Copenhagen, Denmark.

Van Neer, W. 2003. 'A second elephant at HK6', Nekhen News 15: 11.

Vogelsang-Eastwood, G. 1995. Fra Faraos Klædeskab. Copenhagen: Nationalmuseet.

Vogelsang-Eastwood, G. 1993. Pharaonic Egyptian Clothing. Leiden: Brill.

Wengrow, D. 2006. The Archaeology of Ancient Egypt. Cambridge: Cambridge University Press.

Zabecki, M. 2008. 'Work levels of a predynastic Egyptian population from Hierakonpolis', in B. Midant-Reynes and Y. Tristant (eds), Egypt at its Origins 2. Leuven: Peeters.

Pomegranates of ancient Egypt: representations, uses and religious significance

Dina M. Ezz el-Din[a] and Sahar Farouk Elkasrawy[b]
[a] Faculty of Tourism and Hotels, Alexandria University
[b] Faculty of Arts, Ain Shams University

The flora of ancient Egypt was very rich, including not only indigenous plants, but also imported species which were adopted and introduced (Germer 2001a: 541). A great wealth of preserved evidence has since helped to develop archaeobotanical studies that shed more light on the different types of plants and crops known to the ancient Egyptians by identifying plant remains found in archaeological contexts (Germer 2001a: 535). Alongside plant remains, tomb scenes and written documents provide further sources about ancient Egyptian flora (Germer 2001a: 535). These same sources also help in reconstructing knowledge about agricultural practices (Wilkinson 1998: 39; Janick et al. 2011: 6).

Egyptian gardens were planted with a great variety of trees providing shade and protection (Torpey 2008: 1). In a text dated to the reign of Merenptah,a scribe describes the beauty of the city of *Pr-R'msw* and how it is rich in pomegranates, apples, olives, and figs (Caminos 1954: 74). Gardens attached to houses were a main source for supplying households with fresh fruits and vegetables. They also provided flowers to make floral bouquets needed in banquets (Germer 2001b: 3-4). One of the trees known to the ancient Egyptians, the pomegranate, features in artistic, textual and archaeological evidence and forms the focus of this research.

The pomegranate's origin and name

The pomegranate (*Punicagranatum* L.) is a fruit-bearing small tree growing between 5 to 8 m high. It is a deciduous plant that grows with several stems to form a rounded bush. It is leafless in winter, its leathery leaves begin to appear in spring and its scarlet flowers emerge in summer. The fruit is characterized by a dentate calyx on its top. The numerous seeds inside the fruit are each enclosed in white watery pulp. The name pomegranate is said to be derived from the Latin word *pomum* meaning apple and *granatus*, which means seeded, or seeded apple (Ward 2003: 530; Hepper 1990: 64; Jaime et al. 2013: 86; Nigro and Spagnoli 2018: 49).

The pomegranate originated in the east of Mesopotamia and moved westward (Ward 2003: 530). Its spread can be traced by archaeological evidence; carbonised remains of pomegranate peels have been found from the Early Bronze Age in Jericho and Arad as well as in Iraq, Lebanon, Greece and Spain (Nigro and Spagnoli 2018: 51). By the Middle Bronze Age, pomegranate grew throughout the Levant and appeared in Egypt (Immerwahr 1989: 408; Jacomet et al. 2002: 84; Torpey 2008: 1; Whitchurch and Griggs 2010: 223; Nigro and Spagnoli 2018: 51). It was one of the earliest fruit crops to be domesticated and planted between 4,000 and 3,000 BC (Jaime et al. 2013: 86).

The tree is not native to Egypt and was possibly first introduced during the New Kingdom as a result of campaigns in western Asia (Loret 1892: 76-7; Lucas 1959: 47; Immerwahr 1989: 405; Manniche 1989: 139-41; Byl 2012: 356). On the other hand, some scholars argue that it was adopted earlier during the Middle Kingdom (Schweinfurth 1885: 5; Geissen and Weber 2008: 287; Whitchurch and Griggs 2010: 225-6; Janicket al. 2011: 2; Nigro and Spagnoli 2018: 51). Others have added that the earliest remains in Egypt were found in Tell el-Dab'a in the Delta, a site that was probably inhabited by the 'Hyksos' culture (Ward 2003: 536; De Vartavan et al. 2010: 200).It has therefore been suggested that the diffusion of the tree took place during the 13th Dynasty due to renewed relationships with the Levant (Nigro and Spagnoli 2018: 52).

The pomegranate's ancient Semitic name is *rummanu*, it is *haraman* in Coptic, *rimmon* in Hebrew and *roumman* in Arabic (Nigro and Spagnoli 2018: 49). In the *Wörterbuch der Ägyptischen Sprache* (Erman and Grapow 1926: 98), the pomegranate is referred to as *inhmn*, a name given to both the tree and its fruit. Since the word was newly introduced to the Egyptian language, this might explain the different writings and spellings found (see table 1), shared letters being *nhm* in the majority of the writings (Faulkner 1962: 24; Hoch 1994: 24; Hannig 1998: 224, 228; Kaelin 2004: 96). Klotz states that the Egyptian word for pomegranate is a loan word that corresponds to the Sumerian *Nuzinurumu* (2010: 225).

Table 1 includes the different writings of the word for pomegranate in the New Kingdom as discussed by Charpentier (1981: 151), Hoch (1994: 24) and Kaelin (2004: 91-128). The determinative is usually a tree ⚘ with plural sign or a mineral ° or both ⚘ı ı ı.

Textual evidence

The pomegranate tree is mentioned in several ancient Egyptian poems and ritual texts, for example in the funerary texts of Tuthmose I (Ward 1990:

59). Sheikholeslami's study of the tree mentioned in Papyrus Turin 1966 compared between persea, pomegranate and sycamore trees. Her research has concluded that the text deals with sycamore rather than pomegranate (Sheikholeslami 2015: 389). However, the poem is usually associated with the pomegranate, stating: 'My seeds are like her teeth, my form like her breasts' (Ward 2003: 530; Sheikholeslami 2015: 389). It is probably understood how female breasts might be compared to the fruit; however, the association of the pomegranate's small seeds with teeth is not accepted by some scholars (Sheikholeslami 2015: 392).

Archaeological evidence

As stated above, the earliest known archeological occurrence of pomegranate in Egypt dates to the Middle Kingdom or the Second Intermediate Period (Murray 2000: 612; Jacomet et al. 2002: 84; Kaelin 2004: 94; De Vartavanet al. 2010: 200). Among the objects that Auguste Mariette found in a 12th Dynasty Theban tomb and placed in the Boulaq Museum, some dried pomegranates were listed (Keimer 1925: 47; Schweinfurth 1885: 3). Furthermore, a pomegranate was identified in the Mayana cemeteries (Sedment) dating to the 15th Dynasty inside grave 1257 (Petrie and Brunton 1924: 16).

The earliest complete pomegranate dated to the New Kingdom is the large desiccated fruit found in the tomb of Djehuty (TT110) who served as overseer of the treasure under Hatshepsut and Tuthmose III (Murray 2000: 612; Kaelin 2004: 94). From the same reign another pomegranate was found in 2009 belonging to Penere (TT65), overseer of the southern foreign lands and Thebes in the reign of Hatshepsut (Bács 2014: 422). In the second scientific meeting on archaeobotanical research in Egypt organised by the Polish Center of Mediterranean Archaeology (PCMA) and the Institut Français d'Archéologie Orientale (IFAO) in Cairo (26 September 2018), Nathalie Beaux discussed the results of her research in 'Botanical remains in Ancient Egyptian foundation deposits' and stated that a pomegranate was found in the foundation deposits of Tuthmose III in the Hathor shrine at Deir el-Bahari.

Artistic representation

Scenes depicting pomegranates appeared on the walls of private and royal monuments during the New Kingdom. Five pomegranate trees are listed in the 18th Dynasty tomb of Ineni, TT81(Baum 1988: 1-2; Manniche 1989: 139).

He was in charge of the building activities of king Tuthmose I and those of his successors (Sethe 1906: 73,12). From the tomb of Neferhotepat el-Khokha (TT49), two well-dressed women are depicted 'sheltered by pomegranates, figs, sycamores, and grape vines of the gardens' (Davies 1933: 26, pl. XIV; Darnell 2016: 26-7). In the tomb of Puyemre at El-Khokha (TT39) dated to the reign of Tuthmose III, a scribe is shown registering tribute from the Ways of Horus. Strings of pomegranate are depicted among the offerings (Davies 1923: 82, pl. XXXI). In another scene from same tomb, a man is represented bringing pomegranates strung on a rod in front of the tomb owner and his wife (Davies 1923: 49, pl. IX).

At Amarna, in the tomb of Meryre, high priest of the Aten, a large representation demonstrates the layout of the garden of the Aten temple. Among the trees, pomegranates are shown flowering (Davies 1903: 42, pl. XXXII; Manniche 1989: 17; Wilkinson 1994: 1-17). Also, at the tomb of Huya (TA 01) at Amarna, the royal family is depicted in front of a table full of pomegranates, while queen Ty is shown holding a pomegranate in her hand (fig. 1; Davies 1905: pl. VI). In another scene a table is divided into four sections, with one part full of pomegranates (Petrie 1894: pl.1.16).

In the 19th Dynasty tomb of Ipuy (TT217), the gardener is seen using a *shaduf* to water the garden (fig. 2). Behind him is a flowering pomegranate tree (Davies 1927: pls XXVIII, XXIX). It is obvious that the ancient Egyptians were good observers of nature as the tree is depicted small with precise details of flowers as they appear in nature.

As for royal examples, the most prominent occurs in the Karnak temple. Pomegranates are illustrated in Tuthmose III's 'botanical garden' at Karnak, probably introduced during the campaigns of the king (Manniche 1989: 139; Ward 2003: 533; Morris 2014: 373). Keimer, however, stated that all the vegetation featuring in the 'botanical garden' was already being cultivated in the gardens of Thebes and that this was the reason why the sculptor was able to represent it (1925: 154). A unique scene occurring on the northern wall of Medinet Habu temple shows destruction during the siege of Tunip. Pomegranates are represented among the trees destroyed in the landscape (Geissen and Weber 2008: 287).

Daily uses of pomegranates

Pomegranates were used in many aspects of the Egyptian daily life. Besides being eaten fresh, they were also used to make juice. Some scenes show the harvest of pomegranate (Hyams 1971: 13, fig. 13). Scholars continue to

Figure 1: After Davies 1905: pl. VI. (Image: Egypt Exploration Society)

Figure 2: After Davies 1927: pl. XXIX.

debate whether there existed a kind of pomegranate wine (Lucas 1959: 33; Tallet 1995: 459; Murray 2000: 293; Hepper 1990: 51), with some proposing that *shedeh* was a pomegranate wine (Loret 1892: 76-78; Breasted 1906: 99 §168; Janick et al. 2011: 12; Nigro and Spagnoli 2018: 52). Others have instead suggested that pomegranate was added as a flavouring for wine (Ward 1990: 58; Ward 2003: 531; Barnard 2010: 7). However, recent studies have concluded that the ancient Egyptian *shedeh* drink was actually made from red grapes (Guasch-Janéet al. 2006: 98).

Pomegranate was also used for dyeing textiles (Jaime et al. 2013: 89) as well as leather (Lucas 1959: 47; Manniche 1989: 37, 140; Hepper 1990: 64; Nigro and Spagnoli 2018: 52). It also had some medicinal properties: many remedies used pomegranates for the treatment of certain conditions, e.g. dysentery, diarrhea and stomach ache (Manniche 1989: 140, 139-40; Whitchurch and Griggs 2010: 228). Besides being consumed as a laxative, its roots were employed to treat some infections of parasitic intestinal worms and skin ailment as stated in Papyrus Ebers 16,17 and 19,19; Papyrus Med. Berlin 3081, 4, 7, 8 (Manniche 1989: 140; http://aaew.bbaw.de: lemma-no. 27690). Some recent studies have claimed the pomegranate to be the 'elixir of youth' because of its regenerative qualities (Jaime et al. 2013: 87).

It is also probable that pomegranate rind was used as an oil or perfume ingredient (Ward 1990: 58). In fact, the myrtle perfumes, whose ingredients were provided by classical Greek and Roman authors, contained pomegranate rind among other elements (Byl 2012: 99).

Pomegranate-shaped artifacts were manufactured to be used in daily life. Containers and jewellery pieces are the most frequent examples. These items were later put among tomb offerings. The funerary offerings found in the tomb of Tutankhamun involved stone and ivory models of pomegranates, as well as pomegranate-shaped golden pendants (Nigro and Spagnoli 2018: 52). Another example from the same tomb is a silver pomegranate-shaped vessel (Hepper 1990: 62-64; Murray 2000: 625), and a cosmetic spoon in the shape of a pomegranate is exhibited in the Brooklyn Museum (42.411). It is carved from a single piece of ivory and dates to the late 18th Dynasty (Cooney 1948: 7). In the Metropolitan Museum of Art, New York, can be found two bottles in the form of pomegranates (26.7.1180 and 44.4.52), which have been dated to the 19th or 20th Dynasties. They probably contained a perfume or scented oil, or more possibly wine (Lilyquist et al. 2001: 14; Byl 2012: 356). There is also a similar breccia miniature vessel in Liverpool's World Museum (56.22.665) found at Abydos and dated to the New Kingdom.

Jewellery and amulets also took inspiration from the pomegranate. Examples include two blue, glazed faience beads from the New Kingdom, now in the British Museum (EA2895, EA48064), and a string of blue, glazed faience flat-backed amuletic pendants in the shape of pomegranate fruits in the World Museum, Liverpool (56.21.683), originally found at Amarna. Moulds used for the manufacture of pomegranate-shaped amulets were also found at Amarna (Petrie 1894: 30, pl. XIX: 471,473).

The inventory of gifts mentioned in the Amarna letters lists six knives of gold with pomegranate at top, one pomegranate of silver and 44 containers of oil decorated with apples, pomegranates and dates (Moran 1992: 27-34; Kaelin 2004: 108). On the other hand, the inventory of gifts from the Mitanni rulers also included ten pomegranates of Carnelian, five of stone and seven small golden ones (Moran 1992: 74; Kaelin 2004: 108). From this brief overview it can be seen that the ancient Egyptians manufactured and decorated items with pomegranate motifs using a variety of materials.

Religious use and significance of the pomegranate

The pomegranate tree was never considered a sacred tree in ancient Egypt (Geissen and Weber 2008: 287). Nevertheless, it is thought that it was a symbol of fertility probably due to the prolific number of seeds it contains (Manniche 1989: 139-40; Geissen and Weber 2008: 287; Whitchurch and Griggs 2010: 223; Nigro and Spagnoli 2018: 49). This explains the presence of pomegranates inside tombs during the New Kingdom and the records of offerings for the gods (Ward 2003: 530).

Pomegranates appear several times in the Opet festival scenes in the Luxor temple (Epigraphic Survey 1994: pl. 56). A pomegranate also features in a scene of Seti I making offerings to the bark of Amun at Abydos (Calverley et al. 1933: Pl.7). The fruit is also seen being offered to gods in private tombs, such as that of Roy-Nebtawy (TT255, Porter and Moss 1960: 166). That pomegranates were an appropriate offering in these situations is further confirmed by mention of it among other gifts to Amun (Breasted 1906: 234, 241, 301, 379; Caminos 1954: 158; Kaelin 2004: 99).

Further evidence of royal offerings of pomegranates can be seen in a statue of Tutankhamun (British Museum, EA75), showing the king in the form of the god Hapi bearing a bouquet that includes pomegranates and other fruits and flowers (Eaton-Krauss 2016: 67-9). In the temple of Ramesses II at Abydos, the Nile god is depicted holding a tray of offerings

including two pomegranates (Porter and Moss 1991: 33). Some royal tombs from the New Kingdom have revealed vessels in the form of pomegranates. In the tomb of Amenhotep II, for instance, 19 votive pomegranates made of faience were found (Immerwahr, 1989: 400; Ward 2003: 533; Whitchurch and Griggs 2010: 225). Since one of the vessels is closed, it is assumed that it represents a votive fruit and not a container in the shape of a pomegranate (Immerwahr 1989: 400).

Collars and garlands were used like the one found on the mummy of Tutankhamun's innermost coffin. In the fifth row, pomegranate leaves were used and sewed to the collar, together with other leaves and flowers. The same was used on ten of divine statuettes in his tomb (Hepper 1990: 9-10, 62-4).

Further depictions of pomegranates in private tombs include: the tomb of Userhat (TT51, see fig. 3), of Tjanefer (TT158, Seele 1959: pls 29, 30, 35), Menna (TT69, Davies and Gardiner 1936: pl. LII), Nakht (TT52, see figs 4a and 4b; Davies 1917: pl. VIII), Amenamhat (TT82, Porter and Moss 1960: 166), Userhat (TT150, Porter and Moss 1960: 261), Djeserkarenseneb (TT38, Davies 1936: pl. VI), and Paheri at Elkab (EK 3, Porter and Moss 2004: 179).

Figure 3: After Davies 1927: pl. IXb.

Dried pomegranates were also found buried among the offerings in the tombs (Ward 2003: 530). Preserved examples include M11113 A-D in the World Museum, Liverpool, and EA35965-EA35962 in the British Museum, all dated to the New Kingdom.

Conclusion

Studying the organic remains of ancient Egypt enriches knowledge of its history. The pomegranate was not a native tree to Egypt and is believed to have originated in central Asia from where it spread. It was introduced to Egypt by at least the Middle Kingdom according to scholars. As the tree gained more popularity in Egypt, its occurrence increased in frequency. It became one of the various trees that decorated the gardens of the Egyptians,

Figures 4a-b: Depictions of pomegranates in the tomb of Nakht (TT 52). (Image: Thierry Benderitter / www. osirisnet.net).

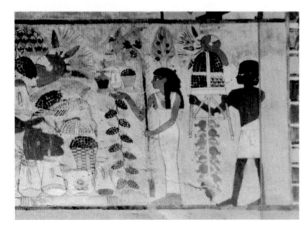

in particular of royalty and the elite. Its offered nutritional value, consumed as raw fruit or juice. It appeared in artistic representations as a frequent motif in tomb and temple decoration, as well as a votive object in the form of its fruit, but it was also valued in daily uses for to its medicinal properties to treat some illnesses. It was probably also used in the manufacture of myrtle perfume. Moreover, its rind was known for its ability to dye leather and textiles. Pomegranate juice was used to make wine or added to grape wine. Pomegranates were given as offerings to gods and kings, either as whole fruits or in the form of floral compositions. It was also thought of as an expression of life, fertility and abundance.

Table 1: Different writings of the word for pomegranate during the New Kingdom

	Transliteration	Source
18th Dynasty		
	inhmnj	P. Ebers 19,19
	nhjmꜣꜣ	P. Ebers 16,16
	inhmn	Sethe 1906: 73.12
19th Dynasty		
	nhꜣmꜣꜣ	Med. P. Berlin 3038, 1, 4
	nhꜣmꜣꜣ	Med. P. Berlin 3038,1,7 and 1,8
	nhꜣmꜣꜣ	Inscription Gebel el-Silsila; Kitchen 1975: 92, 11. Ramesses II and Merenptah
	nhꜣmꜣꜣ	Inscription Gebel el-Silsila; Kitchen 1975: 92, 11. Ramesses II and Merenptah
	iwnhꜣmꜣꜣ	P. Boulaq 19; Kitchen 1989: 103, 1, 6, 8.

	Transliteration	Source
𓏺𓈖𓂋𓃀𓇹𓏺𓏺	*iwnm33*	P. Boulaq 19, Kitchen 1989: 103, 3
𓏺𓈖𓎛𓃀𓇋𓃀𓇹𓏺𓏺	*iwnh3m33*	P. Anastasi III, 2,5 Caminos 1954: 75, 77
𓏺𓈖𓃀𓇋𓃀𓇹=	*iwnhrrm33*	P. Anastasi IV 7, 5. Lesko, I,40; Caminos, 1954:155, 158
𓏺𓈖𓃀𓇋𓃀𓇹𓏺𓏺	*iwnrhm33*	P. Anastasi IV 14, 5; Caminos, 1954: 199, 206
𓏺𓈖𓃀𓃀𓇹𓏺𓏺	*iwnhr3m33*	P. Anastasi IV 14,7 Caminos, 1954:199
𓏺𓈖𓃀𓇹𓏺𓏺	*iwnrh3m33*	P. Rainer 53; duplicate of Anastasi III; Caminos, 1954:505
𓈖𓃀𓇋𓃀𓇹𓏺𓏺	*iwnh3m33*	P. Chester Beatty V rto 8,10
20th Dynasty		
𓏺𓈖𓃀𓇋𓃀𓇹𓏺𓏺	*iwnrh3m33*	P. Harris I 16a,10; 19b,13; 19b,14; 65b,10; 71b,1 (Kaelin 2004: 99)
𓏺𓈖𓃀𓇋𓃀𓇹	*iwnrh3m33*	P. Harris I 56a,5 (Kaelin 2004: 99)

65

Dina Ezz el-Din and Sahar el-Kasrawy

Bibliography

De Vartavan, Ch., Arakelyan, A. and Amorós, V. A. 2010. Codex of Ancient Egyptian Plant Remains. London: Academic Books.

Eaton-Krauss, M. 2016. The Unknown Tutankhamun. London: Bloomsbury.

Epigraphic Survey. 1994. Reliefs and Inscriptions at Luxor Temple (I): The Festival Procession of Opet in the Colonnade Hall. Oriental Institute Publications 112. Chicago: University of Chicago Press.

Erman, A. and Grapow, H. 1971. Das Wörterbuch der Aegyptischen Sprache (I). Leipzig: J. C. Hinrichs'sche Buchhhandlung.

Faulkner, R. O. 1962. Concise Dictionary of Middle Egyptian. Oxford: Griffith Institute.

Geissen, A. and Weber, M. 2008. 'Untersuchungen zu den Ägyptischen Nomenprägungen X'. Zeitschrift für Papyrologie und Epigraphik 164: 277-305.

Germer, R. 1990. 'Pflanzlicher Mumienschmuck und andere altägyptische Pflanzenreste im Ägyptischen Museum'. Forschungen und Berichte 28: 7-15.

Germer, R. 2001a. 'Flora', in D. Redfordet al. (eds), The Oxford Encyclopedia of Ancient Egypt (I). Oxford: Oxford University Press, 535-41.

Germer, R. 2001b. 'Gardens', in D. Redfordet al. (eds), The Oxford Encyclopedia of Ancient Egypt (I). Oxford: Oxford University Press, 3-5.

Guasch-Jané, M. R., Andrés-Lacueva, C., Jáuregui, O., and Lamuela-Raventós, R. M. 2006. 'The origin of the ancient Egyptian drink Shedehrevealedusing LC/MS/MS'. Journal of Archaeological Science 33(1): 98-101.

Hannig, R. and Vomberg, P. 1998. Wortschatz der Pharaonen in Sachgruppen. Hannig-Lexica 2, Kulturgeschichte der Antiken Welt 72.

Hepper, F. N. 1990. Pharaoh's Flowers. London: HMSO.

Hoch, J. E. 1994. Semitic Words in Egyptian Texts of the New Kingdom and Third Intermediate Period. Princeton: Princeton University Press.

Hyams, E. 1971. A History of Gardens and Gardening. New York: Praeger.

Immerwahr, S. 1989. 'The pomegranate vase: Its origins and continuity'. The Journal of the American School of Classical Studies at Athens 58(4): 397-410.

Jacomet, S. et al. 2002. 'Punica Granatum L. (pomegranates) from early Roman contexts in Vindonissa (Switzerland)'. Veget Hist Archaeobot 11: 79-92.

Jaime, A. et al. 2013. 'Pomegranate biology and biotechnology: A review'. Scientia Horticulturae 160: 85–107.

Janick, J., Daunay, M. C., and Paris, H. S. 2011. 'Plant iconography: A source of information for archaeogenetics', in G. Gyulai (ed.), Plant Archaeogenetics. Hauppauge: Nova Science Publishers, 143-59.

Kaelin, O. 2004. 'Produkte und Lehnwörter: Der Granatapfel als Fallbeispiel', in T. Schneider (ed.), Das Ägyptische und die Sprachen Vorderasiens, Nordafrikas und der Ägäis. Alter Orient und Altes Testament 310. Münster: Ugarit-Verlag, 91-128.

Keimer, L. 1925. 'Egyptian formal bouquets (bouquets montés)'. The American Journal of Semitic Languages and Literatures 41(3): 145-61.

Kitchen, K. 1975. Ramesside Inscriptions (I), 92. Oxford: B. H. Blackwell.

Kitchen, K. 1989. Ramesside Inscriptions (VII), 12-16. Oxford: B. H. Blackwell.

Klotz, D. 2010. 'Emhab versus the tmrhtn: Monomachy and the expulsion of the Hyksos. Studien zur Altägyptischen Kultur 39: 211-41.

Lilyquist, C., Hill, M., Allen, S., Roehrig, C. H. and Patch, D. C. 2001. 'Ars Vitraria: Glass in the Metropolitan Museum of Art'. Metropolitan Museum of Art Bulletin 59(1): 11-17.

Loret, V. 1892. La flore pharaonique d'après les documents hiéroglyphiques et les spécimens découverts dans les tombes. Paris: Ernest Leroux.

Lucas, A. 1959. Ancient Egyptian Materials and Industries. London: Edward Arnold.

Manniche, L. 1989. An Ancient Egyptian Herbal. London: British Museum Press.

Moran, W. L. 1992. The Amarna Letters. Baltimore: Johns Hopkins University Press.

Morris, E. 2014. 'Mitanni enslaved, prisoners of war, pride, and productivity in a new imperial regime', in J. M. Galan, B. Bryan, and P. F. Dorman (eds), Creativity and Innovation in the Reign of Hatschepsut: Occasional Proceedings of the Theban Workshop. Chicago: Oriental Institute, 361-80.

Murray, M. A. 2000. 'Fruits, vegetables, pulses and condiments', in I. Shaw and P. T. Nicholson (eds), Ancient Egyptian Materials and Technology. Cambridge: Cambridge University Press, 609-55.

Nigro, L. and Spagnoli, F. 2018. 'Pomegranate (Punica Granatum L.) from Motya and its deepest Oriental roots', Vicino Oriente XXII: 49-90.

Petrie, W. M. F. 1894. Tell el Amarna. London: Methuen & Co.

Petrie, W. M. F. and Brunton, G. 1924. Sedment (I). London: British School of Archaeology in Egypt.

Porter, B. and Moss, R. 1960. Topographical Bibliography of Ancient Egyptian Hieroglyphic Texts, Reliefs, and Paintings (I). Theban Necropolis, Part 1. Private Tombs. Oxford: Griffith Institute.

Porter, B. and Moss, R. 1991. Topographical Bibliography of Ancient Egyptian Hieroglyphic Texts, Reliefs, and Paintings (VI). Upper Egypt: Chief Temples (Excluding Thebes). Oxford: Griffith Institute.

Porter, B. and Moss, R. 2004. Topographical Bibliography of Ancient Egyptian Hieroglyphic Texts, Reliefs, and Paintings (V) (2nd ed.). Upper Egypt: Sites. Oxford: Griffith Institute.

Seele, K. C. 1959. The Tomb of Tjanefer at Thebes. Oriental Institute Publications 86. Chicago: University of Chicago Press.

Sethe, K. 1906. Urkunden der 18. Dynastie (I). Leipzig: J. C. Hinrichs'sche Buchhhandlung.

Schweinfurth, M. G. 1885. 'Notice sur les restes de végétaux de l'ancienne Égypte contenus dans une armoire du Musée de Boulaq'. Bulletin de l'Institut Egyptien, (deuxième série) 5 (Année 1884): 3-10.

Sheikholeslami, C. M. 2015. 'Pomegranate, persea or sycamore fig in the love song of P. Turin 1966/I', in F. Haikal (ed.), Mélanges offerts à Ola el-Aguizy, textes réunis et édités. Bibliothèque d'étude 164. Cairo: IFAO, 389-405.

Tallet, P. 1995. 'Le shedeh: étude d'un procédé de vinification en Égypte ancienne'. Bulletin de l'Institut Français d'Archéologie Orientale 95: 459-92.

Torpey, A. 2008. 'Gardens in Ancient Egypt', in H. Selin (ed.), Encyclopaedia of the History of Science, Technology, and Medicine in Non-Western Cultures. Heidelberg: Springer.

Ward, C. 1990. 'Shipwrecked plant remains'. The Biblical Archaeologist 53(1): 55-60.

Ward, C. 2003. 'Pomegranates in Eastern Mediterranean contexts during the late Bronze Age'. World Archaeology 34(3): 524-41.

Whitchurch, D. M. and Griggs, C. W. 2010. 'Artifacts, icons, and pomegranates: Brigham Young University Egypt Excavation Project'. Journal of the American Research Center in Egypt 46: 215-31.

Wilkinson, A. 1994. 'Symbolism and design in ancient Egyptian gardens'. The Garden History Society 22(1): 1-17.

Wilkinson, A. 1998. The Garden in Ancient Egypt. London: Rubicon Press.

Why was a minor dislocation included amongst the more serious cases listed in the Edwin Smith papyrus?

Roger J. Forshaw
University of Manchester

The Edwin Smith papyrus is one of the so-called 'medical papyri' that have survived from ancient Egypt (fig. 1). These texts are an important source of knowledge relating to the medical procedures, healing practices and treatments adopted in that ancient culture. The main papyri are usually considered to be about a dozen in number, although there are several other papyri and ostraca which refer to medical matters. Some of the papyri are often considered specialist medical works such as the Kahun papyrus which is largely gynaecological in nature, while others contain treatments for a wide variety of conditions that even include household hints and recipes for cosmetics. The term medical papyri is a modern label, a catch all expression, and one unlikely to be recognised by the ancient Egyptians.

The classic analysis of the Edwin Smith papyrus, comprising translation, interpretations and detailed commentaries was published by James Henry Breasted in 1930. Since then the papyrus has been the subject of a number of philological studies and medically orientated interpretations, most notably by Courville (1949), von Deines et al. (1954-73), Ghalioungui (1963), Westendorf (1966), Majno (1975), Bardinet (1995), Nunn (1996), Allen (2005) and van Middendorp et al. (2010). More recently an updated translation of the treatise with modern medical commentaries has been published by Sanchez and Meltzer (2012).

Description of the papyrus

The papyrus has been dated on stylistic grounds to about 1650-1550 BC but may be a copy of an even older text, although opinions vary on this suggestion (Breasted 1930: xiiv-xv, 9-10; Nunn 1996: 27; Allen 2005: 70; Sanchez and Meltzer 2012: 12). The Edwin Smith papyrus is named after its original owner, an American Egyptologist, who purchased it from a merchant in Luxor in 1862. It originally comprised twelve sheets glued into a continuous roll measuring 4.68 m in length, although Smith was to later cut the papyrus into separate sheets (Allen 2005: 70). Edwin Smith

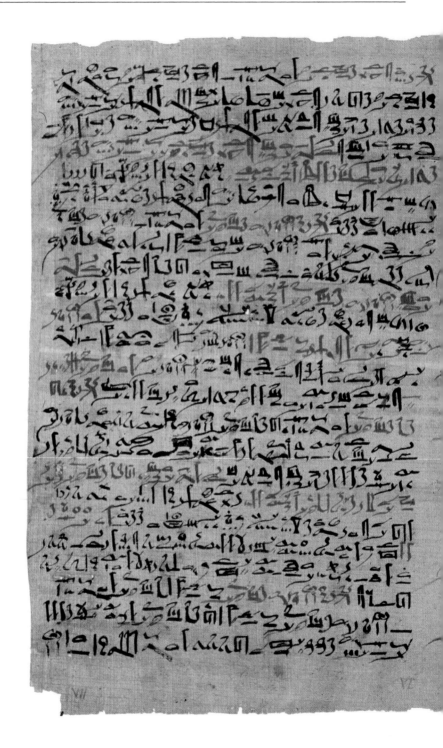

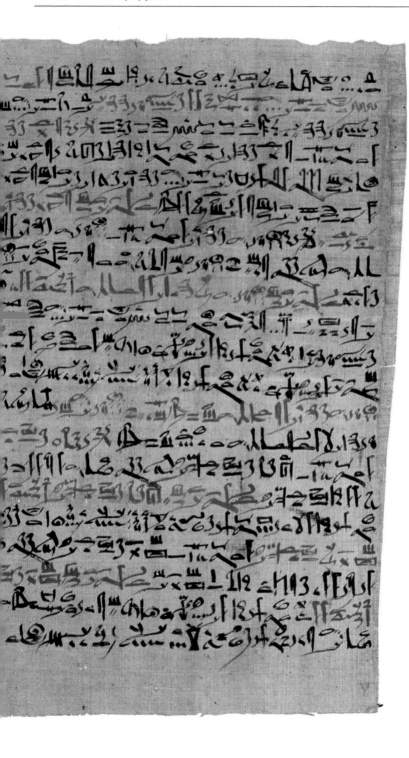

Figure 1: Edwin Smith papyrus. Recto columns 7 and 6. (Image: National Library of Medicine)

worked on the translation of the document until his death, although never publishing any of his research. It was then donated by his daughter to the New York Historical Society, later housed in the Brooklynn museum and finally transferred to the New York Academy of Medicine where it resides today (Sanchez and Meltzer 2012: 1-2).

The document is perhaps best described as a didactic trauma treatise, the oldest known such text in history, and is also credited with containing the earliest scientific writings on rational observations in medicine (Breasted 1930: 12; van Middendorp et al. 2010: 1815). In contrast to the other medical papyri, which are mainly lists of recipes often incorporating a magical incantation within the text, the Edwin Smith is a systematically organised manuscript in which prognoses are presented and predominately rational therapies recommended. It follows a logical clinical approach to injuries that is not too dissimilar to the methodology that is practised today. That the ancient Egyptians understood the principles of trauma care is illustrated by many of the case descriptions recorded in the document which incorporate detailed anatomical, clinical and therapeutic information. For example, Case 6 describes a severe head wound with a depressed skull fracture that has exposed the surface of the brain. The explicit and detailed anatomical descriptions of the brain and the dura mater membrane enveloping it, whilst also recognising the existence of cerebrospinal fluid, are quite exceptional for this early date in history (Sanchez and Meltzer 2012: 65-70).

The papyrus is in excellent condition, written in neat rows of hieratic script and lists 48 medical case descriptions, commencing at the top of the head, progressing downwards in a systematic manner and terminating at the upper part of the thorax and arms. It ends mid-sentence in Case 48 and it would seem likely that at one time there would have been further parts to this treatise that would have related to examples of trauma to the lower parts of the body, but to date such texts have not been discovered. The trauma cases are detailed in 377 horizontal lines on the recto of the papyrus, while the verso comprises 92 lines of recipes and incantations, some of the latter are written in a different hand and so may be a later addition. The remedies listed on the verso are similar to those found in other papyri and lack the objectivity and rational approach to medicine and healing found on the recto.

Each trauma case has a coherent structure which commences with the title and then the diagnostic procedure in which relevant clinical signs are detailed. This is followed by a prognosis which comprises three treatment possibilities of 'favourable', 'uncertain' or 'unfavourable'. A treatment regime is specified depending on the particular verdict issued, which in

the 'unfavourable' category can be merely palliative. Finally, there are the explanatory sections, the glosses or footnotes, in which definitions and alternative interpretations are discussed. These include a dictionary of terms, which perhaps could imply that various expressions or words were no longer in the current language and so required an explanation, giving some credibility to the suggestion of a date prior to the 1500s BC (Breasted 1930: 61-75; Sanchez and Meltzer 2012: xi-xiii). Although it is possible that certain archaic features were deliberately introduced into the text to give the appearance of antiquity, a concept held in esteem by the ancient Egyptians.

All the cases are examples of typical injuries that might be encountered either on the battlefield or in the numerous building sites or quarries that were distributed throughout pharaonic Egypt. This has led to the suggestion that the papyrus is a manual of practice or instructional guide for operators who had to treat such injuries (Nunn 196: 29-30; Allan 2005: 70). Of the 48 clinical cases described in the papyrus, 14 relate to injuries of the head, seven are cervical injuries, one concerns the lower spine, with wounds or lesions of the chest and arms constituting the remainder. What is apparent is that many of these are quite acute injuries with 14 been given an unfavourable verdict and many of the others describing serious conditions.

Major injuries in the papyrus

Case 3: Head injury with skull perforation

An example of just such a serious injury is Case 3, a stab wound to the head that has penetrated the scalp and perforated the bone of the skull. The severity of this would depend on the depth of the lesion, area of brain involved and extent of damage to the skull. The physician (*swnw*) or person examining the injury is directed to probe the wound in order to assess, by touch, the extent of damage to the skull. The instruction is then to look for rigidity in the back of the neck and whether the injured person can look at his shoulders and chest. Today it is understood that such a penetrating wound would cause irritation and bleeding in the meningeal layers covering the brain, as well as pressure on the spinal fluid which would result in neck rigidity and pain. It is quite remarkable that the ancient Egyptian physician, without all the benefits of modern medical knowledge and facilities, was able to display an insight similar to that which is recognised today (Breasted 1930: 125-38; Sanchez and Meltzer 2012: 45-51).

Treatment advised for this condition involved suturing the wound, laying the injured person to rest and observation. If the injured survived, then the instruction was to treat the wound with oil and honey until complete recovery. As with any wound of this kind infection would be a major problem, particularly in antiquity where the nature of this condition was not fully understood. However, honey, which has known antibacterial properties, was used in many prescriptions and its healing properties must have been recognised.

Figure 2: Left: soldier 25. Right: soldier 54. Both display 1 cm open skull fractures (Winlock 1945: pl. ix, B and D).

Human remains from ancient Egypt, discussed in the publication, *The Slain Soldiers of Neb-Ḥepet-Rē' Mentu-Ḥopte* (Winlock 1945), include a number of injuries consistent with those described in the Edwin Smith papyrus. These remains, belonging to more than 60 individuals, were discovered in a mass grave, and as their bodies were surrounded by military equipment, they were identified as soldiers killed in combat. Winlock interpreted these remains as those of the soldiers of the victorious Theban army of Mentuhotep II, slaughtered during the storming of the fortress of Herakleopolis. This interpretation, based mainly on the nature of injuries the soldiers sustained and the location of the tomb in close proximity to the mortuary temple of Mentuhotep, has since been challenged and it seems uncertain when and where these soldiers met their death (Vogel 2003). Plate IX, B (soldiers 25 and 54) of Winlock's publication (fig. 2) appear similar to that of Case 3 of the papyrus.

Case 5: Head injury with open, comminuted, depressed skull fracture

Case 5 is another severe head injury, in this instance an open, comminuted, depressed skull fracture. The glosses describe this as an example of a direct shattering blow to the head by a blunt object, causing bone fragments to penetrate the interior of the skull. In the context of warfare such an injury could be caused by a blow from a mace, sling shots or rocks thrown from fortresses (fig. 3). An illustration of such a depressed skull fracture is that of soldier 62 in Winlock's publication (Plate X, D) (fig. 4).

Figure 3: Assault on a fortress. Tomb of Amenemhat (tomb 2, Beni Hassan) (Newbery 1893: pl. xiv).

Figure 4: Depressed skull fracture. Soldier 62 (Winlock 1945: pl. x D; c).

The diagnosis expressed in the papyrus is based on the physical appearance of the fracture and by palpitation of the wound. The visible signs of such an injury are sunken bone fragments in the vicinity of the wound, bleeding from the nose and ears, and rigidity in the back of the neck. Not unexpectedly, this particular injury is given an unfavourable verdict, as such severe wounds would require advanced medical treatment, therapy that has only become available in the last hundred years. However, the injured was not abandoned but placed on bed rest and observed 'until the critical period of his injury passes', perhaps implying a hope of recovery (Breasted 1930: 156-64; Sanchez and Meltzer 2012: 60-4). Such care points to a humanitarian aspect of treatment in ancient Egypt, and such a concept is supported by a passage from a New Kingdom text, *The Instruction of Amenemope*: 'Do not laugh at a blind man nor taunt a dwarf, neither interfere with the condition of a cripple' (British Museum, Papyrus 10474, l. 24.9-10, translated in Simpson 2003: 241).

Seqenenera Taa

Examination of the mummy of the 17th Dynasty ruler, Seqenenra Taa, indicates that his death was the result of several violent blows to the skull. The severe injuries sustained are again consistent with those types of cases described in the Edwin Smith papyrus. The mummy was originally examined by Gaston Maspero (1889: 526-28) and then a later more comprehensive investigation was undertaken by Grafton Elliot Smith (1912: 1-6, pls II, III) (fig. 5).

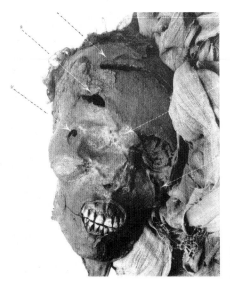

Figure 5: Mummy of Seqenenera Taa. (Smith 1912: pl. II).

Perforation of the skull (Edwin Smith Papyrus, Case 3) is classically shown in fig. 5, arrows 1 and 2. A depressed comminuted fracture to the nasal area (arrow 3) correlates to Case 12 of the papyrus. The detailed description in the papyrus of Case 12 includes a considerable amount of anatomical, clinical and therapeutic detail. The management of this case involves prompt manual reduction of the fracture, although there is little detail on how the shape of the nose is to be restored. This is then followed by thorough cleansing of intranasal clots, lubricated internal packing, external nasal splinting and finally the application of local dressings of oil and honey. What is interesting is that the management of this traumatic injury is the same as that in use today and although infection control, anaesthesia and surgical intervention have added considerably to modern therapy, the underlying principles for the care of a broken nose remain the same (Breasted 1930: 319-23; Sanchez and Meltzer 2012: 114-19).

Non-battlefield injuries

Although the wounds so far discussed would seem mainly to relate to those inflicted on a battleground, many of the other fractures and trauma cases listed in the papyrus could also be as a result of industrial injuries, sustained at quarries and building sites where rock falls and collapsed scaffolding are known to cause such lesions. Examples include Case 35, a fracture of the clavicle; Case 37, a compound fracture of the humerus, and Case 44, fractures to the ribs.

A study of 271 skeletons excavated from Old Kingdom cemeteries on the Giza plateau, probably to be identified as workers who built the pyramids, found a very high incidence of fractures. Nearly 44 percent of the male workers and 21 percent of the high officials displayed evidence of fractures, with 90 percent of these showing signs of complete healing with good alignment, an outcome which could only be achieved by the correct use of splints (Hussein et al. 2008: 85). Although these examples relate back to the Old Kingdom, the high incidence of injuries sustained illustrates the hazardous nature of working on buildings in ancient Egypt during the pharaonic period, and hence the need for an instructional manual to provide guidance on treating such injuries.

Treatment for a dislocated jaw

Among all the traumatic injuries listed in the Edwin Smith papyrus, many of which, as illustrated above, are serious and life threatening, is Case 25,

the treatment for a dislocated jaw, which by comparison is a fairly minor traumatic event. Dislocation of the jaw occurs when there is an interruption in the normal sequence of muscle action during closure from maximal opening of the mouth. This then results in the jaw locking in an open position and the mouth is unable to close (fig. 6). Common causes of this condition today include yawning, laughing, vomiting, dental treatment and to a lesser extent, trauma (Luyk and Larsen 1989: 330).

Figure 6: Schematic representation of a dislocation of the jaw (Forshaw 2015: fig. 4).

For an individual suffering from such a dislocation, with the mouth wide open and impossible to close, eating and drinking will be extremely difficult if not impossible, and the overall experience would be very distressing. Today this dislocation is an infrequent presentation at the accident and emergency departments of hospitals (Lowery et al. 2004), with the condition representing approximately 3 percent of all reported dislocated joints in the body (Lovely and Copeland 1981: 180).

Treatment for this condition as documented in Case 25 of the Edwin Smith states:

If you should examine a man having a dislocation in his mandible, and should you find his mouth open, and his mouth cannot close for him. Then you must put your thumbs upon the ends of the two rear sections of the forked bones (rami) of the mandible, in the inside of his mouth and your two claws (meaning two groups of fingers) under his chin. Then you should cause them to fall back, so that they are put in their places. (P. Edwin Smith 9, 2-5. Translation based on Breasted 1930: 304; Sanchez and Meltzer 2012: 173)

The technique demonstrates a logical approach taken by the operator, and the straightforward treatment prescribed which, although simple, differs little from that in use today. The procedure is not difficult to perform but some prior knowledge or instruction is necessary. So why should such a comparatively rare condition as a dislocation of the jaw be included among the more significant injuries, such as compound fractures, stab wounds and serious head lesions, that are listed in the Edwin Smith papyrus. Although this dislocation is a comparatively rare occurrence today it seems likely it may have been more commonplace in antiquity.

In ancient Egypt excessive tooth wear was widespread and is a condition that has been found in very many of the surviving ancient Egyptian skulls throughout the dynastic period (Ruffer 1920: 348-56; Hillson 1979; Leek 1979: 75; Forshaw 2009: 421). The primary cause of the tooth wear was the chewing throughout life of a coarse fibrous diet made even more abrasive by contamination with inorganic particles, such as quartz from sand which was blown in from the desert, and fragments from soft sandstone implements used to grind the grain for bread, the staple food of the ancient Egyptians. Often it was so extensive that the pulp, the living matter in the centre of the tooth became exposed in the mouth, and this could result in infection, abscesses and possible tooth loss (Forshaw 2009: 421).

Many ancient Egyptian skulls display considerable numbers of teeth having been lost during life, and one consequence of this would have been even more wear on the remaining teeth, as the residual dentition attempted to cope with mastication. Over a period of time the teeth would, as a result, become misaligned and the upper and lower jaws gradually assume a position closer together. The ligaments that normally keep the condyle (the head of the jaw) in place would become stretched, and as a consequence the mechanical function of the joint would alter, and recurrent dislocation of the joint may well occur.

As the condition of tooth wear and loss of teeth was widespread in ancient Egypt, dislocation of the joint may not have been that uncommon,

and hence its inclusion in an instructional manual such as the Edwin Smith papyrus. Compared to the other fractures, wounds and injuries itemised in the papyrus, the correction of a dislocated joint is notable in that such a striking injury can be treated quickly and in an effective manner.

Later history of the technique

Some 1,200 years after the Edwin Smith papyrus, Hippocrates was to discuss the treatment for a dislocated jaw in his account *On the Articulations*, and his method bears strong parallels to the technique recorded in the papyrus (Hippocrates III, xxx-xxxi, translated by Withington 1928: 253-7; Stiefal et al. 2006: 187). This similarity could perhaps suggest an ancient Egyptian influence on Greek medicine and certainly following the Greek invasion of Egypt in 332 BC many Greek intellectuals visited Egypt, staying principally at Alexandria, the city they helped to establish (Bagnall 1979: 46; Scheidel 2004). The pharmacopeia of Hippocratic medicine includes products from Egypt such as nitrate, oil and alum, all of which are testimony at least to commercial exchanges, if not to an influence of one medicine on the other. Also, there are a number of references to the positive nature of Egyptian medicine in the writings of Greek authors such as Homer, Herodotus and Diodorus Siculus (Jouanna 2012).

It is, however, possible that the Hippocratic technique was not necessarily derived from the ancient Egyptian method, as such a therapeutic act may be one of those elementary practices established in many civilisations, even before medicine became a codified art (Marganne 1993: 39). Nevertheless, the close similarity between the two methods has resulted in a number of authors identifying a link (Breasted 1930: 17; Lipton 1982: 112; Stiefal 2006: 187).

The Hippocratic Corpus was later to become incorporated in Roman medical practice, and during the medieval period many classical texts, including parts of the Hippocrates Corpus, which might otherwise have been lost, were translated into Arabic (Conrad 1995: 93). By AD 950, Arabs were settling in Europe and their Islamic heritage was passed on to other cultures. Many Arabic texts were translated into Latin by western scholars and it is known that a number of these researchers also consulted earlier Greek versions.

In the Middle Ages, Greek medicine was to form the basis of the university medical curriculum and in 1525 in Venice new editions of the Hippocratic Corpus were being published (Wear 1995: 253). Between the 17th and 19th centuries the influence of Hippocrates was still being

felt in Western Europe. Thomas Sydenham (1624-89), a physician, often considered the father of English medicine, extoled the value of Hippocratic clinical medicine and integrated some of these theories into his own medical practices (Low 1999).

Finally, Hippocratic medicine based on an observation of clinical signs and rational conclusions, whilst not relying on religious or magical beliefs, found its way into modern medical theory. Included within the works was the Hippocratic method of correcting a dislocated jaw, a technique first committed to writing by the ancient Egyptians some 3,500 years previously. Today this ancient technique is still universally popular and is used in surgeries and hospital accident and emergency departments throughout the world – a technique that has certainly stood the test of time.

Bibliography

Allen, J. P. 2005. The Art of Medicine in Ancient Egypt. New Haven: Yale University Press.

Bagnall, R. S. 1979. 'The date of the foundation of Alexandria', American Journal of Ancient History 4: 46-9.

Bardinet, T. 1995. Les papyrus médicaux de l'Égypte Pharaonique: traduction intégrale et commentaire. Paris: Fayard.

Breasted, J. H. 1930. The Edwin Smith Surgical Papyrus. Chicago: University of Chicago Press.

Conrad, L. I. 1995. 'The Arab-Islamic medical tradition', in L. I. Conrad et al. (eds), The Western Medical Tradition 800 BC to AD 1800. Cambridge: Cambridge University Press, 93-138.

Courville, C. B. 1949. 'Injuries to the skull and brain in ancient Egypt; some notes on the mechanism; nature, and effects of cranial injuries from predynastic times to the end of the Ptolemaic period', Bulletin of the Los Angeles Neurological Society 14(2): 53-85.

Forshaw, R. J. 2009. 'Dental health and disease in ancient Egypt', British Dental Journal 206(8): 421-4.

Ghalioungui, P. 1963. Magic and Medical Science in Ancient Egypt. London: Hodder and Stoughton.

Hillson, S. 1979. 'Diet and dental disease', World Archaeology 11(2): 147-62.

Hippocrates. 1928. Hippocrates (3). Transl. E. T. Withington. London: Heinemann.

Hussein, F., el-Banna, R., Kandeel, W., and Sarry el-Din, A. 2008. 'Similarity of fracture of workers and high officials of the pyramid builders', in J. Cockitt and R. David (eds),

Pharmacy and Medicine in Ancient Egypt: Proceedings of the Conferences Held in Cairo (2007) and Manchester (2008). Oxford: Archaeopress, 85-9.

Jouanna, J. 2012. 'Egyptian medicine and Greek medicine', in J. Jouanna, P. van der Eijk and N. Allies (eds), Greek Medicine from Hippocrates to Galen: Selected Papers. Leiden: Brill, 3-20.

Leek, F. F. 1979. 'The dental history of the Manchester mummies', in A. R. David (ed.), The Manchester Museum Mummy Project. Manchester: Manchester University Press, 65-77.

Lipton, J. S. 1982. 'Oral surgery in ancient Egypt as reflected in the Edwin Smith papyrus', Bulletin of the History of Dentistry 30: 108-14.

Lovely, F. C. and Copeland, R. A. 1981. 'Reduction eminoplasty for chronic recurrent luxation of the temporomandibular joint', Journal of the Canadian Dental Association 47: 179-84.

Low, G. 1999. 'Thomas Sydenham: The English Hippocrates', ANZ Journal of Surgery 69: 258-62.

Lowery, L. E., Beeson, M. S., and Lurn, K. K. 2004. 'The wrist pivot method, a novel technique for temporomandibular joint reduction', Journal of Emergency Medicine 27: 167-70.

Luyk, N. H. and Larsen, P. E. 1989. 'The diagnosis and treatment of the dislocated mandible', Journal of Emergency Medicine 7: 329-35.

Majno, G. 1975. The Healing Hand: Man and Wound in the Ancient World. Cambridge, MA: Harvard University Press.

Marganne, M. H. 1993. 'Links between Egyptian and Greek medicine', Forum 3: 35-43.

Maspero, G. 1889. Les momies royales de Déir el-Baharî. Paris: Ernest Leroux.

Newberry, P. E. 1893. Beni Hassan (I). London: The Egypt Exploration Society.

Nunn, J. F. 1996. Ancient Egyptian Medicine. London: The British Museum Press.

Ruffer, M. A. 1920. 'A study of abnormalities and pathology of ancient Egyptian teeth', American Journal of Physical Anthropology 3(1): 335-82.

Sanchez, G. M. and Meltzer, E. S. 2012. The Edwin Smith Papyrus: Updated Translation of the Trauma Treatise and Modern Medical Commentaries. Atlanta: Lockwood Press.

Scheidel, W. 2004. 'Creating a metropolis: A comparative demographic perspective', in W. V. Harris and G. Ruffini (eds), Ancient Alexandria between Egypt and Greece. Leiden: Brill, 1-31.

Simpson, W. K. 2003. 'The Instruction of Amenemope', in W. K. Simpson (ed.), The Literature of Ancient Egypt. New Haven: Yale University Press, 23-44.

Smith, G. E. 1912. Catalogue général des antiquitiés Égyptiennes du Musée du Caire: The Royal Mummies. Cairo: Institut français d'archéologie orientale.

Why was a minor dislocation included amongst the more serious cases listed in the Edwin Smith papyrus?

Stiefel, M., Shaner, A., and Schaefer, S. D. 2006. 'The Edwin Smith papyrus: The birth of analytical thinking in medicine and otolaryngology', Laryngoscope 116: 182-8.

Van Middendorp, J. J., Sanchez, G. M. and Burridge, A. L. 2010. 'The Edwin Smith papyrus: A clinical reappraisal of the oldest known document on spinal injuries', European Spine Journal 19(11): 1815-23.

Vogel, C. 2003. 'Fallen heroes? Winlock's "Slain Soldiers" reconsidered', Journal of Egyptian Archaeology 89: 239-45.

von Deines, H., Grapow, H., and Westendorf, W. 1954-73. Grundriss der Medizin der alten Ägypter (9 vols). Berlin: Akademie-Verlag.

Wear, A. 1995. 'Medicine in Early Modern Europe, 1500-1700', in L. I. Conrad et al. (eds), The Western Medical Tradition 800 BC to AD 1800. Cambridge: Cambridge University Press, 215-361.

Westendorf, W. 1966. Papyrus Edwin Smith: Ein Medizinisches Lehrbuch aus dem alten Ägypten: Wund- und Unfallchirurgie, Zaubersprüche gegen Seuchen, verschiedene Rezepte. Bern: Hans Huber.

Winlock, H. E. 1945. The Slain Soldiers of Neb-Ḥepet-Rē' Mentu-Ḥopte. New York: The Metropolitan Museum of Art.

SR. 12191: An example from the collection of hieratic ostraca from Mond's excavation at Sheikh Abd el-Qurna

Faten Kamal
Cairo University

Ostracon SR. 12191 belongs to a group of ostraca, now in the Egyptian Museum Cairo (EMC 13 SR C.A.G), that was discovered during Robert Mond's 1903-06 excavations at Sheikh Abd el-Qurna. Unfortunately, only very brief reports about the first two seasons of these excavations were published (Mond 1904; 1905), which provide limited information about his work. Based on these reports, it would seem that these ostraca must have been found in the south west of the site, where Mond worked in the tombs of Ken-Amun (TT93), Sennefer (TT96), Menna (TT69), etc. (Mond 1904).

The ostraca date from the 18th Dynasty to the Ramesside period. The texts on them are varied: some are administrative reports and others literary or religious texts, including a hymn to Amun, a eulogy for king Ramesses III, and a miscellany text. Many of the texts studied belong to the corpus of the so-called Deir el-Medina documents, with the palaeography exhibiting several parallels with handwritings known from that site (Černy 1931; Demarée, pers. comm.) and also from the so-called Ramesseum school, where scribes active in the area of the Sheikh Abd el-Qurna tombs had been trained in the traditions of both Deir el-Medina and the Ramesseum (Bavay and Laboury 2012). The texts provide insights on religious subjects as well as adding to knowledge about administration in ancient Egypt. Hagen has posited that the administrative group is similar in character to ostraca from the tomb of Senmut (TT71) (Hagen, pers. comm.).

In view of the limited space allotted here, only one example from the corpus is presented. It was chosen because it joins the already known O. DeM 1218 (Posener 1951-1952-1972; Fischer-Elfert 1983; Demarée, pers. comm.), which presents general advice to a student not to be 'lazy'.

Ostracon SR.12191:
Material: Limestone
Condition: Good, but incomplete
Dimensions: 14 × 11 cm
Provenance: Qurna, excavations of Sir Robert Mond (C.A.G)
Contents: Inscribed on both sides in black ink with some red punctuation marks.
Date: Ramesses III, years 25 and 26 (Goedicke and Wente 1962)

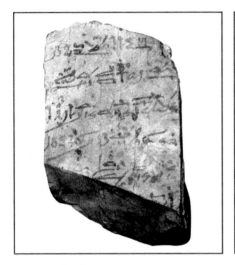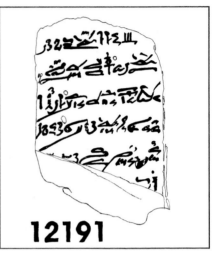

12191

(a) recto:

$(x+1)$

$(x+2)$

$(x+3)$

$(x+4)$

$(x+5)$

$(x+6)$

Figure 1a-b: Ostracon SR.12191. Recto (top), verso (opposite page).
(Photos: Sameh Abd El-Mohsen. Facsimiles by the author)

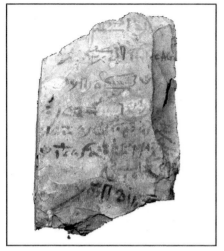 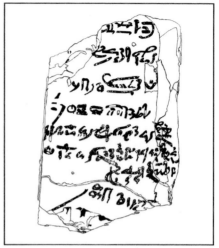

(b) verso:

(x+1)

] (x+2)

(x+3)

(x+4)

(x+5)

(x+6)

(x+7)

(x+8)

Transliteration

(a) recto:

(x+1) *Ptr(i) ʿm*
(x+2) *.k{wỉ}*[a] *mr*[b] *bꜣk*
(x+3) *n s ỉwty ḏrt.f*[c] *ỉw wꜣḥ*
(x+4) *mtrw*[d] *m-bꜣḥ.f m ṯnw*
(x+5) *nb(w) ʿšꜣt*[e] *r-ḏd [mki?],*
(x+6) *ḥʿt [......],*

(b) verso:

(x+1) *[............] ỉnḳ*[f]*,*
(x+2) *[šfd]wt smdt*[g] *......,*
(x+3) *nb m ḫnw.f,*
(x+4) *ḥꜣt-sp 25 ꜣbd 4 šmw sw 13,*[h]
(x+5) *ḥms*[i]*.k{wỉ} m-bꜣḥ wrw ʿꜣyw,*
(x+6) *mšʿ*[j] *twtw m-bꜣḥ.k{wỉ}*[k] *s nb,*
(x+7) *ỉw.sn ḥr ỉrt ḥnt*[l] *........,*
(x+8) *(ḥꜣt-sp 26) ꜣbd 2(?) prt sw 10*[m]

Translation

(a) recto:

(x+1) Behold, that you may understand
(x+2) how painful is work
(x+3) for a man who has no hand (lazy) while
(x+4) witnesses are placed before (in front of) him in
(x+5) countless number, saying [protect?],
(x+6) yourself (?)......,

(b) verso:

(x+1) [because] they (?) put together
(x+2) all staff-register,
(x+3) inside it,
(x+4) year 25, fourth month of summer, day 13,
(x+5) you sat before (in front of) the high officials,
(x+6) of the united army in front of you, every man,
(x+7) (while) they are doing work (business),
(x+8) (year 26), (second?) month of winter, day 10

Commentary

This text belongs to the group of miscellanies texts (Ragazzoli 2011) and in particular the so-called 'idle scribe texts' (Caminos 1954: 131-7, 226-9, 319-21, 381-3, 404, 436-7, 450-2). The text gives general advice to a student, telling him not to be 'lazy' and ignorant before the magistrates. Demarée has noted that SR 12191 re. is the upper half of O. DeM 1218 (Demarée, pers. comm.). The passage about sitting in front of the magistrates is written on O. DeM. 1218 by a teacher, as is clear because of *ḥms.k{wi} m-bꜣḥ wrw ꜥꜣyw, mšꜥ twtw m bꜣḥ.k{wi}* – discussed below – and then copied by a pupil on the verso of our ostracon SR 12191. It is noteworthy that the young scribe or student made several palaeographical mistakes.

(a) ⟨hieratic sign⟩ *.kwi*: this should be the suffix *.k* but as the *sḏm.f* form is regularly written *.kwi* in Late Egyptian, it could be used as subjects for certain conjugations (Junge 2005: 52).

(b) ⟨hieratic sign⟩ *mr*: this is an example of the same, but not identical, style of writing *mr* as ⟨hieratic sign⟩ (see Wimmer 1995).

(c) ⟨hieratic sign⟩ *n s iwty ḏrt.f*: Ragazzoli (2010) gives an interpretation for hands and mouths as an example for the lexical keys of scribal identity in LEM texts. She asserted that hands played a role as a leitmotiv in the instructions given by the master to his pupil. Besides, the scribal literature insists on warning the pupil who has rejected the trade of letters. That confirms literacy was depicted as the power of a scribe's hand. Further, such texts considered that other trades use their limbs for pure strength but they 'do not have hands'. The expression we have here refers to the man who could not be a scribe, which is also stated in by p.Lansing 9,4:

is bw sḫꜣ.n.k pꜣ iwty ḏrt.f
nn rḫ.tw rn.f
wnn.f ꜣtp r-ḫꜣt sš rḫ ḏrt.f
mi n.k r mry wꜥw

Can you not remember the one who does not have a hand,
one does not know his name,
when he will carry loads in front of the scribe who knows his hand.
Come (for me to tell you) the woes of the soldier.

Caminos translated the expression 'who has no hand' as 'unhandy', 'clumsy', and this was further confirmed by Posener (Blackman and Peet 1925; Caminos 1954; Posener 1951; Dorn 2004). Thus, hands/handwriting are particularly powerful keys in the scribal milieu, features of identity, and a sign of acknowledgement (Ragazzoli 2010).

(d) ⳾ *mtrw*: This word occurs from the 19th Dynasty onwards meaning 'witness', and it should be written ⳾ (WB II: 172).

(e) ⳾ *m ṯnw nb ꜥšꜣt*: this phrase has been mentioned in WB V (376-7) as a whole term to mean 'in every countless number'. We may note that the scribe made a mistake while writing the word *ṯnw*, as he wrote the sign 𓏴 looking like the sign ⳾ .

(f) ⳾ *ink*: this verb may end with the determinative ⳾ , which means 'to merge (collect)' (WB I: 100; Hannig 2006: 309). The scribe made a mistake while writing the sign ⳾ , which looks more like the sign M. 254 (Möller 1967).

(g) ⳾ *smdt*: Here, the scribe wrote the determinative as a ligature ⳾ .

(h) ⳾ *ḥꜣt-sp* 25 *ꜣbd* 4 *šmw* *sw* 13: Although Fischer-Elfert (1997) hesitated to attribute year 25 to either Ramesses II or Ramesses III, Beckerath (1997) stated that year 25 belongs to Ramesses III. Moreover, the date that we have here has been confirmed according to O. DeM 32 (Kitchen, V, 497-8). The scribe wrote in a very strange way; for example in the group ⳾ , he took a very small part (as a dot) of the sign *t* and merged it with the sign *sp* into one form. Furthermore, he wrote the sign *sw* ⊙ top down; he should have begun vice versa.

(i) ⳾ *ḥms*: the scribe made a mistake with the determinative of ⳾ ⳾ *ḥms*. We may observe that he merged the head with the back hand (rear arm) in one movement, making it continuous with the body and then the legs were sloping form, but he forgot to represent the hand to the mouth.

(j) ⳾ *mšꜥ*: Here the scribe wrote the sign incorrectly. He started the sign from the feather combined with the head, omitted the representation of the quiver, and let the bow stand on the leg. He should have started with the head, moving continuously to the body and legs, then the arm that holds the bow,

the quiver and at the end the feather from right to left as in O. DeM 1218 ⟨hieratic sign⟩ (Möller 1967; Posener 1951-1972).

k) ⟨hieratic signs⟩ *ḥms.k{wi} m-bꜣḥ wrw ꜥꜣyw, mšꜥ twtw m bꜣḥ.k{wi}*: These two lines prove that O. DeM. 1218 joins our ostracon. R. J. Demarée (pers. comm.) noted that SR 12191 recto is the upper half of O. DeM. 1218. The text is a general advice telling a student not to be 'lazy' and not to be ignorant before the magistrates. The passage about sitting in front of the magistrates is written on O. DeM. 1218 by a teacher and then again by a pupil on the verso of our ostracon SR 12191 (even with the date when the pupil wrote this text as an exercise – Demarée, pers. comm.).

(l) ⟨hieratic sign⟩ *ḫnt*: this sign is the determinative for the word *ḫnt*; it is combined with the verb *iri* to mean 'doing a task', which fits well in our text (WB III: 121; Faulkner 1972: 171; Hannig 2006: 1692).

(m) ⟨hieratic signs⟩ [*ḥꜣt-sp* 26] *ꜣbd* 2 *prt sw* 10: this date could be [year 26], (third?) month of winter, day 10. The scribe possibly made a mistake and wrote *ꜣbd* 2 instead of *ꜣbd* 3 according to O. Michaelides 5 (DeM., Ramesses III) ⟨hieratic signs⟩ (Goedicke and Wente 1962).

The following tables present the palaeographical comparisons in order to show the similarities and differences between this ostracon and other ostraca or papyri.

1	SR 12191 (X+1, x+2r°)	O. BM EA 41541
	⟨hieratic sign⟩	⟨hieratic sign⟩
		Posener 1955: pl. 4

Here, it is clear that the palaeography of the word ꜥ*m.k{wi}* is totally different from the comparison example in O. BM EA 4154, although the sign ⟨hieratic sign⟩ ⟨hieratic sign⟩ is written in a somewhat similar form.

2	SR 12191 (X+2,x+3r°)	P. Sallier No. 1	P. Ch. Beatty no. 5 r°
		Hawkins 1841: pl. VI	Gardiner 1935: pl. 25A

According to this comparison, we may observe that the palaeography of the word *b3k* in the Cairo ostracon is totally different from the compared examples, proof of a new style of the handwriting.

3	SR 12191 (X+4r°)	O. DeM 1221
		Posener 1951-1952-1972: pl. 51

Here, it is clear that *m-b3ḥ.f* is somewhat similar to the technique of the script of O. DeM 1221 with another suffix pronoun (.*k*), but it is not exactly identical.

4	SR 12191 (X+5 vs)	O. BM EA 41543 r° (Thebes?)
		Demarée 2002: pl. 95

However, *m-b3ḥ* is written in a totally different manner from O. BM EA 41543.

5	SR 12191 (X+4 vs)	O. DeM 1219
	ḥ3t-sp 25 *3bd* 4 *šmw sw* 13	Posener 1951-1972: pl. 50

This ostracon is inscribed with the same date as O. DeM 1219 except for the day. The Cairo ostracon records day 13, but O. DeM 1219 records day 18.

6	SR 12191 (X+6 vs)	O. DeM 1218 re	O. DeM 1601r°
	mšꜥ	Posener 1951-1972: pl. 50	Posener 1978: pl. 50

As is clear from this comparison, the word *mšꜥ* is totally different from the other examples because the scribe wrote the sign incorrectly; this has been discussed in the notes above notes.

7	SR 12191 (X+7 vs)	O. DeM 1218 re
	ḥr	Posener 1951-1972: pl. 50

In the case of the sign *ḥr*, the scribe wrote it in a way similar to that found on O. DeM. 1218, but the lines are thicker because that text was written by the master, something that is normal during 19th Dynasty, and our text was written by a student.

Judging by the number of mistakes he made, this ostracon seems to have been written by an idle scribe. The text, phrasing, and palaeography suggest that scribes from Deir el–Medina taught students from Sheikh Abd-el-Qurna.

Acknowledgements

Egyptian Museum SR 12177 – 12180 – 12185 – 12188 – 12190 – 12191 – 12197 – 12206 –12209 – 12213 – 12214 – 12216 – 1979. They all bear the mark C.A.G. = Cheikh Abdel Gurnah. I am very thankful to Dr Lotfy Abd el-Hamid who was most helpful during the course of my work. My study was done under supervision of Prof Ola el-Aguizy, Prof Robert J. Demarée, and Dr Mohammed Sherif Ali. I am grateful for all their help and advice. Further, I am also grateful to Prof Salima Ikram for her help in editing this text and I wish to express my thanks to Dr André J. Veldmeijer, Stichting Mehen, Claire Messenger, Dr Cédric Gobeil, Dr Carl Graves, and Dr Hisham

Elleithy. I owe the understanding of the type of text in the ostracon under discussion to Prof Richard Parkinson and Dr Chloé Raggazoli.

Bibliography:

Bavay, L. and Laboury, D. 2012. 'Dans l'entourage de Pharaon. Art et archéologie dans la nécropole thébaine', in L. Bavay et al. (eds), Ceci n'est pas une pyramide… Un siècle de recherche archéologique belge en Égypte. Leuven: Peeters, 62-79.

Beckerath, J. von. 1997. Chronologie des pharaonischen Ägypten. Mainz: Verlag Phillip von Zabern.

Blackman, A. M. and Peet, T. E. 1925. 'Papyrus Lansing: A Translation with Notes', Journal of Egyptian Archaeology 11: 284-98.

Caminos, R. 1954. Late Egyptian Miscellanies. Oxford: Oxford University Press.

Černy, J. 1931. 'Les ostraca hiératiques, leur intérêt et la nécessité de leur étude', Chronique d'Égypte 6(12): 214-24.

Collins, L. 1976. 'The private tombs of Thebes: Excavations by Sir Robert Mond 1905 and 1906', Journal of Egyptian Archaeology 62: 14-40.

Demarée, R. J. 2002. Ramesside Ostraca. London: British Museum Press.

Dorn, A. 2004. 'Die Lehre Amunnachts', Zeitschrift für ägyptische Sprache und Altertumskunde 131: 38-55.

Faulkner, R. 1972. A Concise Dictionary of Middle Egyptian. Oxford: Griffith Institute.

Fischer-Elfert, H. W. 1983. 'Eine literarische "Miszelle": A propos ODeM 1040, 1218 und UC 31 905', Studien zur altägyptischen Kultur 10: 151-6.

Fischer-Elfert, H. W. 1997. Lesefunde im literarischen Steinbruch von Deir el-Medineh. Wiesbaden: Harrassowitz.

Gardiner, A. H. 1935. Hieratic Papyri in the British Museum (3rd series). London: British Museum.

Goedicke, H. and Wente, E. F. 1962. Ostraka Michaelides. Wiesbaden: Harrassowitz.

Hannig, R. 2006. Ägyptisches Wörterbuch II: Mittleres Reich und Zweite Zwischenzeit. Mainz: Philipp von Zabern.

Hawkins, E. 1841. Select Papyri in the Hieratic Character from the Collections of the British Museum, I. London: British Museum.

Junge, F. 2005. Late Egyptian Grammar: An Introduction (2nd ed.). Oxford: Griffith Institute.

Kitchen, K. A. 1968-90. Ramesside Inscriptions, V. Oxford: Blackwell Publishing

Möller, G. 1965. Hieratische Paläographie: Die ägyptische Buchschrift in ihrer Entwicklung von der fünften Dynastie bis zur römischen Kaiserzeit (4 vols). Osnabrück: Otto Zeller.

Mond, R. 1904. 'Report on work done in the Gebel esh-Sheikh Abd-el-Kurneh at Thebes, January to March 1903', Annales du Service des Antiquités de l'Égypte 5: 97-104.

Mond, R. 1905. 'Report of the work in the Necropolis of Thebes the winter of 1903-1904', Annales du Service des Antiquités de l'Égypte 6: 65-97.

Posener, G. 1951. 'Ostraca inédites du Musée de Turin: Recherches littéraires III', Revue d'égyptologie 8: 171-89.

Posener, G. 1951-1952-1972. Catalogue des ostraca hiératiques littéraires de Deir el-Médineh. Cairo: Institut français d'archéologie orientale.

Posener, G. 1955. 'L'exorde de l'Instruction Éducative d'Amennakht', Revue d'égyptologie 10: 61-72.

Posener, G. 1977-80. Catalogue des ostraca hiératique littéraires de Deir el-Médineh III. Cairo: Institut français d'archéologie orientale.

Ragazzoli, C. 2011. Les artisans du texte: La culture des scribes en Égypte ancienne d'après les sources du Nouvel Empire. PhD Thesis, Paris.

Ragazzoli, C. 2010. 'Weak hands and soft mouths', Zeitschrift für ägyptische Sprache und Altertumskunde 137: 157-70.

Wimmer, S. 1995. Hieratische Paläographie der nicht-literarischen Ostraka der 19. und 20. Dynastie. Wiesbaden: Harrassowitz.

Pauline Norris
Independent researcher

Toward the end of Queen Victoria's reign, the wealth created by the Industrial Revolution in the United Kingdom led to an increase in disposable income amongst the middle classes, which allowed time for cultural diversions. At the same time, the restrictive moral attitudes prevalent earlier in the reign began to move toward a less formal and less prudish outlook in comparison with the over-refined manners and all engulfing delicacy of feeling that had previously stifled society.

This over-refinement of manners and morals that developed throughout European culture during the 18th and 19th centuries began to change toward the end of the 1880s. At the same time, the regard in which the human female figure was held also altered. Hitherto, depictions of nude goddesses, nymphs, and long-dead foreign queens could be displayed, but not representations of the naked human body, which was regarded as divine and could not therefore be reproduced (Johns 1989: 15-35). Paintings such as 'Hylas and the Nymphs' (1896) by John William Waterhouse in the Manchester Art Gallery, for example, do not depict human figures but naked nymphs. They were, therefore, socially acceptable for the so-called educated upper classes to view in the seclusion of an art gallery away from the apparently uneducated working masses. This painting again became the subject of controversy in 2018 when it was removed from the gallery wall for a short time, provoking a dispute over questions of 'taste' (Rea 2018).

However, by the end of the century and heavily influenced by classical Greek and Roman art, female human nudes of a limited genre became acceptable. The works of Aubrey Beardsley and Oscar Wilde together with the decadent art that adorned the Café Royal in London all contributed to '*Il faut épater le bourgeois*', as Baudelaire is believed to have said (Oxford Dictionary of Quotations 1996: 55) or 'the art of shocking' (Jackson 1976: 128) particularly of the middle classes who, after the repression of emotion suffered in the earlier years of the century, were now ripe for excitement.

Whereas rich gentlemen had previously accessed erotica in secret museums through the simple expedient of paying for the privilege, following the Industrial Revolution the middle classes now had money

and time to indulge in such activities. Now they, too, were able to acquire works of art depicting nude nymphs, fairies and exotic foreign ancient queens or goddesses. It became relatively acceptable for almost anyone to bring what one journalist has recently described as 'mild smoking-room erotica' (Mallalieu 2017) into the home, provided it was kept away from the ladies. Accordingly, at the turn of the century it was hardly surprising that a fashion developed amongst certain classes of gentlemen for bronze models of Egyptian icons such as sphinxes, sarcophagi and seated colossi which opened at the press of a button or turn of a lever to reveal naked ladies in a variety of poses.

Franz Bergman (1861–1936)

The leading specialist in these erotic ornaments was Franz Xaver Bergman (also spelled Bergmann) of Vienna. He was not a sculptor but a founder, that is: he owned a foundry, in his case having inherited it from his father Franz (1838-1894), and he employed designers and sculptors to create his bronzes. His interest in ancient Egypt appears to have been commercially motivated rather than being based on a predilection for Egyptology because his work embraced 'nudes to lizards' (Mallalieu 2017). Bergman's work can be distinguished by a capital B in a two-handled vase or, on his erotica, 'Nam Greb', his surname in reverse. This was ostensibly to disassociate himself from the erotic pieces because his family disapproved of them and to avoid upsetting his more conservative clientele. For the same reasons, a number of his erotic works were left unsigned (Berman 1974: 206–7).

The Egypt-related erotic figures discussed here were produced in three main types. An online search of sales websites indicates that the most common was the so-called 'sarcophagus'. This opens at the touch of a button to reveal a standing lady with short hair wearing only a simpering expression, a bracelet, a headband and a necklace, who is making a vague attempt to preserve her modesty with her hands. The example shown in figure 1a-b was made circa 1900. It is a type often referred to in modern advertisements as a 'Yummy Mummy', a description apparently first used in Berman's seminal work on bronzes (Berman 1980: 941, no. 3596).

A seated figure, possibly very loosely based on one of the Colossi of Memnon, that opens down the centre front to reveal its contents (fig. 2a-b) is less common. The lady within is seated on a pedestal draped in a cloth and wearing a necklace reminiscent of an Egyptian broadcollar and a somewhat lugubrious expression. Her hair is wavy and shoulder length.

Figure 1a–b: A 'Yummy Mummy', c. 1900. (Image: Hickmet Fine Arts, London)

Figure 2a–b: Seated figure, perhaps based on one of the Colossi of Memnon. (Image: Skinner Inc., Marlborough, Massachusetts)

Pauline Norris

Perhaps the rarest type is the sphinx which opens flat, or only one side dropping, to reveal the nude figure (fig. 3a-b). The ladies depicted were Grecian or European in appearance rather than Egyptian, with their hair piled on top of the head. The one in figure 3b is wearing a long necklace and has pink flowers lying across her thighs. The models in the sarcophagi usually have their hands depicted making some attempt at preserving their modesty but those in the sphinx and seated figures are more brazen.

Figure 3a-b: Sphinx with Grecian- or European-style nude. (Image: Leonard Joel Auction House, South Yarra, Victoria, Australia)

Often described as metamorphic reveal figures, these Art Nouveau objects were made of cold-painted bronze which should not be confused with cold-cast models made of resin and bronze powder. Bergman's pieces were decorated with several layers of cold-painted enamel colours or 'dust paint', which was not fired hence 'cold-painted' The dust paint was often applied whilst the bronze was still warm to anneal the paint into the metal. This lead-based paint was applied by women working at home at some considerable risk to their health and, perhaps fortuitously, the formula has now been lost, but modern, lead-free substitutes are not as intense or subtle as the original (Mallalieu 2017).

This display of hypocrisy was followed shortly after in the 20th century by the Art Deco movement and another Egyptian Revival that burgeoned after the discovery of the tomb of Tutankhamun in 1922. During this period,

the rich had money to spare for the conspicuous display of fashionable, luxury jewellery and demand spiralled for Egypt-themed items. In response, many jewellers created new Egypt-inspired collections as they had done for earlier revivals, particularly in France following the opening of the Suez Canal in 1869 and the Franco-Egyptian Exhibition at the Louvre in 1911. These new designs were not mere costume jewellery pieces but high-end luxury items, often large and frequently ostentatious. As one writer for the *Guardian* newspaper expressed it: 'One man's *style et luxe* is another man's tasteless bling' (Sansom 2011).

Louis Cartier (1875–1942)

Probably the best-known jeweller to use genuine Egyptian artefacts was Louis Cartier, grandson of Louis-François (1819-1904) the founder of the dynasty. There were three Cartier grandsons: Pierre, who opened a shop on Fifth Avenue in New York; Jacques, who went to London and eventually opened a store on the prestigious New Bond Street; whilst the eldest, Louis, remained to run the Paris branch. Rudoe divided Cartier's Egyptian style in the late 19th and early 20th centuries into two groups: the first, starting around 1910, consists of gem-set objects whose design is based on Egyptian motifs such as scarabs and Egyptian heads set in gold; this continued into the 1930s. The second consists of original designs incorporating genuine artefacts which appear between 1922 and the late 1920s (Rudoe 1997: 135). It is this second group that is the subject of the next section.

After the Tutankhamun discovery, Louis Cartier created around 150 pieces that were a combination of fragments of artefacts and rare stones mounted in modern settings (Arkell 2014: 24-5) and 'the curse of the pharaoh became an overnight money-spinner' (Nadelhoffer 1999: 154).

Louis, based in Paris, was reluctant to advertise in magazines (Rudoe 1997: 36) but a feature article promoting Cartier of London appeared in the *London Illustrated News* (Cartier of London 1924: 143) proclaiming:

> *Women interested in Egyptology, who desire to be in the Tutankhamen fashion, can now wear real ancient gems in modern settings as personal ornaments.*

Instead of advertising, jewellery would be lent to socialites and actresses appearing at high-profile events where the press would photograph the pieces for free. Fashion photography also proved a fertile ground for free advertising,

especially when modelled by famous individuals, along with exhibitions and charity events in various parts of the (wealthy) world (Rudoe 1997: 36-7).

A collector and dealer in antiquities himself, Louis Cartier had a knack for exploiting fads and trends and was described as a 'highly instinctive market tactician' (Nadelhoffer 1999: 8). He had contacts in the antiquities trade, particularly with the Armenian Kalebdjian brothers Hagob and Garbis and with Dikran Garabed Kelekian, all of whom had establishments in Paris and Cairo (Bierbrier 2012: 292-3; Hagen and Ryholt 2017: 64, 67). Cartier's feature article quoted above appears to have been inspired by a catalogue entry that the Kalebdjian brothers had produced for their exhibition of 147 pieces at Christmas 1913 (Nadelhoffer 1999:152):

> *Today fashion decrees that the elegant Parisienne should wear ancient jewellry, and not merely stale imitations, but the very jewels themselves that once adorned the bosom of an ancient Egyptian queen or a Greek empress.*

Through his knowledge of ancient Egypt (including owning a copy of the *Description de l'Égypte*), research and study plus his connections, Cartier was able to source and utilise more unusual deities for his creations adding to the exclusivity and value of the products. One of his favourite subjects was the lion goddess Sekhmet, preferably in faience. His use of Egyptian faience was unique (Rudoe 1997: 14).

In 1923, Cartier of London produced two brooches in the form of a *flabellum*, the long-handled fan made of ostrich feathers which would have been familiar to those interested in the treasures being removed from the tomb of Tutankhamun. One consisted of a semi-circular glazed faience plaque inscribed with the name Montuemhat, a mayor of Thebes c. 600 BC. The edge of the *flabellum* is bordered with diamonds and a diamond ram head supports the fan-shape (Rudoe 1997: 138, fig. 66). The second was described in the *Illustrated London News* as a 'sacred ram' but is a Late Period faience head of Sekhmet wearing the sun-disc (Cartier of London 1924: 143). The fragment is set in lapis lazuli studded with diamonds to represent stars and the whole piece is bordered with diamond lotus flowers set in enamel. Again, the fan-shape is supported by a ram head of diamonds (Rudoe 1997: 137, fig. 65; Arkell 2014: 24).

In 1925, Cartier produced a vanity case for a client in an exercise that was never repeated. In the eyes of an Egyptologist and the context of this paper, this was probably just as well. A carved calcite amulet, depicting a

girl carrying a basket on her head with an ibis walking beside her, had been split into two to become the front and back of the vanity case. Known as the 'Sarcophagus vanity case' and elaborately decorated and set with gold and gems, it was made to resemble the curved wooden lids raised on posts of 26th Dynasty coffins (Rudoe 1997: 137, 152, catalogue 87; Nadelhoffer 1999: 153, pl. 13). However, the carved bone or ivory is now thought to be relatively modern and it has been suggested (Los Angeles 1982-3: no. 22) that it might be 18th century Persian. Humbert, however, disagrees because the female figure carved on the lid section does not conform to the accepted view of Egyptian art of the period as the entire body is depicted in profile (Humbert 1994: 540, catalogue 371). It is surprising that Cartier did not notice or at least remark on this in view of his alleged expertise in Egyptian art.

In 1929, a Late Period faience figure of the goddess Bastet seated atop a papyrus column was incorporated into a gold, lapis and coral cigarette box (Nadelhoffer 1999: 153, pl. 15). At least two Ptolemaic figures of Isis had modern stick pins inserted into them and a coral square-faceted bead added on top of the altered, original head-dress to convert them into hat-pins (Cartier of London 1924: 143; Rudoe 1997: 137; Arkell 2014: 24, no. 2).

Discussion

Bergman's bronze figures are now highly collectable and are seen today as an innocuous amusement that is hardly offensive, but Cartier's valuable creations raise several ethical questions.

Bergman was not an expert in Egyptology. He perceived ancient Egypt as something exotic, mysterious, slightly risqué and different, not of Western culture and therefore something that could be utilised. His market was the newly affluent middle class who, as mentioned earlier, were ripe for titillation. In contrast, although 'Egyptianising objects' of the Art Deco period were not confined to the wealthy (Curl 2005: 374), Cartier supplied luxury items to the rich and famous, pandering to their demands for ever newer and up to the minute crazes.

Cartier purported to be a serious, educated collector, but he was perhaps not that knowledgeable an expert. Apart from the error with the 'Sarcophagus vanity case' discussed above, he apparently failed to notice that a New Kingdom faience plaque depicting part of a cartouche with the Gardiner sign M23 for *sw* (Gardiner 1957: 492) was mounted upside down within a pylon frame. In 1928, the model and socialite Iya, Lady Abdy, a Russian emigrée and former wife of the English shipping magnate Sir

Robert Henry Edward Abdy, was pictured in American *Vogue* wearing the piece (Hoyningen Huene 1928). Known for re-working her jewels, the stones along the lower edge are a later addition to Cartier's original design. In 2013, this item was offered at auction by Sotheby's of New York and sold for $180,000 (£115,000) (Arkell 2014: 24-5). It is tempting to speculate whether, over time, any of the wearers of this expensive jewel noticed or were even concerned about the error of the upside-down faience plaque.

To be able to use artefacts and ideas as Bergman and Cartier did, each in his own way considered ancient Egypt and its artefacts as exotic and far removed from modern Europe. They saw them as 'the other' and therefore open to and ripe for exploitation because they were not part of Western culture. In short, they both perceived ancient Egypt as a means to make money.

Bibliography

Arkell, R. 2014. 'Cartier's Egypt – ancient and modern', Antiques Trade Gazette, 15 February: 24-5.

Berman, H. 1974. Bronzes, Sculptors and Founders 1800-1930, I. Chicago: Abage.

Berman, H. 1976. Bronzes, Sculptors and Founders 1800-1930, II. Chicago: Abage.

Berman, H. 1980. Bronzes, Sculptors and Founders 1800-1930, IV. Chicago: Abage.

Bierbrier, M. L. (ed.) 2012. Who Was Who in Egyptology (4th rev. ed.). London: The Egypt Exploration Society.

Cartier of London. 1924. 'The Tutankhamen influence in modern jewellery', Illustrated London News, 26 January: 143.

Chaille, F. and Aliaga, M. 2007. Cartier: Innovation Through the Twentieth Century Paris: Flammarion.

Curl, J. S. 2005. The Egyptian Revival. London: Routledge.

Gardiner, A. 1957. Egyptian Grammar (3rd ed.). Oxford: Griffith Institute.

Hagen, F. N. and Ryholt, K. 2017. 'The antiquities trade in Egypt during the time of Rudolf Mosse', in J. Helmbold-Doyé and T. L. Gertzen (eds), Mosse im Museum: Die Stiftungstätigkeit des Berliner Verlegers Rudolf Mosse (1843-1920) für das Ägyptische Museum Berlin. Berlin: Hentrich and Hentrich, 59-74.

Hoyningen Huene, G. 1928. 'A jewel song from Paris: The wearing of the gem is an ancient art to which the Parisienne brings modern interpretations', American Vogue, 8 December, photograph feature.

Humbert, J-M., Pantazzi, M. and Ziegler, C. 1994. Egyptomania: Egypt in Western Art 1730-1930. Ottawa: National Gallery of Canada.

Jackson, H. 1913. The Eighteen Nineties. Brighton: EER Publishers.

Johns, C. 1989. Sex or Symbol? Erotic Images of Greece and Rome. London: British Museum Press.

Los Angeles. 1982-83. Retrospective Louis Cartier: Masterworks of Art Deco, 1915-1935. Los Angeles: County Museum of Art.

Mallalieu, H. 2017. 'From nudes to lizards – a lively cast of bronze figures'. Available at: https://www.thetimes.co.uk/article/from-nudes-to-lizards [last accessed 20 July 2018].

Markowitz, Y. J., Kaplan, R. J. and Kaplan, S. B. 2018. 'The allure of ancient Egyptian jewelry', Aegyptiaca 2: 138-45.

Nadelhoffer, H. 1999. Cartier. London: Thames and Hudson.

Partington, A. (ed.). 1996. Oxford Dictionary of Quotations (4th rev. ed.). Oxford: Oxford University Press.

Rea, N. 2018. 'British art museum banishes a famed Pre-Raphaelite fantasy over its depiction of "femme fatale" nymphs'. Available at: https://news.artnet.com/art-world/museum-removes-nymph-painting-1213358 [last accessed 9 November 2018].

Rudoe, J. 1997. Cartier 1900-1939. London: British Museum Press.

Sansom, I. 2011. 'Great dynasties of the world: The Cartiers'. Available at: https://www.theguardian.com/lifeandstyle/2011/jul/09/cartier-jewellers-ian-sansom [last accessed 18 November 2018].

The geomorphological evidence for the Early Dynastic origins of the Great Sphinx of Giza: a response to Drs Lehner and Hawass

Colin D. Reader
Engineering geologist and independent researcher

Having examined the weathering and erosion of the limestones that were exposed by the excavation of the Great Sphinx, this author has previously concluded that whilst the Sphinx is a product of the Pharaonic culture, its excavation pre-dates the 4th Dynasty Pyramids at Giza. Although space here prevents the repeating of detailed arguments leading to this conclusion, the following pages will revisit a number of relevant issues in the context of criticism that has been presented by Dr Mark Lehner and Dr Zahi Hawass in their publication, Giza and the Pyramids (2017: 58-61).

When presenting their criticism, Lehner and Hawass refer to only one of a number of articles published by this author on this subject. The article that Lehner and Hawass cite (Reader 2014) was an exploration of the iconography of the sphinx and did not address geological issues in detail. This apparent lack of familiarity with the full range of published material may explain why on a number of occasions in their rebuttal, Lehner and Hawass suggest that certain issues have been ignored. For example, they state 'Reader ignores the fact that the southeasterly sloping lower beds of Member II, which show the greatest erosion, are not exposed at the eastern end of the ditch' (2017: 59). Rather than having ignored the distribution of the various limestone units, however, these issues have been explored at length (Reader 1997; 2001; 2002; 2005; 2006; 2006a). As shown on figure 1, contrary to the view expressed in Lehner and Hawass (2017: 59), the lower beds of the Member II limestones are exposed in the eastern end of the Sphinx enclosure, with unit i extending for some distance across the enclosure floor (Lehner 1991: figs 4.4 and 4.5).

There is also an issue with the way in which Lehner and Hawass generalise about the degraded state of the limestones within the Sphinx enclosure. The Member II strata are the most widespread of three exposed limestone Members (Reader 1997), extending along the southern and western walls of the enclosure (fig. 1), as well as being exposed across most of the body of the Sphinx. As will be explored in more detail below, the Member II

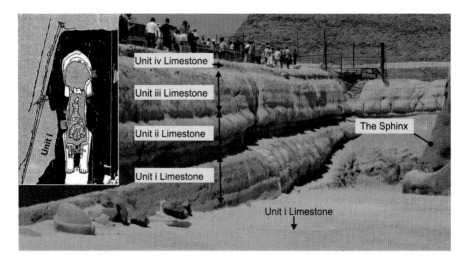

Figure 1: The Member II limestones, looking west along the southern wall of the Sphinx enclosure. It is evident from this view that the south easterly dip of the Member II strata causes the lowest unit (unit i) to dip below the enclosure floor. Although unit i is not exposed in the most easterly walls of the enclosure, as the extract from fig. 4.4 of Lehner's PhD thesis shows (inset), unit i is exposed across the eastern floor of the enclosure.

strata exposed along the western enclosure walls have a rounded and more intensely degraded morphology that is not apparent elsewhere. This distribution is considered to be particularly significant when attempting to determine when the excavation of the Great Sphinx took place.

A context for an Early Dynastic Great Sphinx

In their rebuttal, Lehner and Hawass note that extensive quarrying was required to construct the Great Sphinx and that 'nowhere else in Giza – or anywhere in Egypt – do we see this scale of stonework in the Early Dynastic, before the 3rd dynasty step pyramids' (2017: 59). In making this statement, Lehner and Hawass are implying that the Great Sphinx could not be a product of the Early Dynastic Period as suggested by this author's interpretation of the geological evidence, because the ancient Egyptians had not mastered the ability to quarry and move large volumes of stone at such an early time.

Lehner and Hawass' statement, however, is not consistent with what is currently understood regarding construction in the Early Dynastic Period

and also appears to contradict statements they have made elsewhere in Giza and the Pyramids. As Lehner and Hawass discuss (2017: 72), the tombs of two early 2nd Dynasty pharaohs (Hetepsekhemwy and Ninetjer) at Saqqara took the form of extensive underground rock-cut galleries, the construction of which involved significant quarrying and tunnelling (Lacher 2008; Lacher-Raschdorff 2014). The volume of limestone bedrock removed for the construction of these early 2nd Dynasty royal tombs, however, will have been dwarfed by the quarrying required for the construction of the Gisr el-Mudir at Saqqara. The Gisr el-Mudir is a largely stone-built walled enclosure which lies to the south-west of the Step Pyramid, with the enclosed space covering an area approximately twice that of the Step Pyramid enclosure. As Lehner and Hawass confirm, the Gisr el-Mudir is generally regarded as having been built in the 2nd Dynasty (Lehner and Hawass 2017: 72).

Surrounding Netjerikhet's 3rd Dynasty Step Pyramid enclosure is a feature known as the Dry Moat which is generally understood to be a trench some 6 m deep and 40 m wide, excavated in the limestone bedrock (Swelim 1988). The Dry Moat may have served as a quarry during the construction of the Step Pyramid (Reader 2017); however, given that a number of 2nd- and early 3rd Dynasty features have been found in the area enclosed by the Dry Moat (Reader 2017; Welc 2008), it is possible that this little understood feature may predate the Step Pyramid. Of particular interest is a pair of 27 m deep rock-cut trenches in the south of the Dry Moat (Swelim 2006). Quarrying would have been impractical from such deep and narrow excavations and given that the locations of these trenches are remarkably close to the entrances to the early 2nd Dynasty tombs of Hetepsekhemwy and Ninetjer, an early 2nd Dynasty date has been suggested for their construction (Dodson 2017; Reader 2017).

Given what is known from just one site – Saqqara – Lehner and Hawass' view that the ancient Egyptians had not mastered the ability to quarry and move large volumes of stone before the beginning of the 3rd Dynasty, is clearly not supported by available evidence. When considering whether my proposed Early Dynastic date for the excavation of the Great Sphinx fits the established context for large-scale stone working in ancient Egypt, it is also important to consider that the Great Sphinx is unique. No other free-standing, rock-cut monument was constructed during the Pharaonic era. As a result, it is difficult to associate the Great Sphinx with any specific trend in monument building in ancient Egypt.

The degradation of the Great Sphinx

Irrespective of when the Great Sphinx was originally excavated, from the outset it will have been subject to a range of processes of weathering and erosion. As explored in detail elsewhere, these processes will have included chemical weathering, the daily heating and cooling of the exposed limestones as the sun rises and sets and abrasion by wind-blown sand. All these processes will have played a role in the degradation of the Great Sphinx, contributing to the form seen today. As previously discussed at length, however (for example Reader 2001), there is one particular feature of the degradation within the Sphinx enclosure that is not consistent with the action of these processes: this is an evident distribution in the intensity of degradation within the Sphinx enclosure, with the rounded, most heavily degraded exposures lying along the western enclosure walls (figs 2 and 3).

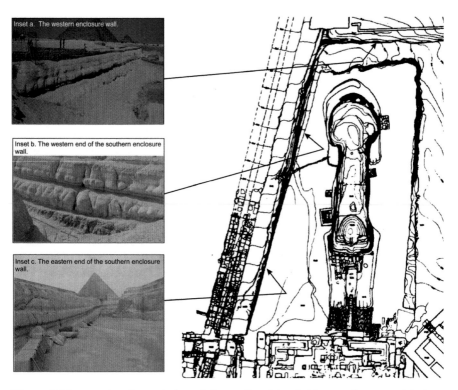

Figure 2: The varying degradation of the walls of the Sphinx enclosure, with the more intense degradation evident along the western exposures.

I consider that this spatial distribution is the result of an additional process, the destructive effects of which have been identified at a number of ancient sites in Egypt including the Giza necropolis (Reisner 1931: 44). This process is often referred to as run-off and occurs when heavy rainfall saturates the ground surface, leading to surplus water discharging downslope. This discharge can have significant erosive potential.

After considering the potential influence of run-off on the Sphinx enclosure in my earliest papers, I first applied the concept of the flow net to the issue in 2006 (Reader 2006; 2006a). Flow nets can be used to model the way in which topography (shown as orange contours and referred to as equipotentials in fig. 4) influences surface water or groundwater in the vicinity of a particular feature, with the spacing of flow lines (shown as blue arrows on fig. 4), indicating the relative intensity of the resulting flow. Although Lehner and Hawass consider that I have ignored 'the fact that the

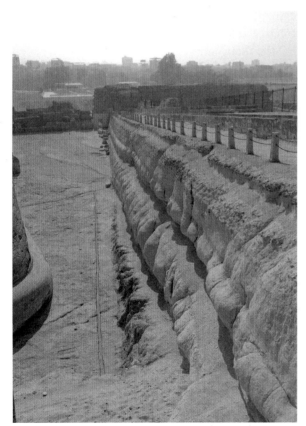

Figure 3: Looking east along the southern wall of the Sphinx enclosure, it is evident that the western end of the enclosure (foreground) has been degraded to a greater extent than the eastern end (background).

bedrock slopes south, away from the Sphinx ditch, as well as east, towards it' (2017: 59), it is clear from the manner in which topography has been modelled on figure 4, that I have taken full account of the slope of Giza plateau when assessing the behaviour of run-off in the vicinity of the Sphinx.

As figure 4 shows, the topography of the area surrounding the Sphinx causes the flow lines to draw closer together as they approach the western wall of the enclosure. These close flow lines indicate an increase in flow intensity in this area and correspond with the area of intense degradation along the western enclosure wall. The absence of flow lines at the eastern end of the southern enclosure wall (the area adjacent to the valley temple and Sphinx temple) suggests that only low intensity flow will have reached this area. The pair of widely spaced flow lines intercepting the western end of the southern enclosure wall suggest that flow intensity along this exposure increased towards the west. Once again, the distribution of flow lines along the southern enclosure wall is consistent with the distribution of more intense degradation evident within the Sphinx enclosure (fig. 3).

I consider that the correlation between the areas of more intense flow indicated by the flow net and the distribution of the more heavily degraded exposures within the Sphinx enclosure, confirms the role that run-off has played in the degradation of the Great Sphinx.

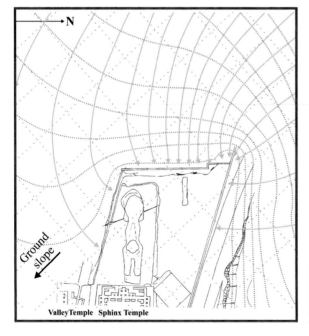

Figure 4: Flow net for the Sphinx enclosure (equipotentials in orange, flow lines in blue).

Quarrying to the west of the Sphinx enclosure

The flow net presented as figure 4 does not give the full picture however, as it does not take account of a feature located some 20 m to the west and upslope of the Sphinx enclosure: an area of ancient quarrying. Prior to this quarrying, run-off from occasional rain storms at Giza will have been able to discharge into the Sphinx enclosure in the manner shown on figure 4, scouring the western walls and leading to the development of the areas of rounded and more intense degradation that are so evident today. Once quarrying began, however, run-off will have discharged into the quarry basin and will not have been able to reach the downslope areas in which the Sphinx enclosure lies. The erosion of the western walls of the Sphinx enclosure by run-off therefore, requires the Great Sphinx of Giza to be older than the adjacent quarry and for this reason, the history of quarrying at Giza becomes hugely significant.

Lehner and Hawass suggest that I attributed the area of ancient quarrying to the west of the Sphinx enclosure to the reign of Khufu (2017: 59, 'Reader's main argument is as follows [...] it was Khufu's workmen who quarried the bedrock west of the Sphinx'). If, as explained above, the erosion of the Sphinx enclosure by run-off took place before this quarrying began, it follows that the Great Sphinx must pre-date the activities of Khufu at Giza.

I was not the first, however, to suggest that this quarry was excavated during the reign of Khufu. As Lehner describes (1985: fig. 3c item C12 and the accompanying text for C12), there is clear archaeological evidence to support such an attribution, with material excavated from between a pair of masonry walls in the base of the quarry containing 'mud seal impressions bearing the name of Cheops [Khufu]' (Lehner 1985: item B9). The evidence recovered from the base of this quarry establishes a date not only for the masonry walls but also for the quarry in which they sit. In Giza and the Pyramids, however, Lehner and Hawass attempt to preserve the conventional date for the construction of the Great Sphinx by revising the date of this quarry, suggesting that its excavation can be attributed to the later reign of Khafre (2017: 59). In contrast to the well-reasoned attribution to Khufu that was presented in Lehner's 1985 paper, however, Giza and the Pyramids offers little more than opinion to support this revised position.

Even if the dating evidence presented by Lehner in his 1985 paper is set aside and it is accepted that the quarrying to the west of the Sphinx enclosure was undertaken during the reign of Khafre as suggested by Lehner and Hawass (2017: 59), this does not significantly alter the conclusion that

the Great Sphinx pre-dates the 4th Dynasty. This is because available data suggests that rainfall was experienced only infrequently in Egypt in the Pharaonic period (Peacock and Maxfield 1997: 183, item 45), occurring at Giza in the Old Kingdom perhaps only a couple of times each century. Given the likely frequency of run-off events, even if the improbable scenario that the Great Sphinx was excavated at the very start of Khafre's reign and the adjacent quarrying took place at the end of his reign is accepted, this gives a limited period of less than 30 years during which run-off events could have affected the Sphinx enclosure (Baines and Malek 1980: 36). Evidence will be presented below to demonstrate that such restricted timescales will not have been sufficient for the development of the more intense erosion of the western walls of the Sphinx enclosure.

Modern rainfall

Having examined the case for erosion by run-off, Lehner and Hawass go on to consider other factors that they consider may have led to the degradation of the Sphinx enclosure and which in their view, do not require any revision of the conventional attribution of the Sphinx to Khafre. They present an extensive discussion of conditions within the Sphinx enclosure that they have encountered following modern rainfall events at Giza. I will address their observations in some detail shortly, however I consider that the conditions existing at Giza today will have little bearing on those that existed for most of the history of the Great Sphinx. In the modern era, the Sphinx has been completely cleared of sand, something that is known to have happened only occasionally in antiquity (for example during the reign of Thutmose IV, see Lehner and Hawass 2017: 476), a modern asphalt road has been built immediately to the north of the Sphinx enclosure, a masonry wall has been built along the western and northern limits of the enclosure and the broader environs of the Sphinx have been subject to extensive archaeological investigation, which has involved the re-distribution of large volumes of sand and accumulated debris. Together, these modern features and activities will have significantly altered the surface hydrology of this part of the Giza plateau, resulting in hydrological conditions today that will differ significantly from those that existed in the pre-modern era. When Lehner and Hawass state that they have observed water washing over the western side of the 'Sphinx ditch' (2017: 59), they appear not to have considered the potential significance of these modern changes.

I have previously referred to a letter written by Karl Lepsius (Reader 2014), which describes a severe rainfall event witnessed at Giza in 1843 (Lepsius 1853: 53-4). Lepsius' account is important because it largely pre-dates the modern interventions that influence current hydrological conditions at the site. Furthermore, from a surface hydrology perspective, conditions on site in 1843 will not have been significantly different from those that prevailed throughout the preceding centuries or even millennia. Lepsius' account of the rainfall event he witnessed is, therefore, likely to be the nearest to reconstructing a pre-modern major rainfall event at Giza and its consequences for the Great Sphinx.

Lepsius' account describes a brief but severe rain storm that led to the development of high-energy run-off capable of washing away tents and equipment, including iron crow-bars. Yet despite the ferocity of this event, within a short distance of washing through Lepsius' encampment, the high-energy run off was brought to a halt and formed a 'lake in a hollow behind the Sphinx' (Lepsius 1853: 53-4). It is with some evident relief that Lepsius confirms that the lake 'fortunately had no outlet', an indication that run-off failed to reach the Sphinx and that no damage was caused to the monument.

Given Lepsius' description, the hollow in which the 'lake' formed cannot have been the sand-filled Sphinx enclosure. A short distance upslope of the Sphinx enclosure, however, is the quarry worked by Khufu (Lehner 1985: fig. 3c item C12), which is separated from the Sphinx enclosure by an unquarried section of limestone bedrock (which Lehner and Hawass refer to as a 'bedrock bridge', see 2017: 59). This unquarried bedrock is the only feature in this area of Giza that will have been robust enough to bring the high-energy run-off described by Lepsius to a halt. The most likely location, therefore, for the 'lake' described by Lepsius is the sand-filled eastern section of the Khufu quarry and with this identification, Lepsius' account provides clear testimony that under the conditions of surface hydrology that existed in 1843 (and were likely to have existed throughout the preceding centuries) even high-energy run-off was unable to reach the Sphinx enclosure. I was not aware of Lepsius' letter when, in the late 1990s, I first reached my conclusions on the impact of quarrying on the surface hydrology of the Giza necropolis. Lepsius' account, however, confirms the conclusions reached independently and corroborates the view that the excavation of the Great Sphinx pre-dates the adjacent quarrying activity.

In order to understand the impact of run-off on the limestones exposed at the Sphinx, it is necessary to consider the competing influences at play. As Lehner and Hawass correctly state, run-off can be generated from

'any and all sized catchments' (2017: 59); however, if run-off from small catchments is considered, there are a number of important factors that need to be addressed. For example, given the presence of a modern wall running along the top of the western Sphinx enclosure, the western catchment will be limited to the sloping face of the enclosure together with the small area between the top of the excavated face and the base of the modern wall. Although this small catchment will generate some run-off, this will have little energy and relatively little erosive potential. This conclusion appears to be supported by Lehner and Hawass when discussing a rainfall event of 25 February 2010 (2017: 60). Their figure 4.13 illustrates accumulations of loose sand at the foot of the western wall of the Sphinx enclosure, which are crossed only by 'little channels' (Lehner and Hawass 2017: 60), consistent with the action of low-energy run-off. A high-energy event, such as that described by Lepsius, is more likely to have washed this sand away. For rainfall such as that encountered on 25 February 2010 to have led to the significant erosion that is evident, it will have been necessary for the western walls of the Sphinx enclosure to have been exposed to repeated low-energy run-off events over prolonged periods of time. Such a scenario is not supported by the available evidence, which suggests that once cleared, the Sphinx enclosure rapidly fills with wind-blown sand (Lehner and Hawass 2017: 477).

The other issue that Lehner and Hawass explore by reference to their figure 4.13 is the nature of the joints and fissures that run through the Member II limestones. They correctly state that these discontinuities are 'not primarily features of surface erosion' and attribute their origin to 'other forces, perhaps tectonic [which] created them in geological ages past' (2017: 60). Their suggestion, however, that these features are more prevalent in the west of the Sphinx enclosure (Lehner and Hawass 2017: 60: 'They happen to be more numerous in the bedrock of the western Sphinx ditch'), is not correct and neglects both the tectonic origins of these features as well as the post-tectonic development that these joints have undergone.

Given their tectonic origins, these sub-vertical discontinuities are distributed relatively evenly throughout the limestones at Giza (Gauri 1984: 39) and therefore, are present along the full length of the Sphinx enclosure walls as well as cutting through the body of the Sphinx. Following the excavation of the Sphinx, all the exposed discontinuities will have been subject to sub-aerial processes including chemical weathering and abrasion by wind-blown sand. As discussed in previous publications (e.g. Reader 1997: fig. 3), it is considered that the action of these sub-aerial processes

has led to relatively moderate degradation of the exposed joints, such as that visible along the eastern end of the southern enclosure wall (fig. 2, inset c). In a relatively small area such as the Sphinx enclosure, however, the factors that affect the intensity of these sub-aerial processes (factors including air temperature, humidity etc.) will not vary to any significant extent. Weathering and erosion by sub-aerial processes cannot therefore account for the more marked degradation of the joints exposed along the western walls of the enclosure.

As modelled by the flow net presented as figure 4, however, prior to Khufu's quarrying at Giza, high-energy run-off discharging into the Sphinx enclosure, will have scoured the joints and fissures exposed along the western enclosure walls, leading to these discontinuities being cut back deeply into the exposed face. When the deep scouring of the exposed joints was combined with the high-energy erosion of the strata between the discontinuities, this led to the development of the heavily rounded features that are present in the west of the Sphinx enclosure (fig. 5). Despite the presence of numerous joints and fissures exposed along the eastern enclosure walls, localised rounded features such as that shown on figure 5 are not evident in the eastern part of the Sphinx enclosure or along exposed sections of the body of the Sphinx.

Figure 5: Heavy rounded degradation in the west of the Sphinx enclosure. The exposed limestones are naturally divided into blocks by sets of nearly vertical joints. Deep erosion of the joints by surface run off has led to the development of rounded features such as this example.

Given these considerations, although the presence of rounded features of degradation along the western walls of the Sphinx enclosure cannot be readily explained by the action of chemical weathering or abrasion by wind-blown sand (either acting alone or in combination), they can be readily

explained by the action of high-energy run-off discharging from the higher areas of the Giza plateau. As discussed above however, such high-energy run-off was only able to reach the Sphinx enclosure before the large-scale quarrying undertaken during the reign of Khufu.

Discussion and conclusions

I fully accept the view of Lehner and Hawass that modern rainfall such as the event encountered on 25 February 2010 will generate run-off, which will discharge into the Sphinx enclosure (Lehner and Hawass 2017: 60). The important distinction to note, however, is that as a result of modern interventions at the site, particularly the wall built along the northern and western limits of the enclosure, the relevant catchments will be limited in size. As a result of these limited catchments, modern run-off will have relatively low energy.

Lehner and Hawass appear to agree with my interpretation that the 'lake' Lepsius observed behind the Sphinx formed within an area of ancient quarrying ('This hollow would be the quarry west of the Sphinx', Lehner and Hawass 2017: 60). This reinforces my conclusion that run-off from the higher reaches of the Giza plateau will have been intercepted by the 4th Dynasty quarry and was therefore, unable to reach the Sphinx enclosure. With the quarry intercepting high-energy run-off from the wider Giza plateau, in the period following the 4th Dynasty quarrying, only low energy run-off from the areas immediately surrounding the Sphinx will have discharged over the enclosure walls.

The key issue, therefore, appears to be whether the low energy run-off that has been experienced since the 4th Dynasty quarrying will have been sufficient to lead to the degradation that is evident within the Sphinx enclosure, particularly the more intense, rounded degradation that characterises the western enclosure walls (fig. 5). As Lehner and Hawass correctly observe, 'Running water could not erode the western Sphinx ditch if sand filled it' (2017: 60), irrespective of the energy associated with a particular run-off event. Given that once cleared, the Sphinx enclosure appears to rapidly re-fill with sand (Hawass 1998: 21-34), the 'windows of opportunity' for erosion by low-energy run-off would appear to be few and relatively brief.

Lehner and Hawass also appear to suggest that the extant degradation can be attributed to processes other than run-off. It is true that the Member II strata is 'always eroding through other processes' and that 'efflorescing

salts are the culprit' (2017: 60). However, as I have explored in previous papers, these chemical weathering processes will act in a relatively uniform manner along any given exposed bed and even the influence of factors such as diurnal temperature ranges, fail to explain the variations in degradation that can be seen within the Sphinx enclosure. In the context of a single limestone stratum (for example Member II, unit ii – see fig. 1), Lehner and Hawass fail to explain how the effects of chemical weathering would be greater in the west of the Sphinx enclosure than in the east.

Figure 6: Chisel marks on the entrance to a Late Period tomb excavated into the western Sphinx enclosure wall.

Perhaps most telling, however, is the evidence presented by a series of tombs that have been cut into the western Sphinx enclosure wall. These tombs, which include the 26th Dynasty tomb of Ptahardais (c. 664 to 525 BC; Porter and Moss, 1974: plan VI and p. 291) are some 2,500 years old and once excavated will have had the same frequency and duration of exposure as the adjacent western enclosure wall. According to Lehner and Hawass, the more intense degradation of the western Sphinx enclosure 'does not require centuries or millennia to have taken place' and can be expected

to occur over a 'few generations' (2017: 60). Lehner and Hawass' model for the degradation of the Sphinx and Sphinx enclosure, however, does not account for the extensive preservation of ancient tool marks along the rock-cut entrances to these Late Period tombs (fig. 6).

The survival of tool marks on these tomb entrances can be explained in the context of high-energy run-off. Unlike the limestones exposed along the adjacent western wall of the Sphinx enclosure, these Late Period tombs were excavated long after Khufu's quarrying at the site and have therefore been exposed only to the low-energy run-off that has been experienced since, together with sub-aerial processes including chemical weathering and abrasion by wind-blown sand. Having not been exposed to the more erosive conditions of high-energy run-off that existed before the reign of Khufu, these tomb cuttings are far less heavily degraded when compared with the adjacent walls of the Sphinx enclosure.

Bibliography

Baines, J. and Malek, J. 1980. Atlas of Ancient Egypt. Oxford: Andromeda.

Dodson, A. 2017. 'The royal tombs of ancient Egypt', Nile 8: 50–60.

Gauri, K. L. 1984. 'Geologic study of the Sphinx', Newsletter of the American Research Centre in Egypt 127: 24–43.

Hawass, Z. 1998. The Secrets of the Sphinx. Cairo: AUC.

Lacher, C. 2008. 'Das Grab des Hetepsechemui/Raneb in Saqqara. Ideen zur baugeschichtlichen Entwicklung', in E. M. Engel et al. (eds), Zeichen aus dem Sand: Streiflichter aus Ägyptens Geschichte zu Ehren von Gunter Dreyer. Wiesbaden: Harrassowitz, 427–51.

Lacher-Raschdorff, C. M. 2014. Das Grab des Königs Ninetjer in Saqqara: Architektonische Entwicklung frühzeitlicher Grabanlagen in Ägypten. Wiesbaden: Harrassowitz.

Lehner, M. 1985. 'The development of the Giza Necropolis: The Khufu Project', MDAIK 41: 109–43.

Lehner, M. 1991. Archaeology of an Image: The Great Sphinx of Giza. PhD Thesis, Yale University, USA.

Lehner, M. and Hawass, Z. 2017. Giza and the Pyramids. London: Thames and Hudson.

Lepsius, R. 1853. Letters from Egypt, Ethiopia, and the Peninsula of Sinai. London: Henry G. Bohn.

Peacock, D. P. S. and Maxfield, V. P. 1997. Mons Claudianus 1987-1993: Survey and Excavation, I: Topography and Quarries. Cairo: IFAO.

Porter, B. and Moss, R. L. B. 1974. Topographical Bibliography of Ancient Egyptian Hieroglyphic Texts, Reliefs and Paintings, III. Part 1: Memphis (2nd ed.). Oxford: Clarendon Press.

Reader, C. D. 1997. 'Khufu knew the Sphinx'. Available at: https://qmul.academia.edu/ColinReader [last accessed 14 August 2019].

Reader, C. D. 2001. 'A geomorphological study of the Giza Necropolis, with implications for the development of the site', Archaeometry 43(1): 149–65.

Reader, C. D. 2002. 'Giza before the Fourth Dynasty', Journal of the Ancient Chronology Forum 9: 5–21.

Reader, C. D. 2005. 'The age of the Sphinx and the development of the Giza Necropolis', in A. Cooke and F. Simpson (eds), Current Research in Egyptology II. Oxford: Archaeopress, 47–56.

Reader, C. D. 2006. 'Response to G. Vandecruys: The Sphinx: Dramatising Data and Dating', PalArch's Journal of Archaeology of Egypt/Egyptology 2(1): 1–13.

Reader, C. D. 2006a. 'Further considerations on development at Giza before the 4th Dynasty', PalArch's Journal of Archaeology of Egypt/Egyptology 3(2): 12–25.

Reader, C. D. 2014. 'The Sphinx: Evolution of a concept', Ancient Egypt 14(6): 34–9.

Reader, C. D. 2017. 'An Early Dynastic ritual landscape at North Saqqara: An inheritance from Abydos?', JEA 103: 71–87.

Reisner, G. A. 1931. Mycerinus: The Temples of the Third Pyramid at Giza. Cambridge, MA: Harvard University Press.

Swelim, N. 1988. 'The Dry Moat of the Netjerykhet Complex', in J. Baines et al. (eds), Pyramid Studies and other Essays Presented to I. E. S. Edwards. London: The Egypt Exploration Society, 12–22.

Swelim, N. 2006. 'The Dry Moat, the south rock wall of the inner south channel', in E. Czerny (ed.), Timelines: Studies in Honour of Manfred Bietak, I. Leuven: Peeters, 363–76.

Welc, F. 2008. 'Some remarks on the Early Old Kingdom structures adjoining the enclosure wall of the Netjerykhet funerary complex on its west side', Polish Archaeology in the Mediterranean 18: 174–9.

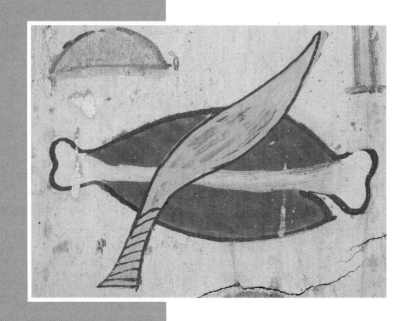

Art as writing, writing as art: selected case studies from New Kingdom Theban tombs

Marina Sartori
Universität Basel

Homo Pictor

If one of the characteristics that distinguish humans from animals is the ability to represent and copy reality through the shaping of figures, no one deserves the title of 'Homo Pictor' (Jonas 1961) more than the ancient Egyptians do. In the land of the Nile, in fact, images conveyed not only visual narratives, but also linguistic ones, both put in constant interplay with each other due to the similarities in their coding. The fact that only fuzzy boundaries existed between the two experiences of 'writing' and 'drawing/painting' – in many modern cultures traditionally separated, even antithetical – is shown by the fact that the Egyptian language knows only one linguistic root, *zḥꜣ*, to express the two.

Nowadays, we *Buchstabenmenschen* (Assmann 2004: 304) would be surprised, when browsing through a dictionary of ancient Egyptian, to find attested for the aforementioned linguistic root such contrasting meanings. For example, as a verb *zḥꜣ* can have the values 'to write', 'to inscribe', 'to paint'; as a noun, 'writing', 'depiction', 'papyrus roll'; as nomina agentis, 'scribe', 'painter', 'draughtsman' (see the lemma *sš* in Faulkner 1991: 246 and the lemma *zḥꜣ*, no. 600375, in the *Thesaurus Linguae Aegyptiae*).

Yet, as it is known, the hieroglyphic script is composed of a number of signs representing a natural (including animals) or human (meaning also everything created or connected to human actions) element, often still recognisable, however deeply rooted in Egyptian culture and difficult to interpret. Of particular interest is the observation that, even though the Egyptian language evolved over millennia and developed different cursive sub-scripts, the detailed original script never went out of use until the 4th century AD, hinting at the absolute importance of retaining the connection to real objects, in contrast to the Mesopotamian cuneiform script.

It is therefore possible to easily decipher one reason why the ancient Egyptian language would not deem it necessary to find two words to distinguish the experiences of writing and drawing; both elements, the linguistic and the

visual, cannot be separated, and are both necessary to express the meaning. Writing is drawing. Even the modern alphabetic signs familiar in everyday life, which no longer retain a direct connection to reality, originally meant to create the image of the object represented by the word they express. The difference lies in the major/minor level of abstraction and the distance from the real object.

This indissoluble connection is best described by Mitchell, who, in trying to define 'What is an image?', addressed the topic from the opposite point of view (Mitchell 1984: 518):

> *Insofar as language is written, it is bound up with material, graphic figures and pictures that are abridged or condensed in a variety of ways to form alphabetical script. [...] The idea of the 'speaking picture' which is often invoked to describe certain kinds of poetic presence or vividness on the one hand, and pictorial eloquence on the other hand, is not merely a figure for certain special effects in the arts, but lies at the common origin of writing and painting.*

The striking similarities between the two ways of describing reality in ancient Egypt, as well as the constant osmosis between them, has led the Egyptological community to look for ways to decipher the scenes that fill tomb and temple walls, columns and statues, as linguistically structured, by reading them as if made out of hieroglyphs. Certainly, through this exercise many additional layers of meaning become visible in the artworks – see, among others, the many examples shown in Wilkinson's (1992) book, programmatically called *Reading Egyptian Art*.

Yet, as Baines summarises, it must not be forgotten that 'writing is a system of visual communication as well as a linguistic one. It was invented as the former and became the latter' (2007: 6). Before labelling Egyptian art as made of hieroglyphs, it should be questioned whether it is possible to adopt the opposite perspective and look at the graphic and semiotic elements that make this interplay possible.

Following the direction of this 'iconic (re)turn' (Assmann 2004), the present paper will focus on some facets of the interaction between the graphic aspects of script and figure in New Kingdom Egypt, taking as examples painted material from a selection of Theban Tombs. These are TT84 and TT95 (investigated by the University of Basel in the context of the SNF-funded project Life Histories of Theban Tombs), TT82, TT92, TT295, TT259 and TT178, and they offer much interesting material to illustrate some preliminary results of this ongoing research.

Hieroglyphs as art

As Hornung (1989: 276) states, 'from the very beginning, writing has been a daughter of art. Out of the boundless store of pictures before the artist's eye, a limited number was chosen to convey the sound and especially of names'. The hieroglyphic script, appearing already at the end of the 4th millennium BC, followed the normal evolution of any writing system: from a vast ensemble of figures used to represent reality, some of them appeared suitable to accommodate an additional phonetic value, in order to express fragments of language. Peculiarly, though, the now linguistic signs retained over the years every bit of their pictoriality in the execution, as they had at their birth – a quality that Egyptian artists could promptly exploit or underline for the sake of complementing figurative scenes.

That hieroglyphs derive from art and not vice versa is testified by the many rare signs that find no place in sign lists; after all, 'le système est thèoriquement ouvert, et peut accueillir comme signe n'importe quelle image' (Vernus 1985: 46).

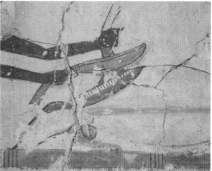

Figure 1a-b: Hieroglyphic sign with knife (Gardiner T30) on joint of meat (Gardiner F44). From a pillar in TT95, Sheikh Abd el-Qurna (left). A visually corresponding representation of butchering from TT84, dated to the reigns of Thutmose III and Amenhotep II, Sheikh Abd el-Qurna. (Images by the author; copyright University of Basel)

The first case in point (fig. 1a) is a hieroglyph found on a pillar in TT95 (dating to the reign of Amenhotep II), showing a composition not otherwise attested: a knife on top of a joint of meat. The meaning of the sign is still not completely understood (the epigraphy in TT95 is currently under investigation by J. K. Paksi); yet, even if its linguistic value remains elusive, a

direct visual parallel can be found in the scenes of other 18th Dynasty tombs showing officiants butchering an ox (fig. 1b). In looking for better ways to express and precise the meaning of the text, scribe-painters do not need to look too far: they can easily find inspiration in the figurative representations that surround them, and with which they were clearly familiar. In addition, the osmosis between written and figurative representation is evident in the rendition of the ox, which a beige line divides in two, just as the bone bisects the joint of meat in the hieroglyphic version.

The impressive pictorial value of the script, however, comes best to light in the extremely delicate and detailed execution of polychrome hieroglyphs, preserved in many 18th Dynasty Theban tombs. This careful execution makes them almost indistinguishable from their larger-scale counterparts in 'proper' figurative art.

Only an artist, as Nina de Garis Davies, could think of giving proper credit to the artistic value of hieroglyphs, after having spent much time copying them and trying to reproduce on paper the finesse and the brilliance of the ancient signs. In a book just as programmatically titled as Wilkinson's, *Picture Writing in Ancient Egypt* (Davies 1958), she collected many examples of polychrome hieroglyphs and compared them with figurative scenes, in order to show the outstanding quality of the signs and their strict relationship with the rest of the tomb art. Many more instances could enlarge her collection: the examples from TT82, presented in figure 2, are enlightening from this point of view.

Figure 2a-c: Gardiner signs F63 (left) and F1 (centre) and their corresponding rendition in a figurative scene (right). From TT82, reigns of Hatshepsut-Thutmose III, Sheikh Abd el-Qurna. (Images by the author; copyright University of Basel)

If not for the context, it would be a struggle to recognise which of the three ox heads are supposedly 'writing' and which 'art'. The signs themselves (fig. 2a-b) undergo the same treatment as the corresponding picture: changes in

colours, in the shape and details of the ear, presence or lack of horns. The painter has the same freedom in the rendition of the sign as in the larger-scale scene (fig. 2c); the only limit to their creativity might be the lack of space, but even this observation is debatable if considering what might be called 'miniature' hieroglyphs.

Present in tombs such as TT295 and TT121, these tiny signs display the same amount of detail expected from polychrome hieroglyphs, but within a much-reduced space, attesting to the remarkable skill of ancient painters. One example (fig. 3a) is the sign Gardiner L2 from TT295 (dating to the reign of Thutmose IV, in el-Khokha).

Figure 3a–b: Gardiner L2, representing a bee, from TT295 (left) and TT95 (right). The hieroglyph from TT295 measures only 3.5 x 3 cm, wherefore it is defined as a 'miniature hieroglyph', in comparison to the example from TT95, measuring 10 x 10 cm. (Images by the author, copyright University of Basel)

In these instances, the artist was able to condense the same incredible expertise seen in the L2 sign from TT95 to one third of the space. In TT295 this choice may have been caused by lack of space; however, this would not have been an issue in TT121 (dated to the reign of Thutmose III, in Sheikh Abd el-Qurna). This type of virtuoso execution shows clear artistic intent and pride: in TT121, for example, even offering lists display these small polychrome signs (again not always included in 'official' sign-lists), whereas in most of the tombs the signs would be simply blue or red (other rare examples of polychrome sign-lists are found in TT82 and TT85).

However, the era of writing as art ended with the transition to the 19th Dynasty. Polychrome, refined hieroglyphs became unfashionable, and

whenever they are present, they reflect an uncertainty of use or simply a lack of attention. Elegant picture writing disappears almost completely: very rare cases feature after the reign of Ramesses II, such as in the tomb of Hori (TT259, 20th Dynasty). The tomb-owner may in this case have decided to employ the graceful writing style specifically because he was a scribe. Yet though some of the signs still display a certain quality, even the correct proportions appear difficult to achieve. The example in figure 4, from TT259, shows a curiously long-bodied man, whose torso seems to have been adjusted, and whose legs seem to be too long considering his sitting position. The arms are quite unnaturally long as well, as they try to keep up with the rest of the body, while the eye is but a line of black paint – the whole effect seeming much stylised.

Figure 4: Gardiner A2 sign from TT259, 20th Dynasty, Sheikh Abd el-Qurna. (Image by the author, copyright University of Basel)

The inscriptions in most of the other tombs of the period tend to be more and more cursive and simplified. In place of a full colour palette, painters start to use a reduced number of colours for parts of the text, red, blue, green and sometimes white, while the biggest part appears in simple, cursive black hieroglyphs (see many examples in the plates from Hofmann 2004). Ramesside painters therefore seem to have focused more on the large narrative, figurative scenes, which absorb all the brilliant colours and details. This shift clearly reflects a change in the concept of the tomb decoration – accompanied maybe also by a change in aesthetic values (and perhaps even in the abilities, or training, of the painters) –, and brings about an apparent break in the relationship between the two modalities of representation.

Hieroglyphs in art

In this turn of (visual) events, painters found another way to take advantage and show their knowledge of the pictorial value of the script and make the two representational systems interact. 'Hieroglyphs' began to fill the walls and fit into the decoration as fully-fledged figurative elements, even as whole friezes. Visually speaking, it seems as if the realm of the 'written' invades the realm of the 'figurative', via the omnipresence of *djed* pillars, *tjet* knots, Anubis jackals and so on.

Of course, the insertion of 'hieroglyphic signs' in a scene was nothing new and is noticeable already in 18th Dynasty tombs. In the Ramesside period, however, this trend evolved and became much stronger, as a proliferation of hieroglyphic elements were inserted within the decoration. This iconographic expedient allowed for the condensation of a larger amount of meaning and of increasingly complex theological concepts.

This growing complexity is attested, for example, by the fact that the classic *ḥkr*-frieze gives way to cryptographic friezes in many Theban tombs (TT51, TT178, TT296), e.g. the one shown in figure 5.

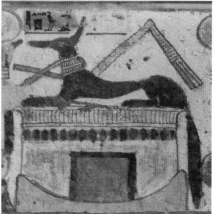

Figure 5a–b: Details of a cryptographic frieze from the tomb of Userhat (TT51, reign of Seti I, Sheikh Abd el-Qurna), showing Hathor's face on Gardiner V30 and N24 signs (left) alternated with the emblem of Anubis on Gardiner N26 sign (right). (Images by the author, copyright University of Basel)

Perfectly fused with the rest of the decoration, a second layer of meaning underlies the figure of the jackal (fig. 5b), as the shrine of secrets on which it is resting fits into the curve made by two mountaintops, a composition that

directly recalls the epithet of the god as '*tp.y-ḏw*'. The same goes for the face of the goddess Hathor, perfectly rendered with all the details of her crown and feathers; the linguistic meaning is only subtly added, with the basket (phonogram *nb*) and the water canal (phonogram *spꜣ.t*) acting as a capital-like base, while spelling the epithet of Hathor as 'Lady of the district'. The epithet itself, however, is as common in tomb decoration as rare in written attestations (Leitz 2002: 126).

Figure 6: Emblematic representation of the necropolis in TT259. (Image by the author, copyright University of Basel)

Finally, the case of the necropolis representation as a supposedly hieroglyphic sign in figure 6 is emblematic in more than in one sense of the word. In one sign list (Grimal et al. 2000: 1 G-2) can be found a similar sign (G131). However, as can be seen in TT259, the painter exchanged the standard with the hieroglyph for 'West' and added a beer jug and a bread on the hilltop; due to the incomplete preservation of the scene, it is uncertain whether a butcher's block was present on the left. It is instinctively recognisable as a hieroglyph because its single components are elements that can be identified as hieroglyphs: the falcon, the hilltops, and the sign for 'West', Gardiner R14. Nevertheless, these elements are manipulated through the artist's knowledge and intent. In fact, no matter how familiar

it might seem, the composition represented in this tomb is absent from any extended sign-list, which suggests it is not found in texts (it is instead present in vignettes of the Book of the Dead papyri, such as the papyrus of Ani, BM 10470, cf. Faulkner 1985: 39). Consequently, it would be legitimate to wonder whether it was invented specifically for the sake of the pictorial decoration and not to be used in an inscription. Either way, this once again underscores the pictorial value of the script, which can be promptly adapted to fit in a figurative narration, bringing with it an additional layer of linguistic meaning. At the same time, it shows once again that hieroglyphs are not fixed, but can be easily altered by knowledgeable people, while still being able to convey the message to those that knew the code.

Conclusions

The relationship between visual and linguistic value in any type of Egyptian pictorial context is by no means easy to define – it is fluid and always evolving. Nonetheless, what stays firm is the fact that hieroglyphs, be they part of a text or of a figurative scene, are not as fixed as it seems at a first glance: just like any other picture, by virtue of their pictoriality they can be modified according to the necessities of the rest of the decoration.

Besides, that specific signs are distinctly recognisable within the figurative narration does not indicate that the linguistic component was predominant over the visual one, nor that it was the only focus of the painter's attention. In the case of polychrome hieroglyphs, the care taken for every single sign, the finesse of the brush lines of the miniature hieroglyphs, all the little details that differentiate one picture from the other – no matter how standardised the repertoire might have been – demonstrate that the visual component was actually highly regarded. It is exactly in this field that Egyptian painters could express pride in their work as skilled artists, letting a specific intent come to light in the smallest of changes.

The case studies outlined in this paper were only some of a larger number of examples, collected for the sake of ongoing research that aims, on one side, at developing a methodology to analyse the different approaches of ancient Egyptian artists to pictorial material. On a secondary level, the focus lies on the interrelationship of written and visual representation in order to establish the horizons of formality and freedom that delimited Egyptian painters (or not).

What appears from the study of these first instances, however, is that Egyptian artists – whether they 'wrote' or 'represented' – were far from

adopting static rules. On the contrary, they had much to offer to the viewer who, like Voltaire's Zadig, had trained his eyes to 'une sagacité qui lui découvrait mille différences où les autres hommes ne voient rien que d'uniforme'.

Bibliography

Allen, J. P. 2015. Middle Egyptian (3rd ed.). Cambridge: Cambridge University Press.

Assmann, J. 2004. 'Die Frühzeit des Bildes – der altägyptische Iconic Turn', in C. Maar and H. Burda (eds), Iconic Turn: Die neue Macht der Bilder. Köln: DuMont, 304-22.

Baines, J. 2007. Visual and Written Culture in Ancient Egypt. Oxford: Oxford University Press.

Davies, N. M. 1958. Picture Writing in Ancient Egypt. London: Oxford University Press.

Faulkner, R. O. 1985. The Ancient Egyptian Book of the Dead. London: British Museum.

Faulkner, R. O. 1991. A Concise Dictionary of Middle Egyptian. Oxford: Griffith Institute.

Grimal, P., Hallof, J., and van der Plas, D. (eds). 2000. Hieroglyphica (2nd ed.). Utrecht/Paris: Centre for Computer-aided Egyptological Research.

Hofmann, E. 2004. Bilder im Wandel: Die Kunst der Ramessidischen Privatgräber. Mainz: Philipp von Zabern.

Hornung, E. 1989. 'Hieroglyphs: Signs and art', in I. Lavin (ed.), World Art: Themes of Unity in Diversity, II. University Park: The Pennsylvania State University Press, 275-82.

Jonas, H. 1961. 'Homo Pictor und die Differentia des Menschen', Zeitschrift für philosophische Forschung 15(2): 161-76.

Leitz, C. (ed.). 2002. Lexikon der ägyptischen Götter und Götterbezeichnungen, IV. Leuven: Peeters.

Mitchell, W. J. T. 1984. 'What is an image?', New Literary History 15(3): 503-37.

Thesaurus Linguae Aegyptiae. 2014. Available at: http://aaew.bbaw.de/tla/index.html [last accessed 20 October 2018].

Vernus, P. 1985. 'Des relations entre textes et représentations dans l'Egypte pharaonique', in A-M. Christin (ed.), Écritures, II. Paris: Le Sycomore, 45-66.

Wilkinson, R. H. 1992. Reading Egyptian Art. London: Thames and Hudson.

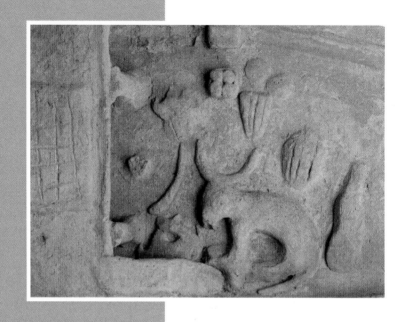

Gardens and agricultural elements in soul houses

Marisol Solchaga
University of Manchester / Universidad Autònoma de Madrid

The topic for this paper is the presence of gardens and agricultural elements in soul houses. This study is part of the author's ongoing PhD research, which aims to analyse soul houses as material traces of the encounter between the living and the dead in cemeteries of the Middle Kingdom.

The term 'soul house' was coined by William Matthew Flinders Petrie to describe clay trays with architectural elements found throughout Egypt. These fired clay models could take many forms: from basic offering-trays, replica houses with domestic features, to cult chapels. All known examples date to the Middle Kingdom (c. 2025-1700 BC). In 1906, Petrie discovered roughly 150 soul houses and offering-trays during excavations at the cemetery of Rifeh in Middle Egypt (Petrie 1907). These soul houses had been placed at the surface of simple tombs with no superstructure. Petrie used consecutive letters A to N to classify these objects. A was used for the objects he considered to be the earliest form, N the latest. Petrie (1907) argued that the earliest examples contained simple shelters at the back of the tray, whereas the later examples were representations of real houses with several rooms, floors, windows and furniture. An example of each type was sent to Manchester Museum forming the type collection held at the Museum today.

Whereas the function of modelled meats, vegetables and bread sculpted in the trays is well understood as offerings for the deceased that are activated through the libation process, the presence of square grid gardens has not yet been fully explored. Information about these gardens comes from depictions in paintings and carved reliefs on tomb and temple walls, as well as archaeological discoveries. This paper aims to show how soul houses also provide a resource for studying these gardens.

In ancient Egypt, rectangular beds surrounded by small dykes for holding water were used for planting. The purpose of this form was to create a system of earthen dykes to retain water and to facilitate the cultivation of crops. These gardens are archaeologically attested in the fortresses of Mirgissa and Buhen, and at Tell el-Daba (Wilkinson 1994; Dunham 1967; Randall-MacIver 1911). As Carroll (2003) states, in Egypt plants relied solely on the

water that was brought to them, there was almost no rain, so in such places narrow straight paths enabled gardeners to walk between a series of grids, and from there they could lean across to water or weed the beds.

Garden grids not only played an important role in the agrarian economy supplying the population with essential products, it was also associated with luxury and leisure as well as divine blessing and fertility (Wilkinson 1994: 12). There is a cult connected to the fertility of crops with two main deities associated with this aspect: Min and Osiris (Hugonot 1989; Wilkinson 1994; Carroll 2003). An example of the fertility cult from the Middle Kingdom, and therefore contemporary with the soul houses, is the White Chapel of Senwosret I, now reconstructed in the Karnak Open Air Museum. In this chapel, the fertility cult associated with the god Min plays an important role and therefore includes depictions of Senwosret I giving offerings to this god (Lacau and Chevrier 1969). Min wears a crown with two tall plumes and carries a flail. The flail represents his role in agriculture and horticulture. Behind Min is a symbol of fertility associated with this god: three cos lettuces planted in the so-called square grid garden (Hugonot 1989; Wilkinson 1994: 3).

The garden is thus both a method of food production and a symbol of fertility. Considering these dual aspects, it is unsurprising that depictions of gardens played a significant role in tomb paintings and reliefs. The earliest evidence of grid gardens is found in the 6th Dynasty private tomb of Mereruka at Saqqara. The relief shows gardeners carrying water pots suspended on a yoke for the irrigation of a grid of square beds (Janick 2002; Carroll 2003: 12).

A series of reliefs from the Middle Kingdom decorated tombs at Beni Hasan and el-Bersheh show more of these square grid vegetable beds (Farrar 2016: 11). In the tomb of Khnumhotep II at Beni Hasan two gardeners, again water carriers, approach square vegetable beds to water plants (Kanawati and Evans 2014: 39). At the tomb of Djehutihotep II at el-Bersheh, gardeners again water square plant beds (Newberry 1895: 34, pl. XXVI). To the right of the garden in all three scenes there is a depiction of a cos lettuce with three large leaves representing the god Min. Carroll (2003: 12) argues that the garden owner was hoping that the god would help this crop and part of it would have been dedicated to the god as a ritual offering. The fact that this is represented within a tomb emphasises the role of fertility and regeneration. These scenes painted and carved on tomb walls represent everyday life with the intention of continuing their existence into eternity for the benefit of the deceased and to be provided with food production, shade and refreshment.

The dichotomy of the function of these gardens between providers of offerings for the deceased as well as the association with fertility and regeneration could explain the recent discovery at Dra Abu el-Naga of a funerary garden in a 12th Dynasty tomb courtyard. Some of the square grids in the newly discovered garden contained seeds that allow the identification of the plants once grown there, many of which held particular religious significance. Research is still ongoing, but some species have been identified, such as coriander, non-sweet melon and certain flowers. Next to the garden, the trunk of a tamarisk was still upright (Galán and García 2019). There are three main reasons that could explain the presence of this type of tree next to the garden: its association with the god Osiris and, therefore, regeneration; the religious belief that the *ba* of the deceased would live on a branch of this tree; and finally, the practical function of providing shade to the garden. As can be seen, gardens could perform multiple functions in a funerary context: as a place for offerings, as a metaphor for regeneration, as well as representing the symbols and beliefs of the ancient Egyptians in relation to fertility cults.

As mentioned, gardens also represented luxury and reflected the status of the tomb owner, who, in a hostile environment such as the desert, was able to ensure that someone would maintain and water the garden (Hugonot 1989: 170; Wilkinson 1998: 12).

The garden found in the courtyard of the Dra Abu el-Naga tomb represents a miniaturisation of a produce garden, with the same form, a square grid garden, but has a different function: as a place to produce offerings, pleasure, opulence and regeneration for the deceased. It is this function that could explain its presence in soul houses. To be provided with a garden in a tomb for the benefit of the deceased was a desire well-attested in Egyptian literature. Hence, it is not surprising that the material and size of the garden would vary depending on the personal wealth of the tomb owner.

Whereas the garden in a tomb courtyard is a miniaturisation of a produce garden with the same form but different meaning, the gardens represented in soul houses are models of tomb gardens with no real plants and vegetation. This research distinguishes between miniature and models, as the latter does not represent the real material in its representation. The gardens in soul houses represent the model of a physical manifestation of a real garden in the tomb. Hence, these gardens, modelled in clay and attached to the tray, would have the same function as the modelled clay food presented in the courtyard of the soul houses: to provide offerings for the wellbeing of the deceased. The benefits of the offerings and garden depicted in the soul houses would

be activated though the process of libation. Libations poured over the object would have activated the magic (*heka*) of the object (David 2008).

Soul houses were hand-built of Nile silt clay and probably assembled by pressing and pinching together rolled out flat slabs of clay manipulated into shape. Their simplicity of manufacture would have made them more accessible to a population who, not having the possibility of building a tomb superstructure with all the requirements for the afterlife, could create cheaper versions as models. Therefore, soul houses, by depicting models of architectural elements, models of food, and sometimes furniture, and models of gardens, were intended to assure that the deceased would enjoy these benefits in the afterlife. Some of the soul houses found by Petrie at Rifeh depict gardens in the courtyard, see for example MM4371 (fig. 1), which represents a model of a square grid garden placed in the spout. The three columns in the courtyard would actually indicate tree trunks, as shown in a drawing of a soul house from Edfu (Kuentz 1981; Hugonot 1989: 194-5).

Figure 1: MM4371. (Image by the author, copyright Manchester Museum)

As stated above, the garden in the soul house acts as a model which, unlike miniature gardens at tombs, may or may not represent a reality. It is in this sense that the representation of a roof-garden should be understood, such as the soul house ANT E.15.1950 (fig. 2) held at the Fitzwilliam Museum (this artefact, although not published in the report, is thought to come from Rifeh). The meaning of the garden in the soul houses should not necessarily

be understood as a reflection of reality simply because it is recognisable as such. As Hugonot (1989) argues, the garden is a microcosm. It represents production, fertility, protection and security as opposed to the hostility of the desert. It depicts a place of shade and refreshment where the deceased would return to earth. The depiction of roof-gardens in the soul houses might also have had a ritual function, but this research is still ongoing.

Finally, the representation of models of square grid gardens can also be attested in a specific type of pottery trays which have been classified by Angela Tooley (1989: 249) in her PhD thesis as 'field-form' because of their square shape divided into sections. These models have sometimes been interpreted as trays with different compartments to make offerings (Legros 2016). However, this research demonstrates that these actually represent square grid gardens (see also Kuentz 1981). One of the reasons for interpreting these trays as gardens is the existence of small holes through which water would run into different compartments. Carter (1912) found a

Figure 2: ANT E.15.1950. (Image: Fitzwilliam Museum, Cambridge)

field-form tray during his excavations in Asasif. This tray is now on display at Cairo Museum (inventory number unknown). Unfortunately, the poor restoration of this tray has covered up the holes in two of the sections, thus losing some of the object's meaning. Further examples of field-form trays include UC18269 (fig. 3) found at Qurneh by Petrie (1909) and now held at the Petrie Museum of Egyptian Archaeology, University College London.

Square grid gardens are an important element when it comes to understanding soul houses and pottery offering trays. The aim of this ongoing research is to shed further light upon these artefacts through a holistic approach in order to understand soul houses and to frame them within their historical context, the Middle Kingdom.

Figure 3: UC 18269. (Image by the author, copyright Petrie Museum of Egyptian Archaeology, UCL)

Acknowledgements

The author would like to thank Dr José Manuel Galán and Dr Campbell Price for their comments and suggestions provided for this paper. She is also grateful to Dr Lubica Hudakova and her team for the creation of the Meketre Project, the online repository of Middle Kingdom scenes: http://meketre.org/

Bibliography

Bietak, M. 1996. Avaris: The Capital of the Hyksos: Recent Excavations. London: The British Museum Press.

Carroll, M. 2003. Earthly Paradises: Ancient Gardens in History and Archaeology. London: The British Museum Press.

David, R. 2002. Religion and Magic in Ancient Egypt. London: Penguin.

Farrar, L. 2016. Gardens and Gardeners of the Ancient World: History, Myth and Archaeology. Oxford: Windgather Press.

Galán, J. M. and García, D. 2019. 'Twelfth Dynasty funerary gardens in Thebes', Egyptian Archaeology 54: 4–8.

Hugonot, J. C. 1989. Le jardin dans l'Égypte ancienne. Frankfurt a. M.: Peter Lang.

Janick, J. 2002. 'Ancient Egyptian agriculture and the origins of horticulture', Acta horticulturae 582: 23–39.

Kuentz, C. 1981. 'Bassins et tables d'offrandes', BIFAO 81: 243–82.

Lacau, P. and Chevrier, H. 1969. Une chapelle de Sesostris I a Karnak. Cairo: Service des Antiquities.

Legros, R. 2016. Stratégies mémorielles. Les cultes funéraires privés en Égypte ancienne de la VIe à la XIIe dynastie. Lyon: Maison de l'Orient et de la Méditerranée-Jean Pouilloux.

Petrie, W. M. F. 1907. Gizeh and Rifeh. London: British School of Archaeology in Egypt.

Petrie, W. M. F. 1909. Qurneh. London: British School of Archaeology in Egypt.

Randall-MacIver, D. 1911. Buhen. Philadelphia: University of Pennsylvania.

Tooley, A. 1989. Middle Kingdom burial customs: A study of wooden and related material. PhD Thesis, University of Liverpool, UK.

Wilkinson, A. 1998. The Garden in Ancient Egypt. London: The Rubicon Press.

Wilkinson, A. 1994. 'Symbolism and design in ancient Egyptian gardens', Garden History 22: 1–17.

Changing faces: the revising of three images of Seth

Ian Taylor
Independent researcher

When investigating the carved images of the god Seth, whether on temple walls or on a stela, it is normal to find that they have been defaced or damaged at some time in antiquity. However, during research into the variations in the representations of the images of Seth, three reliefs were discovered that display evidence of re-carving sometime after the initial image had been produced. The three images were all of Seth in biomorphic form and dated from the 18th, 19th and 27th Dynasties, respectively. Two of the images are located in the Nile valley, on the west bank at Medinet Habu and on the east bank at Karnak Temple, while the third is located in the Western Desert in Hibis Temple (fig. 1).

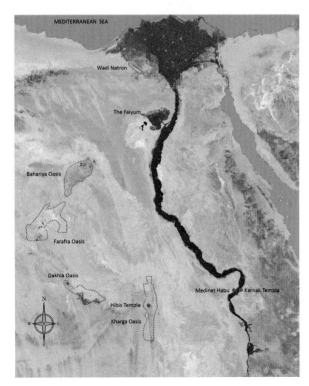

Figure 1: Location of the three re-carved images of Seth. (Image by the author, after Google Earth)

Medinet Habu

Dealing with the images in chronological order, the first image, dating to the 18th Dynasty, is located in the Small Temple built by Hatshepsut and Thutmose III that was later incorporated into the 20th Dynasty Medinet Habu temple and palace complex of Ramesses III. The image is located on the western face of a pier on the northern side of the ambulatory around the barque shrine enclosure (fig. 2).

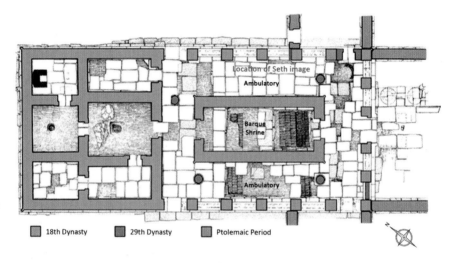

Figure 2: Location of Seth image in the 18th Dynasty Small Temple, Medinet Habu. (Image by the author, after Hölscher 1939: pl. 2)

The image, in incised relief, depicts Seth in bimorphic form wearing a tripartite wig and holding Thutmose III by the hand while placing three *ankhs* representing eternal life into a bowl held in Thutmose III's other hand. Seth is identified by the epithet 'Lord of the land of the south, Lord of the sky' (fig. 3).

On close inspection of the relief there is evidence that the image of Seth has suffered damage and has later been restored by re-carving. The faint outline of a forehead, ears, shoulder, tripartite wig, leg and two feet with a ground line from another earlier image are visible. The re-carved image is not located in exactly the same position, as indicated by the fact that the remains of an earlier outline are still visible and the feet of the new image do not align with the base line of either the removed image and that of the undamaged image of Thutmose III. In addition, the surface of the stone

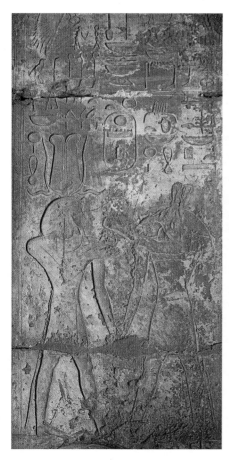

Figure 4: Seth relief outlined in black with the remains of an earlier image outlined in red. (Image by the author)

Figure 3: Seth giving life to Thutmose III, ambulatory, Small Temple at Medinet Habu. (Image by the author)

where the Seth image is carved is slightly concave suggesting the removal of the original surface along with the image on it, while the depth of the re-carved Seth is shallower and less rounded or three-dimensionally defined than that of the adjacent image of Thutmose III (fig. 4). The most likely scenario is that the image of Seth was defaced during the Amarna heresy, the same applying to those in the mortuary temple of Hatshepsut at Deir el-Bahri with the image being later restored under the Ramessides (Ćwiek 2008: 46), when it was re-carved in a slightly different pose to the original figure. A later defacement of the head of Seth and the part of the text relating to him occurred at the same time as the damage to Thutmose III's face, possibly during the Coptic Period. If this is the case, then what is now visible is a Thutmosid scene overlain with a Ramesside image of Seth.

Karnak Temple

The second image is located in the Karnak temple. The image is carved in shallow bas-relief on the north end of the west wall of the 19th Dynasty Hypostyle Hall built and decorated by Seti I and his son Ramesses II (fig. 5).

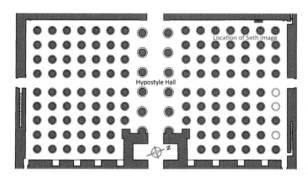

Figure 5: Location of the Seth image in the 19th Dynasty Hypostyle Hall, Karnak. (Image by the author after Nelson 1941: pl. III)

The image of Seth is part of a scene depicting the purification of the pharaoh, often incorrectly called the baptism of the pharaoh, depicting Horus and Seth, both in bimorphic form, pouring a stream of *ankh* hieroglyphs over the standing pharaoh (fig. 6). Examination of Seth's head has found indications that there had been an element of re-carving to the eye, muzzle and leading ear. The earlier original line of the head was much more rounded, running smoothly into the tripartite wig, no eyebrow over the eye and a straighter front edge to the secondary ear. The curvature of the muzzle was revised to form a tighter curve with brow ridge over the eye and the top of the head adjusted to run straight into the base of the lead ear. A new eye was carved below the original eye which was changed into an eyebrow, though part of the lower section of the eye was left *in situ*. A nasal ridge was added to the muzzle following its new line. The front edge of the tripartite wig was adjusted to meet the new line of the head, and finally the front edge of the leading ear was cut back to a shallow curve (fig. 7).

Why and when this alteration took place is unknown, but it is possible that the revision occurred during the reign of Seti I or possibly early in the reign of Ramesses II during the completion of his father's works to the Hypostyle Hall. Whatever the reason for the change, what is significant is that the revisions were obviously approved and no further attempt at re-carving or repairs were made. To date no other comments or observations on this re-carving of Seth's features have been suggested.

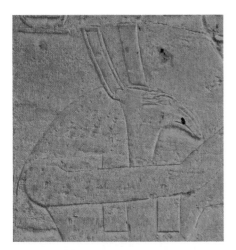

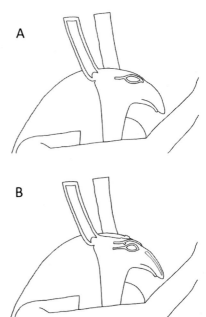

Figure 6: Head of Seth from the scene of ritual purification of Seti I, showing evidence of alterations to the eye, muzzle and secondary ear. (Image by the author)

Figure 7: A: the suggested restored original shape of head and ears. B: revised line of the head, new eye added with old eye altered to form an eyebrow, nasal ridge added and lead ear shape changed to have a curved leading edge. (Image by the author)

Hibis Temple

The third image of Seth occurs in the Temple of Amun at Hibis, the ancient administrative capital of Kharga Oasis, the southernmost of the Western Desert oases. The image is located at the north end of the east face of the 26th Dynasty wall that forms the west end of the later 29th Dynasty Hypostyle Hall (fig. 8).

The current relief in heavy bas-relief is of a bimorphic Seth spearing the serpent Apep on which he is standing. In this instance, Seth is not portrayed with his regular animal head but that of a hawk, a representation prevalent in the oases from the around the 25th Dynasty (Taylor 2017: 140) (fig. 9). The register above the image refers to 'Setekh, great of strength, great god in the midst of Hebet (Hibis)' (fig. 10).

The text register identifying Seth is in the same style of shallow incised relief that matches that of the hieroglyphs in the cartouche of the pharaoh

Darius (von Beckerath 1984: 220-1) and of the adjoining scenes so it can be concluded that they are of a comparable date. However, the relief of Seth is different in form and style of execution to the adjoining reliefs, being carved in a deep bas-relief with the background to the relief being cut back a minimum of 15 mm from the surface of the wall while the bas-relief

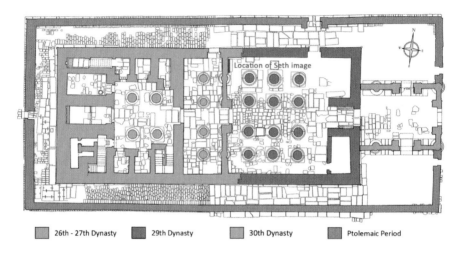

| 26th - 27th Dynasty | 29th Dynasty | 30th Dynasty | Ptolemaic Period |

Figure 8: Location of the Seth image in the temple of Amun at Hibis in the Kharga oasis. (Image by the author after Winlock 1941: pl. XXXIII)

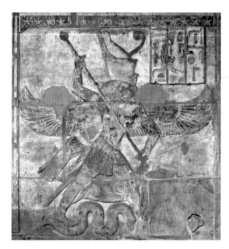

Figure 9: The hawk-headed Seth spearing the serpent Apep. (Image by the author)

Figure 10: Incised hieroglyphs in the top right-hand corner of the image of Seth in fig. 9. (Image by the author)

projects a maximum of 10 mm from the back face (fig. 11) compared to the adjacent images which are carved in a shallow incised relief to a maximum depth of 5 mm, suggesting it is a later re-carving of an earlier relief and confirming Davis' suggestion that it is not the one originally carved in the 27th Dynasty during the reign of Darius I or II (Davis 1953: 23).

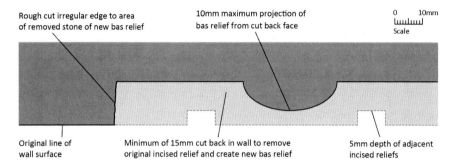

Figure 11: Sketch showing the extent of the removal of original incised relief and wall surface to re-carve the image of Seth in bas-relief. (Image by the author)

Carving the image in bas-relief removed all evidence of the earlier incised relief, with no remains of the incised cuts marring the high points of the later bas relief. It is worth noting that the vertical and horizontal cut edge of the bas relief was roughly cut with an irregular external arris with sections not projecting at right angles to the face of the wall but rather a few degrees beyond the right angle giving a battered edge sloping towards the back of the relief. Where the stone has been cut back along the base of the accompanying text there is no guide line as with the surround to outer edges of the relief, which resulted in an irregular cut line, with the left-hand end of the cut impinging into the last hieroglyph (fig. 12). This roughly cut edge was also left as raw stone with no form of decoration (fig. 13).

These observations support the suggestion that an incised relief of Seth dating to the time of Darius I or II was re-carved in bas-relief at a later date, with only the identifying incised hieroglyphs remaining untouched. A further comparison of the representation of the body of the hawk-headed bimorphic Seth relief with those of a hawk-headed bimorphic Horus carved on the adjacent wall in the temple and those from the Ptolemaic Period reveal that the Seth figure bears several similarities to the Ptolemaic figures (fig. 14).

The modelling of the Seth figure with a more detailed rounded muscular appearance (Robins 1994: 257-8) was more in keeping with the Ptolemaic

Figure 12: Line of roughly cut back stone along the bottom of the accompanying hieroglyphs, showing damage to the bottom edge of the lowest hieroglyph. (Image by the author)

Figure 13: Roughly cut back stone along the top edge and side of the bas-relief, exhibiting a poor-quality finish and lack of decoration. (Image by the author)

A B C

Figure 14: A: incised relief of Horus adjacent to the Seth relief from the Hibis temple, attributed to reign of Darius I or II. B: bas-relief of Seth from the Hibis temple (background hawk and lion greyed out to show the Seth figure more clearly). C: bas-relief of Horus from the Ptolemaic Temple of Horus and Sobek at Kom Ombo. (Images by the author)

images and differed considerably from the slim gracile image of the Hibis temple Horus. In addition, Seth was depicted wearing a kilt with vertical pleating with a convex curve on the line of the buttocks, as well as wearing bicep and wrist bracelets with horizontal and vertical decoration, the same as the Ptolemaic images as opposed to the straight radial kilt pleating and the lack of arm jewellery of the Hibis Horus. Of all the reliefs found within the temple, Seth is the only one portrayed wearing a *Königsjacke*, which enjoyed a resurgence during the Ptolemaic Period and continued to be employed in reliefs through to the Roman Period (Borchardt 1933: 17).

The unusual composition of the humanoid figure superimposed over the body of a bird displaying outspread wings giving the appearance that the figure has wings and tail should also be noted. A small sandstone stela, E21160 in the Louvre, dated to the Ptolemaic Period is carved in bas-relief and depicts a standing anthropomorphic figure wearing an *atef* crown and a *nemes* headdress superimposed over the body, tail and outspread wings of a hawk in a style very similar to that employed on the Seth relief (fig. 15).

Figure 15: Ptolemaic stela E21160, Musée du Louvre. (Image by the author)

Finally, the size, style, format and content of the Seth register is noticeably different to those on the rest of the wall. It fails to depict the pharaoh or refer to him, instead it contains only the figures of Seth and Apep. As discussed by Kaper, the representation of Seth killing Apep had considerable importance in the oases (Kaper 1997: 210; 1999: 70-3; 2002:

215). It is the author's proposition that the panel did originally contain a similar scene but at a smaller scale and one in keeping with shallow incised images as the adjacent reliefs (fig. 16).

From the analysis of the Seth image it was most likely re-carved during the Ptolemaic Period, possibly during the works undertaken by Ptolemy II or Ptolemy III (Winlock 1941: 57). In the oases, a series of fragile fertile eco-systems in the desert that could easily be destroyed or damaged by desert storms, Seth the desert deity was treated with reverence throughout Egyptian

Fig. 16: Layout of the reliefs on the north end of the west wall of the Hypostyle Hall in Hibis temple showing the Seth image.

A: Existing re-carved Seth image. (Image by the author after Winlock 1941: pl. XXXIX; Davies 1953: pls 39, 41, 42)

B: Hypothetical layout showing a possible image of Seth killing Apep before Amun in keeping with the scale of the adjacent reliefs (Image by the author after Winlock 1941: pl. XXXIX; and Davies 1953: pls 39, 41, 42)

history including the Roman Period (Taylor 2017: 394, 396). However, the Ptolemaic Period saw the introduction of the new god Amun-Nakht, an assimilation of Amun-Ra and Horus, into the oases in an attempt to oust Seth (Arnold 1999: 246; Kaper 2004: 136-7). It is feasible that the Hibis image was re-carved in a larger and more imposing form as a rejection of the forced intrusion of Amun-Nakht and a reaffirmation of Seth worship in the oases.

Conclusion

The research into the variations in the representation of Seth highlighted three images of the god Seth that had been subjected to re-carving. The first image in the 18th Dynasty Small Temple at Medinet Habu was defaced, possibly during the Amarna Period, and subsequently re-carved in the 19th Dynasty. The second image in the 19th Dynasty Hypostyle Hall in Karnak Temple endured an artistic change in the interpretation of the image of Seth resulting in the re-carving of part of the head. The third image in the 26-27th Dynasty temple at Hibis was a Ptolemaic removal and recarving of an earlier image, leaving only the identifying text register. The new image was carved in bas-relief style and the image was made larger than the shallow incised adjacent reliefs, making the whole of the register larger as a reaffirmation of the strength of Seth worship in the oases of the Western Desert. The size of the image could also demonstrate an emphatic rejection of Amun-Nakht who was introduced into the oases in order to supplant Seth at this time.

Bibliography

Arnold, D. 1999. Temples of the Last Pharaohs. Oxford: Oxford University Press.

Borchardt, L. 1933. 'Die Königsjacke', in L. Borchardt (ed.), Allerhand Kleinigkeiten. Leipzig: Privatdruck, 13-18.

Ćwiek, A. 2008. 'The fate of Seth in the Temple of Hatshepsut at Deir el-Bahari', Etudes et Travaux XII: 38-60.

Davis, N. D. G. 1953. The Temple of Hibis in El Khargheh Oasis, Part III: The Decoration. New York: The Metropolitan Museum of Art.

Hölscher, U. 1939. The Temples of the Eighteenth Dynasty. Chicago: University of Chicago Press.

Kaper, O. E. 1997. 'A painting of the gods of Dekhla in the Temple of Ismant el-Kharab', in S. Quirke (ed.), The Temple in Ancient Egypt: New Discoveries and Recent Research. London: The British Museum Press, 204-15.

Kaper, O. E. 1999. 'Epigraphy at Ismant el-Kharab 1992-1994: Interim observations', in C. A. Hope and A. J. Mills (eds), Dakhleh Oasis Project: Preliminary Reports on the 1992-1993 and the 1993-1994 Field Seasons. Oxford: Oxbow, 69-74.

Kaper, O. E. 2002. 'A group of priestly Dipinti in Shrine IV at Ismant el-Kharab', in C. A. Hope and G. E. Bowen (eds), Dakhleh Oasis Project: Preliminary Reports on the 1994-1995 to 1998-1999 Field Seasons, Oxford: Oxbow Books, 209-16.

Kaper, O. E. 2004. 'Conferences de M. Olaf E. Kaper', École pratique des hautes études, Section des sciences religieuses. Annuaire 113: 135-9.

Nelson, H. H. 1941. Key Plans Showing Locations of Theban Temple Decorations. Chicago: University of Chicago Press.

Taylor, I. R. 2017. Deconstructing the Iconography of the God Seth. PhD Thesis, University of Birmingham, UK. Available at: http://etheses.bham.ac.uk/7714/ [last accessed 14 August 2019].

Von Beckerath, J. 1984. Handbuch der ägyptischen Königsnamen. Mainz: von Zabern.

Winlock, H. E. 1941. The Temple of Hibis in El Khargheh Oasis. Part I: The Excavations. New York: The Metropolitan Museum of Art.

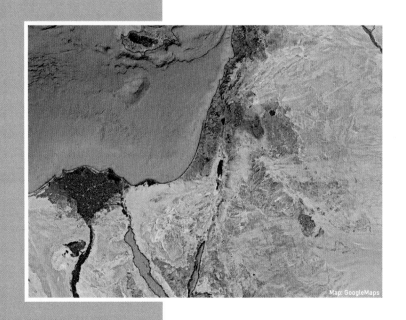

Alexandre Vassiliev
Independent researcher

Retenu in the New Kingdom

The land of Retenu (*Rt/tnw*) was known to the Egyptians since the Middle Kingdom, but its geography can be seen more clearly in documents of the New Kingdom. It is a 'country' (*ḥꜣst Rṯnw*) or group of 'countries' (*ḥꜣswt Rṯnw*) ruled by 'princes' (*wrw nw Rṯnw*). There are Upper Retenu (*Rṯnw Ḥrt*) and Lower Retenu (*Rṯnw Ḫrt*). Upper Retenu is first mentioned in the 'Story of Sinuhe', and it means that this subdivision of Retenu existed from the beginning. Lower Retenu, however, appears in documents only together with Upper Retenu. By itself, in contrast to Upper Retenu, Lower Retenu never appears in historical and geographical records and this fact complicates its localisation. The designations 'Upper' and 'Lower' suggest that Upper Retenu was situated somewhere in the highlands, while Lower Retenu was located in the lowlands – in valleys or along the seacoast (Allen 2015: 76). And the references to 'all princes of Upper Retenu' and 'all princes of Lower Retenu' in the tomb of Amenemheb (TT85; *Urk.* IV 907: 10-13; De Garis Davies 1934: 190, pl. 25) only allow to argue that Lower Retenu, as well as Upper Retenu, was a country ruled by 'princes'.

The visible absence of Lower Retenu on the Egyptian map of Asia has long been explained by the assumption that in the New Kingdom this country was known under a different name. And since it seems that at that time Lower Retenu really did exist as a part of Retenu and as some kind of Asiatic country significant to the Egyptians, this explanation seems correct. The question, therefore, is to which of the well-known Asiatic countries of the New Kingdom it might correspond.

Initially, it was assumed that Upper Retenu was to be equated with Syria-Palestine and Lower Retenu with the valley of the Euphrates River, designated as 'Naharin' during the New Kingdom (Müller 1893: 143-7). Later, when it became clear that Retenu and Naharin were two different countries, Gardiner suggested that Lower Retenu was Palestine and Lebanon, designated as 'Djahy' in the New Kingdom, and Upper Retenu was Syria

(Gardiner 1947, I: 142-9*). This interpretation, however, contradicts basic information about Upper Retenu.

The most complete geographical representation of Upper Retenu is contained in the list of towns defeated by Thutmose III on his first victorious campaign. The superscription of this list presents it as 'the list of countries of Upper Retenu' (*Urk*. IV: 780: 4, 16). It includes only Canaanite cities (with the exception of Qadesh) and covers almost all territory of Canaan (Rainey and Notley 2006: 67-8, 72-4). Today, it can be argued that, in addition to this list, Yenoam (*Urk*. IV 744: 3-5) and the land of Takhsi (*Urk*. IV 1296: 13-1297: 4) are the only locatable toponyms situated 'in Upper Retenu'. Thus, Upper Retenu should be located in Palestine and southern Syria, that is, in the land of Canaan.

In this connection, if Retenu is Syria-Palestine, it seems possible that Lower Retenu was located in northern Syria (Unger 1957: 14-15). However, it appears that the use of the term 'Retenu' in reference to the whole of the Levant is limited to several references to 'rulers of Retenu' in such a broad geographical context (*Urk*. IV 1308: 19; K*RI* I: 19, 14; K*RI* II: 147, 12). Beyond that, it seems that Retenu, as well as Upper Retenu, is also confined to the territory of Canaan. Thus, the conquest of Retenu is often mentioned in documents of Thutmose III as a result of his first victorious campaign (*Urk*. IV 740: 7-8; 745: 12-13; 757: 15; 1234: 8; 1235: 2; 1246: 14-15; 1256: 6; Redford 2003: 108-9, 130, 137, 140, 146, 149, 156) and the impression that there was no other land between Naharin and Retenu can be explained by the fact that northern Syria was made up of several relatively small kingdoms and had no conventional general designation in Egyptian documents. Although the Euphrates River was a border between Egyptian Asia and Naharin at the time of Thutmose III (*Urk*. IV 1232: 5-6; Redford 2003: 106), it is nowhere designated as a border of Retenu. Moreover, with reduction of the zone of Egyptian domination in Asia, the designations 'Naharin' and 'Hatti' could be also applied to the territory of northern Syria (Kitchen 1999: 81-4). Also, the inscription of Amenhotep III with the list of countries 'Naharin, Upper Retenu and Lower Retenu' (*Urk*. IV 1658: 19), often cited as evidence of differentiation between Upper Retenu, Lower Retenu and Naharin, belongs to the time when 'Naharin' denoted both Mesopotamia and northern Syria. In this context, Upper Retenu and Lower Retenu of this list could correspond to Canaan.

As Canaan, Retenu appears in the Egyptian conventional lists of foreign lands in which Upper and Lower Retenu feature together with other countries (Helck 1971: 257-9). These lists contain country names of northern Syria

(Qadesh, etc.), but not of Canaan. The latter are apparently covered by the designations Upper Retenu and Lower Retenu. Canaanite cities, including cities of the Lebanese coast (Byblos etc.; Edel and Görg 2005: 103-5), usually appear in topographical lists of other types – in lists of Canaanite cities which do not contain toponyms outside Canaan (Edel 1966: 8-9). Thus, it seems that Retenu corresponds to Canaan and if Retenu is Canaan then Lower Retenu should be also located in Canaan, somewhere outside the territory covered by the Canaanite list of Thutmose III. It is therefore noteworthy that a significant part of Canaan which is not present in the 'list of countries of Upper Retenu' of Thutmose III is the Lebanese coast. This absence can be explained by the fact that its cities (Byblos, Ullaza, Irqata) did not participate in the Canaanite coalition defeated by Thutmose III during his first Asiatic campaign (Rainey and Notley 2006: 67). But it also allows for the possibility that Lower Retenu is to be found in Lebanon, taking into account its coastal location, its significance for the Egyptians, and existence of this region as a separate country (that is Lebanon, eg. *Rmnn*).

Retenu in the Middle Kingdom

The references to Retenu in the Middle Kingdom have allowed for the assumption that this geographical designation has the same meaning as in the New Kingdom (Posener 1949: 72; 1971: 557) and the lists of Asiatic rulers and countries in the Execration Texts are usually understood as lists of potential enemies of the king in the land of Retenu (Maisler 1947: 40; Rainey and Notley 2006: 52-3). All their locatable toponyms are situated in Canaan, and such Asiatic geography of the Execration Texts has long been understood as a zone of Egyptian domination in Asia. In the north, it extends to the borders of the kingdom of Qatna (= Qedem?), which does not appear in the lists (Maisler 1947: 66-8). The absence of the name 'Retenu' in the Execration Texts is usually explained by the fact that it does not correspond to any of the small Canaanite states listed in them and seen as an argument in favor of the wide geographical meaning of this designation (Bietak 2010: 147).

The same broad understanding of 'Retenu' already seems to be the case in the 'Story of Sinuhe'. Although its information pointing to the location of Retenu and Upper Retenu is expressed only in a few geographical designations, one can conclude that Retenu of Sinuhe was the same country as in the New Kingdom. In the 'Story of Sinuhe' Upper Retenu is mentioned apart from Byblos and Qedem:

'Country (ḥȝst) gave me to country (ḥȝst). I travelled to Byblos, I went on to Qedem (Ḳdm). I spent a year and a half there. Then Ammunenshi, the ruler of (ḥḳȝ n) Upper <Re>tenu, fetched me. (Sinuhe B 28-31)

And Retenu is different from Qedem, Kushu and the Fenkhu:

You circled the foreign countries (ḥȝswt), going from Qedem to Retenu, country (ḥȝst) giving you to country (ḥȝst). (Sinuhe B 181-182)

May Your Majesty command to have brought to you Meki from Qedem (Ḳdm), Khenty-Yaush from Kushu (Kšw), and Mennus from two (sic) lands of the Fenkhu (Fnḫw). They are rulers (ḥḳȝw) of renown who have grown up in the love of you. Without mentioning Retenu – it is yours like your dogs. (Sinuhe B 219-223)

In recent years Egyptian 'Qedem' is usually identified with the kingdom of Qatna in northern Syria (Schneider 2002: 261-3; Allen 2015: 75-6). However, if the final 'm' of Qedem just reflects mimation of the Middle Kingdom, it can be better identified with the land of Qode of the New Kingdom, and it is as Qode (Ḳd) or as Qadesh (Ḳdš) that the New Kingdom Ashmolean Ostracon of Sinuhe understands Qedem (Sinuhe AOS 8/B 182, AOS 30/B 219; Sinuhe AOS 20/B 29). In the Ramesside period, the land of Qode was situated somewhere in northern Syria, outside of Egyptian Canaan, on the territory designated at that time as 'land of Naharin' or 'land of Hatti'. It also seems that the name Qode was occasionally used in a broad sense, as a designation of northern Syria as a whole. Thus the 'people of Khurru (Canaan)' and 'people of Qode' in the annals of Thutmose III (*Urk.* IV 64: 10; Redford 2003: 14) can be understood as 'Palestinians' (Canaanites) and 'Syrians' (people of northern Syria; Gardiner 1947, I: 134*-6*; Kitchen 1999: 81). Qedem of Sinuhe must be located outside of Canaan. 'Kushu' is usually identified with biblical Kushan (Hab. 3:7) and located in Midian or Edom (Maisler 1947: 37-8) and is also situated outside of Canaan.

'Fenkhu' (or usually 'lands of the Fenkhu' *tȝw Fnḫw*) is a well-known designation, but its exact meaning remains unclear. In the Old Kingdom Pyramid Texts the Fenkhu appear in context with celestial gates, through which the king can reach heaven and join the world of the immortal gods:

The Fenkhu's doors that bar [...] will be open for you. (Pepi I, 6th Dynasty, Leclant 1984; Allen 2005: 190, P 541)

Ram-bolted gate that bars [the Fenkhu]. (Pepi II, 6th Dynasty)

[The ram-bolted gate] that bars the Fenkhu. (Aba/Ibi, 8th Dynasty, Sp. 716 § 2223b, Faulkner 1969: 63; Leclant 1985: 85; Allen 2005: N 67)

These gates are not real fortifications on the Egyptian border, which prevent the entrance of the Fenkhu to Egypt (contra Redford 1992: 63). The texts clearly refer to gates that prevent the Fenkhu from entering into the celestial realm of the gods and of the dead king. Therefore, the Fenkhu of the Pyramid Texts are not necessarily neighbours of Egypt. They are situated somewhere on the horizon, on the edge of the earth.

In the same celestial context, the Fenkhu and 'lands of the Fenkhu' appear in the Middle Kingdom Coffin Texts:

I have come that I may pass to the sky, for the fear of me is in the sky and the terror of me is in the hearts of the Fenkhu. (Sp. 265, CT III, 394f-g; Faulkner 2002, I: 202)

I ascend and appear as a god, my signs of rank are on me, and I will make the lands of the Fenekhu impotent through them. (Sp. 469, CT V 390-l; Faulkner 2002, II: 102)

Since the Middle Kingdom (reign of Senwosret I) 'the lands of the Fenkhu' regularly appear in the 'universalist' statements proclaiming the king's domination over the whole world (Lacau and Chevrier 1956: 209-11). And the fact that the Fenkhu hardly appear in historical context in the Old Kingdom and Middle Kingdom periods suggests that they represent faraway countries in Asia.

In the New Kingdom, since the reign of Ahmose, it is already the living king who fights in the 'lands of the Fenkhu':

His slaughtering is in Khenet-hen-nefer (Nubia)*, his war-shout is in the lands of the Fenkhu.* (*Urk.* IV 18: 5-6; Ahmose)

Smiting the princes of Retenu, all mysterious countries, all lands of the Fenkhu. (*Urk.* IV 773: 2-4; Thutmose III)

Overthrowing all lands of the Fenkhu. (*Urk.* IV 1560: 4; Thutmose IV)

They appear as lands 'which did not know (*ḥm*; i.e., 'did not recognise', 'had no relations with'; Lorton 1974: 121-4) Egypt' (*Urk*. IV 1708: 11-12; K*RI* II 168: 11; 169: 14; 187: 2; K*RI* V 93: 8), in context with 'mysterious countries' (*ḫ3swt štзwt*; *Urk*. IV 708: 2; 773: 2-4; 774: 1; 1559: 19; 1560: 4; K*RI* I 25: 15-16; K*RI* II 169: 14) and 'northern confines of Asia' (*pḥw Stt*, Legrain 1914: 41; Clere et al. 1975: fig. 10; K*RI* II 168: 11). In one case, they are even located in the last area:

> *Smiting the chiefs of Nubians and Asiatics* (*wrw iwntyw mntyw*), *all mysterious countries and all lands of the Fenkhu of* (nw) *the northern confines of Asia.* (K*RI* I 25: 15)

At that time, the term seemingly represents a poetical general designation for remote Asiatic countries, and as such it can be also understood even as 'Asiatic countries' in general (see the version of B 220-221 on the Ashmolean Ostracon of Sinuhe – 'putting your guidance in the lands of Fenkhu').

It seems that the old identification of the Fenkhu with the Phoenicians and location of the lands of the Fenkhu on the Phoenician coast (see Kitchen 1994: 162-3) are not supported by the textual evidence. It can be only argued that these lands were situated somewhere further away in Asia, outside Retenu and Qedem, and since they are always designated as 'lands' (in plural), they must represent many countries. Moreover, since the Phoenician coast is part of the land of Canaan, it is likely that in the 'Story of Sinuhe' it belongs to Retenu, not to the 'lands of the Fenkhu'. And the fact that Byblos was part of Retenu before the New Kingdom is possibly reflected in a recently published seal impression of a 'Ruler of Retenu' Ipy-Shemu from Tell el-Daba (14th Dynasty) who can be seen as a ruler of Byblos (Kopetzky and Bietak 2016).

Thus, it seems that all three countries (Qedem, Kushu, lands of the Fenkhu) mentioned in the message to the king together with Retenu are situated outside of Canaan. Accordingly, Retenu of the 'Story of Sinuhe' can be identified as Canaan. It is exactly as this designation of Canaan, whose loyalty to Egypt is already well-known, that Retenu can be seen in the context of the message of Sinuhe, while the rulers of Kedem, Kushu and Fenkhu apparently represent rulers of more distant Asiatic countries, whom Sinuhe wants to present to the king (Schneider 2002: 272; Allen 2015: 129). Moreover, Upper Retenu is mentioned separately from Byblos, and it makes it possible again to locate Lower Retenu on the coast of Lebanon, as in the case with the Canaanite list of Thutmose III.

Conclusion

This paper has demonstrated that Retenu can correspond to Canaan, while Lower Retenu can be equated with the Phoenician coast. In view of its significance for the Egyptians, it seems possible that they could distinguish it from the rest of Canaan as Lower Retenu from Upper Retenu. But the Phoenician coast usually appears in documents under other designations, and already in the tomb of Khnumhotep III it is known as Lebanon (*Rmnn*, Allen 2008: 35-6). Later, this name is characteristic for documents of the New Kingdom, which also frequently refer to 'princes of Lebanon' (*wrw nw Rmnn*, *Urk.* IV 700: 9; 739: 17; 1242: 2; K*RI* I 14: 5). And it seems that these 'princes of Lebanon' can be identified with the 'princes of Lower Retenu' of the tomb of Amenemheb.

Bibliography

Allen, J. P. 2005. The Ancient Egyptian Pyramid Texts. Atlanta: Society of Biblical Literature.

Allen, J. P. 2008. 'The historical inscription of Khnumhotep at Dahshur: Preliminary report', Bulletin of the American Schools of Oriental Research 352: 29-39.

Allen, J. P. 2015 Middle Egyptian Literature. Eight Literary Works of the Middle Kingdom. Cambridge: Cambridge University Press.

Bietak, M. 2010. 'From where came the Hyksos and where did they go?', in M. Marée (ed.), The Second Intermediate Period (Thirteenth-Seventeenth Dynasties): Current Research, Future Prospects. Leuven: Peeters, 139-81.

Clère, P., Ménassa, L., and Deleuze, P. 1975. 'Le socle du colosse oriental dressé devant le Xe pylône de Karnak', Cahiers de Karnak 5: 159-66.

De Garis Davies, N. 1934. 'Foreigners in the tomb of Amenemhab (No. 85)', Journal of Egyptian Archaeology 20: 189-92.

Edel, E. 1966. Die Ortsnamenlisten aus dem Totentempel Amenophis' III. Bonn: Hanstein.

Edel, E. and Görg, M. 2005. Die Ortsnamenlisten im nördlichen Säulenhof des Totentempels Amenophis' III. Wiesbaden: Harrassowitz.

Faulkner, R. O. 1969. The Ancient Egyptian Pyramid Text, Translated into English. Supplement of Hieroglyphic Texts. Oxford: Clarendon Press.

Faulkner, R. O. 2002. The Ancient Egyptian Coffin Texts: Spells 1-1185 & Indexes. Warminster: Aris and Phillips.

Gardiner, A. H. 1947. Ancient Egyptian Onomastica, vols 1-2. Oxford: Oxford University Press.

Helck, W. 1971. Die Beziehungen Ägyptens zu Vorderasien im 3. und 2. Jahrtausend vor Christus. Wiesbaden: Harrassowitz.

Kitchen, K. A. 1994. 'Sinuhe's foreign friends', in C. Eyre, L. M. Leahy and M. A. Leahy (eds), The Unbroken Reed: Studies in the Culture and Heritage of Ancient Egypt in Honour of A. F. Shore, London: The Egypt Exploration Society, 161-164.

Kitchen, K. A. 1999. Ramesside Inscriptions, Translated and Annotated: Notes and Comments, II: Ramesses II, Royal Inscriptions. Oxford: Blackwell.

Koch, R. 1990. Die Erzählung des Sinuhe. Brussels: Fondation Égyptologique Reine Élisabeth.

Kopetzky, K. and Bietak, M. 2016. 'A seal impression of the green jasper workshop from Tell el-Dab'a', Ägypten und Levante 26: 357-75.

Lacau, P. and Chevrier, H. 1956. Une chapelle de Sésostris Ier. Cairo: Institut français d'archéologie orientale.

Leclant, J. 1984. 'T. P. Pépi Ier, VII: Une nouvelle mention des Fnxw dans les Textes des Pyramides', Studien zur Altägyptischen Kultur 11: 455-60.

Leclant, J. 1985. 'T. P. Pépi Ier, VI: À propos des §§ 1726 a-c, 1915 et *2223 des Textes des Pyramides', in P. Posener-Kriéger (ed.), Mélanges Gamal Eddin Mokhtar. Cairo: Institut français d'archéologie orientale, 83-92.

Legrain, G. 1914. 'Au pylône d'Harmhabi à Karnak (Xe pylône)', Annales du Service des antiquités de l'Egypte 14: 13-44.

Lorton, D. 1974. The Juridical Terminology of International Relations in Egyptian Texts through Dyn. XVIII. Baltimore: The Johns Hopkins University Press.

Maisler (Mazar), B. 1947. 'Palestine at the Time of the Middle Kingdom in Egypt', Revue de l'histoire juive en Égypte 1: 33-68.

Müller, M. W. 1893. Asien und Europa nach altägyptischen Denkmälern. Leipzig: Wilhelm Engelmann.

Posener, G. 1949. 'Le pays Retenu au Moyen Empire', in Actes du XXIe Congrès international des orientalistes: Paris, 23-31 Juillet 1948. Paris: Société asiatique, 72-3.

Posener, G. 1971. 'Syria and Palestine c. 2160-1780. Relations with Egypt', in Cambridge Ancient History, I(2), 532-58.

Rainey, A. F. and Notley, R. S. 2006. The Sacred Bridge: Carta's Atlas of the Biblical World. Jerusalem: Carta.

Redford, D. 1992. Egypt, Canaan and Israel in Ancient Times. Princeton: Princeton University Press.

Schneider, T. 2002. 'Sinuhes Notiz über die Könige: Syrisch-Anatolische Herrschertitel in ägyptischer Überlieferung', Ägypten und Levante 12: 257-72.

Unger, M. F. 1957. Israel and the Aramaeans of Damascus: A Study in Archaeological Illumination of Bible History. London: James Clarke & Co.

Abbreviations

CT = De Buck, A. and Gardiner, A. H. 1935-1961. The Egyptian Coffin Texts, vols 1-7. Chicago: University of Chicago Press.
KRI = Kitchen, K. A. 1975-1990. Ramesside Inscriptions, vols 1-8. Oxford: Blackwell.
Urk. IV = Sethe, K. and Helck, W. 1905-1958. Urkunden der 18. Dynastie. Leipzig: J. C. Hinrichs.

The text and traditional context of the 'Hay cookbook' and associated magical texts on leather

Michael Zellmann-Rohrer
University of Oxford

Among the artefacts acquired in Egypt by the antiquarian Robert Hay (1799-1863) is a group of seven Coptic manuscripts or fragments thereof on leather, bearing texts in a genre that may by convention be called magical (on the convention for Coptic magic see recently Richter 2015: 188). The manuscripts are now kept in the British Museum (Department of Egypt and Sudan). Over the past two years the texts have been re-edited and analysed as part of a project funded by the British Museum Research Board. (For a prospectus and images of all the manuscripts see O'Connell et al. 2016-). This multi-disciplinary undertaking aims to develop and publish a new approach to the conservation and mounting of manuscripts on leather; disseminate the results of scientific analysis on leather production; and provide the first complete edition and English translation of the ensemble of texts. There is also an opportunity to contextualise the manuscripts, beyond the cursory commentaries in their first editions by Angelicus Kropp (1930-1) and Walter Crum (1934a, b), amid the expanded corpus of Coptic magical texts published in the intervening years.

The contents include recipes for divination, healing and apotropaic rituals, and erotic magic, functioning via oral invocations of a range of angelic and demonic powers, inscription of text, signs, and figural drawings, and the performance of offerings. It is these manifestations of an instrumental kind of cult practice, focused on directly applying writing and speech acts, or coercing angelic and demonic beings, all for personal gain, that is meant by the term 'magical'. For a conspectus of the manuscripts and their contents see below. Five of the manuscripts present handbooks, or formularies, with instructions for magical ritual. The sixth represents a finished product in the same genre. A small fragment identified in the course of the project may belong to one more handbook.

Crum tentatively proposed a dating for the assemblage in the 6th or 7th century AD (1934a: 51), which remains probable from a palaeographic perspective (cf. the document from Edfu P.Lond.Copt. I 445 with pl. 1, dated c. 620 via prosopography). Preliminary results from radio-carbon dating undertaken for the new project on two of the manuscripts may suggest a later

range in the 7th or 8th century (Wills et al. forthcoming), which could also be reconciled with the palaeography (cf. the Theban document P.Lond.Copt. I 398 with pl. 3: internally dated to 749), but further testing and calibration is planned. No information on the find-spots of the manuscripts has been recorded. The generally Sahidic character of the dialect may point to an origin in the vicinity of Thebes, as Crum already saw (1934a: 51), which finds further circumstantial support from Hay's extended residence in that area during his Egyptian travels.

The Hay manuscripts: a conspectus

Text 1 ('Hay cookbook')
 P.Brit.Mus. inv. EA 10391
 Registration no. 68.11.2.464
 Trismegistos no. 100015
 Ed. pr.: Kropp 1930-1, 1:55-62 text M
 Contents: Formulary for summoning of angels and decans; erotic and aggressive magic; medical recipes.

Text 2
 P.Brit.Mus. inv. EA 10376
 Registration no. 68.11.2.462
 Trismegistos no. 99554
 Ed. pr.: Crum 1934a
 Contents: Formulary for erotic magic.

Text 3
 P.Brit.Mus. inv. EA 10414a
 Registration no. 68.11.2.461
 Trismegistos no. 99562
 Ed. pr.: Crum 1934b: 195-7 text A
 Contents: Formulary for erotic magic and attraction of business.

Text 4 (see Fig. 1)
 P.Brit.Mus. inv. EA 10122
 Registration no. 68.11.2.458+459
 Trismegistos no. 99566
 Ed. pr.: Crum 1934b: 197-9 text B
 Contents: Formulary for protection and attraction of business.

Text 5
 P.Brit.Mus. inv. EA 10434a
 Registration no. 68.11.2.463
 Trismegistos no. 99565
 Ed. pr.: Crum 1934b: 199 text C
 Contents: Formulary for protection and attraction of business.

Text 6
 P.Brit.Mus. inv. EA 10434b
 Registration no. 68.11.2.460
 Trismegistos addendum
 Ed. pr.: Crum 1934b: 200 text D
 Contents: Finished product (amulet or archival copy).

Text 7
 P.Brit.Mus. inv. EA 10414b
 Registration no. (as Text 3)
 Trismegistos addendum
 Unpublished
 Contents: Small fragment of formulary.

In the re-edition of the texts, new readings and interpretations have been made possible by the conjunction of conservation, a round of advanced multispectral imaging, and further philological contextualisation. Three examples are selected here. The first comes from the most extensive of the seven manuscripts, sometimes known as the 'Hay cookbook' (Text 1 = P.Brit.Mus. inv. EA 10391). The ritual includes a lengthy, multi-part invocation and closes with ingredients for an aromatic burnt offering. The relevant portion of the invocation runs (12-18; text and translation here and throughout follow the new edition):

I beg, I entreat you today, Horus, the great one strong in his power, the one who stands upon the iron bars [or, *'on iron legs'*], *crying out as follows, 'It is I. Prick up your ears at my needs* [Greek χρεία, suggested by K. Dosoo]. *I went to Pellonia, I came out of a door of iron. I found a beautiful woman, red, dark-eyed, sitting on a lofty throne. I desired her, I cried out, saying, 'Come to me today, great one, strong and powerful in his heart, rouse yourself and go to her, so-and-so, to bring her to so-and-so, now, before she stings ...'*

†ⲥⲟⲡⲥⲡ † vac. ⲡⲁⲣⲁⲕⲁⲗⲉ ⲙⲙⲟⲕ ⲛⲡⲟⲟⲩ ⲍⲱⲁ ⲡⲛⲟϭ ⲛⲭⲱⲱⲣⲉ ⲍⲛ ⲧⲉϥϭⲟⲙ
ⲡⲁⲓ ⲉⲧⲁⲍⲉ ⲉⲣⲁⲧϥ ⲉⲭⲛ ⲛⲕⲉⲗⲉ ⲃⲓⲛⲓⲡⲉ ⲉϥϣⲱ ⲉⲃⲟⲗ ⲛⲧⲉⲍⲉ ⲭⲉ ⲁⲛⲟⲕ ⲡⲉ ⲍⲱⲕ
ⲛⲉⲕⲙⲁⲭⲉ ⲍⲛ ⲛⲁⲭⲓⲁ ⲁ⟨ⲓ⟩ⲍⲱⲁ ⲉⲍⲟⲩⲛ ⲉⲡⲉⲗⲗⲱⲛⲓⲁ ⲁⲓⲉⲓ ⲉⲃⲟⲗ ⲛⲟⲩⲣⲱ ⲙⲙⲡⲉⲡⲓⲛⲓⲡⲉ
ⲁⲓⲕⲓⲛⲉ ⲛⲟⲩⲥⲁⲉⲓⲏ ⲛⲧⲱⲣϣ ⲛⲕⲁⲙⲃⲁⲗ ⲉⲥⲍⲙⲟⲟⲥ ⲉ[ⲭⲛ ⲟ]ⲩⲑⲣⲟⲛⲟⲥ ⲉϥⲭⲟⲟⲥⲉ
ⲁⲓⲉⲡⲓⲑⲏⲙⲁ ⲉⲣⲟⲥ ⲁⲓϣⲱ ⲉⲃⲟⲗ ⲉⲓⲭⲱ ⲙⲟⲥ ⲭⲉ ⲁⲙⲟⲩ ϣⲁⲣⲟⲓ ⲍⲱⲧ ⲛⲡⲟⲟⲩ ⲡⲛⲟϭ
ⲛⲭⲱⲣⲉ ⲛⲧⲏⲛⲁⲧⲟⲥ ⲍⲛ ⲡⲉϥⲍⲏⲧ ⲛⲉⲍⲥⲉ ⲙⲙⲟⲕ ⲛϭⲃⲱⲕ ϣⲁ ⲁ̄ⲗ̄ ⲛⲉⲓⲛⲉ ⲙⲙⲟⲥ
ⲛⲁ̄ⲗ̄ ⲍⲛⲧⲉⲟⲩⲛⲟⲩ ⲙⲡⲁⲧⲉⲥⲭⲱⲕ

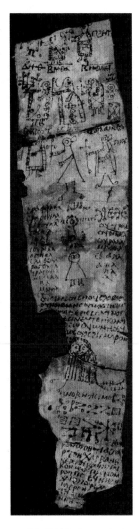

Figure 1: Text 4 = P.Brit.Mus. inv. EA 10122, front. Infrared-reflected image. (Image:
Lucy-Anne Skinner, copyright Trustees of the British Museum)

Horus goes on to invoke three decans and report a further dialogue between himself and this 'great one', the purpose of which is to put in Horus' mouth the request of the procedure itself, the ritual activation of some radish oil to serve 'as a preparation for everything that I may undertake'. The key new reading here is the name of the god Horus (ϩⲱⲗ for ϩⲱⲣ: cf. Crum 1939: 697b s.v.). In fact, as had been suspected before but can now be more securely accepted, the invocation belongs among a group of Coptic reflexes of earlier Egyptian myths on Horus and his scorpion-brides, applied in turn in incantations (see most recently Blumell and Dosoo 2018). A reminiscence is preserved in the description of the beautiful woman as 'red' (ⲧⲱⲣϣ) and 'dark-eyed' (ⲕⲁⲙⲃⲁⲗ), and of course in the threat of her stinging (ⲙⲡⲁⲧⲉⲥⲭⲱⲕ [ⲭⲱⲕ for ⲭⲱ(ⲱ)ⲕⲉ]), which is precisely what befell Horus in those myths. The placeholders 'so-and-so', for the names of male aggressor and female target, respectively, are remnants of the motif's original context, apparently in an invocation for use in erotic magic, from which it has now been dislocated to serve a more general purpose.

The second example comes in another formulary with an invocation of a demon spoken over a cup of wine, to be given to a female victim, who is supposed to be overcome with erotic desire for the male user (Text 2 = P.Brit.Mus. inv. EA 10376). The demon itself is described in its fearsome emergence from the sea, followed by a sort of dialogue between it and a first-person speaking voice, in which the two pledge to call each other brothers. Then the speaker comes to the point, the specification of the effect sought on the beloved (13-17):

In desire may she desire me, in love may she love me, may desire for me and love for me be within her, so-and-so daughter of so-and-so, like an angel of God in her presence. For this is the lust that Mastema scraped (?) [cf. Greek ξυρίζω] into a bowl, and cast into the source of the four rivers

ϩⲛ⟨ⲟⲩ⟩ⲟⲩⲱϣⲉ ⲙⲁⲣⲉⲥⲟⲩⲟϣⲧ ϩⲛⲟⲩⲙⲉ ⲙⲁⲣⲉ⟨ⲥⲙⲉ⟩ⲣⲓⲧ ⲙⲁⲣⲉⲡⲗⲟⲩⲱϣⲉ ⲙⲛⲡⲁⲙⲉ ϣⲱⲡⲉ ϩⲣⲁⲓ ⲛϩⲏⲧⲥ ⲛⲛⲓⲙ ⲧϣⲉⲣⲉ ⲛⲛⲓⲙ ⲛⲑⲉ ⲛⲟⲩ vac. ⲁⲅⲅⲉⲗⲟⲥ ⲛⲧⲉ ⲡⲛⲟⲩⲧⲉ ⲙⲡⲉⲥⲙⲧⲟ ⲉⲃⲟⲗ ϫⲉ ⲧⲉⲡⲉⲑⲓⲙⲓⲁ ⲧⲁⲓ ⲧⲉⲛⲧⲁⲙⲁⲥⲧⲁⲙⲁ ϭⲏⲣⲉⲥⲥⲉ ⲙⲙⲟⲥ ϩⲛ ⲟⲩⲫⲉⲗⲗⲉ ⲁϥⲛⲟϫⲥ ϩⲣⲁⲓ ϩⲛⲧⲁⲣⲭⲏ ⲙⲡⲉϥⲧⲟⲟⲩ ⲛ⟨ⲓ⟩ⲉⲣⲟ

The reading of ⲫⲉⲗⲗⲉ 'bowl' (a Greek loanword, φιάλη), provides the clue to a previously obscure passage, which proves to be a piece of folklore

elaborating on biblical apocrypha. Mastema is a chief among demons or evil angels, originally a figure of apocalyptic Judaism (Michl 1962: 221 no. 135), and here he takes over for Satan in a version of an episode found in Greek in an apocryphal text associated with the apostle Bartholomew, onto which the rest maps closely. As Satan tells it there, 'I took a bowl in my hand and scraped the sweat from my chest and armpits and washed in the outlets whence the four rivers [of Paradise] flow, and Eve drank and contracted lust. For if she had not drunk that water, I could not have deceived her' (*Questions of Bartholomew* 4.59, ed. Bonwetsch 1897: 26; tr. Kaestli and Cherix 1993: 129). It is this etiology of lust, then, the very inception of the affect, that the Coptic procedure aptly invokes.

The third example belongs to another formulary recipe with an erotic aim (Text 3 = P.Brit.Mus. inv. EA 10414a). It invokes 'the favour that was given to the stone of king Solomon, on account of the virginity and love of women' (2, ⲧϫⲁⲣⲓⲥ ⲛⲧⲁⲩⲧⲁⲁⲥ ⲁⲡⲟⲛⲏ ⲛⲡⲟⲣⲟ ⲥⲟⲗⲟⲙⲟⲛ ⲉⲧⲃⲉ ϩⲁⲣⲁⲩⲛⲉ ϩⲓ ⲙⲉ ⲛⲥⲓⲙⲉ) to inflame them 'until they take their virginity and cast it off upon the ground' (2-4, ϣⲁⲛⲧⲟⲩϫⲓ ⲛⲧⲟⲩⲙⲛⲧⲡⲁⲣⲑⲉⲛⲟⲥ ⲧⲟⲩⲛⲁϫⲟⲩ ⲁⲃⲟⲗ ϩⲓϫⲛ ⲡ2ⲟ ⲛⲡⲕⲁϩ). The first editor of the text, Crum, doubtfully referred ⲡⲟⲛⲏ to ⲱⲛⲉ, which in one of its senses appears to gloss the Greek ψωλή, 'phallus', but like the latter has the feminine grammatical gender. With the better-attested sense, and gender, of this word, a precious stone set in the biblical Solomon's ring can be identified instead. The latter became famous in post-biblical lore exemplified by the demonological *Testament of Solomon*, in which the king receives a divine ring, set with a stone that allows him to compel demons to do his bidding (recensions A-B in the edition of McCown 1922: 10), which is precisely what the rest of the invocation proceeds to attempt.

The project provides a chance to set the Hay manuscripts in the context of the diachronic development of magical texts in Coptic, and the synchronic compilation of an assemblage. To begin with the former, magical texts are already well-represented in the corpus of Old Coptic. Here, and continuing into the classical phase of the language, there is a repertoire rooted in ancient Egyptian traditions while also receptive to influences from Greek-language traditions informed by both Hellenic and Jewish religion and culture, in fact already circulating in Egypt for centuries by this time (Dieleman 2005; Love 2016; Bohak 2016). Thus, incantations can be found recounting myths of Horus and Isis (Blumell and Dosoo 2018), among other traditional Egyptian deities, their language marked by poetic and archaic features, alongside references to angels and the Jewish god Yahweh, and amuletic applications of verses from Homer.

In a sense, the Hay manuscripts witness an end-point to the ancient Egyptian stratum: the Horus narrative is barely recognisable, subsumed within a demonological frame, and in fact this is its latest known occurrence. The assemblage falls at a transitional point, where the Greek-inflected, Christian tradition is gaining the upper hand. There is a high concentration of Greek loanwords, and invocations of supernatural powers described as angels predominate, with Christian scripture and hagiography also coming into play: there is for example an invocation of St. George, 'he who sang in the Psalm, "God, attend to my help"' (Text 1 = P.Brit.Mus. inv. EA 10391, 67-8: ⲛⲧⲁϥⲯⲁⲗⲉ ⲍⲛ ⲡⲉⲯⲁⲗⲙⲟ ⲡⲛⲟⲩⲧⲉ † ⲍⲧⲏⲕ ⲉⲧⲁⲃⲟⲏⲑⲉⲓⲁ), that is, the first verse of Psalm 69(70), said to have been used by the saint in prayer before his interview with the Roman authorities (see the Coptic text edited by Budge 1888: 7 [wrongly attributed to Psalm 22:19] and the Greek text edited by Canart 1982, §5). An eclectic make-up of the collection from multiple traditions can still be discerned, such as inter-testamental apocryphal lore, reflected in the episodes of the poisoning of the rivers by Mastema and the ring given to king Solomon, conferring power over demons. The preference for leather as substrate is still operative, probably under the influence of Nubian traditions as in the roughly contemporary Blemmyan documentary archive of Greek and Coptic texts from Pathyris (Mitthof 2007: xxv-xxxi; for brief comments on Coptic magical texts on leather see also Jördens, Kiyanrad and Quack 2015: 332-3). The Hay manuscripts may, in fact, belong to the Islamic period, but there is no discernible influence of Islam, and the eventually more economical paper has made no inroad here.

The scope of the Hay collection is diverse, yet there is every reason to believe that it did constitute a collection also in antiquity. There are, first of all, the characteristic use of tall, narrow rolls of leather and the circumstances of accession to the British Museum, in a single group (indicated by the original registration numbers, despite the disparate inventory numbers: see the conspectus above), with two cases in which a fragment of one of the manuscripts was fused to another (Text 2 = P.Brit.Mus. inv. EA 10376 and Text 3 = P.Brit.Mus. inv. EA 10414a; Text 3 = EA 10414a and Text 5 = EA 10434a), probably during storage in antiquity. There is also support among shared textual elements, such as a peculiar arrangement of divine names and ritual drawings associated with the four cardinal directions, which appears in both Text 4 (P.Brit.Mus. inv. EA 10122) and Text 5 (P.Brit.Mus. inv. EA 10434a). Crum (1934b: 200) identified all the texts as the work of a single hand. Closer comparison suggests instead at least two copyists who built up the collection as a working archive, perhaps for the use of a family or

association of practitioners: the identification of a single hand in Texts 1 and 3-5 can be accepted, but Text 2 differs in general impression and in enough particulars to warrant a separate writer, perhaps trained by or taking the first as a model, while the small sample size in the short Text 6 shows general similarities but remains insufficient for a firm conclusion. Diversity in phonological and orthographic features suggests additional complexities in the exemplars from which these copyists compiled.

Further evidence for an eclectic and opportunistic process of gathering comes in two forms. First, internally, a list of ingredients in a medicinal prescription gives one herb, 'all-heal', followed by what amounts to a notation of a variant reading in another exemplar collated by the writer: 'another one had "white calamus"' (Text 4 = P.Brit.Mus. inv. EA 10122, 41-3: ϫⲁⲣⲃⲁⲛⲏ ⲛⲉⲣⲉⲕⲟⲩ ⲕⲟϣ ⲛⲗⲉⲩⲕⲟⲛ; on collation in magical texts see Dieleman 2005: 36-9 and 72; Love 2016: 191). Second, externally, the use of off-cuts from leather manufacture (Wills et al. forthcoming) suggests occasional and opportunistic as opposed to large-scale institutionalised production, and hence is consistent with the eclectic collection of aims and textual motifs in the texts.

If the identification of a single ancient collection is accepted, what can be concluded about the collectors behind it? The manuscripts themselves provide some direct indications, which can be illustrated by a survey of their contents. Two are wholly dedicated to one or two recipes each (Text 2 = P.Brit.Mus. inv. EA 10376; Text 3 = P.Brit.Mus. inv. EA 10414a), with long invocations of demonic powers to force a female beloved into submission, including the motif of Mastema and the etiology of lust. Two shorter formularies show more varied collections, but no less concern with personal advancement, in particular protecting and attracting custom to a place of business (Text 4 = P.Brit.Mus. inv. EA 10122; Text 5 = P.Brit.Mus. inv. EA 10434a). The most diverse selection is copied on both sides of a leather roll over two feet long, which offers a total of 26 recipes (Text 1 = P.Brit.Mus. inv. EA 10391). The collection opens with three invocations, each followed by instructions for a ritual offering including aromatic substances. Explicit specification of the purpose is lacking, as each section launches directly into an invocation, one of which gives the narrative of Horus and his scorpion bride. Apparently, there is a general appeal for the attention of supernatural beings which are urged to come, or descend, upon the offerings to provide revelation and assistance to the user. Following these are three short medical recipes, one prescribing the inscription of magical signs to cure headache, the other two pharmacological approaches to disorders of the legs and eyes.

The collection continues on the reverse, opening with four short recipes for healing and protection prescribing ritual invocations or inscriptions. Then the format shifts to give a short prayer invoking a single divinity, which is then applied over 14 sets of directions for primarily aggressive aims, some of which add, or substitute, a list of holy names, that is, those of the 24 elders of the biblical book of Revelation (4:4-11; see further Kropp 1930-1, 3: 83-5, 130-2; Grosjean 1954). The collection closes with another aggressive procedure, an invocation to bind the sexual potency of a man with a woman. Self-interested, to be sure, but there are signs of integration within a community, most tellingly, among the 14 applications of the prayer, one to bring prosperity to a workshop.

Another manuscript in the collection may offer a concluding illustration of the collecting activity at work behind the constitution of the assemblage. Occupying a small sheet of leather, folded after writing, it lacks rubrics or instructions, presenting instead only a single sentence in syntactic Coptic surrounded by ritually efficacious vocables and signs (Text 6 = P.Brit. Mus. inv. EA 10434b). Hence it appears to be either an activated ritual object, or more probably given its context in a collection, an archival copy thereof; in view of the syntactic portion of the content (ⲡⲃⲁⲗ ⲛⲁⲧⲁⲩⲟⲡ ⲡ2ⲏⲧ ⲛⲁⲟⲩⲱϭ, 'The eye will become familiar (?) [ⲧⲁⲩⲟⲡ for ⲧⲱⲱⲡ], the heart will desire'), the aim may be the attraction of favour for the bearer of the object. The collector may have encountered this text in the field, or received it by correspondence, a situation in fact attested in earlier Coptic and Greek private letters by which such knowledge circulated. A 3rd-century Greek private letter on papyrus requests a copy of a healing amulet (P.Oxy. XLII 3068 = Suppl.Mag. I 5; see also Love 2016: 277), while another in Coptic from a Manichaean context in the 4th century includes a copy of a bilingual Greek-Coptic invocation for aggressive magic (P.KellisCopt. 35: see P.Kellis V; Mirecki, Gardner, and Alcock 1997; Love 2016: 273-6).

This brief survey has hopefully shown some of the interest of this rather unique collection of Coptic ritual texts on leather, situated at a transitional point among magical traditions in late Byzantine or early Islamic Egypt. The manuscripts attest the selective preservation of motifs from traditional Egyptian cult and myth as well as those of apocalyptic Judaism, integrated in ritual techniques harnessing angelic and demonic powers alongside saints and the supreme deity in a Christian belief-system. In the context of a new, multidisciplinary research project, they are now receiving well-deserved conservation, to preserve this witness for years to come.

Bibliography

Blumell, L. H. and Dosoo, K. 2018. 'Horus, Isis, and the dark-eyed beauty: A series of magical ostraca in the Brigham Young University collection', Archiv für Papyrusforschung und verwandte Gebiete 64: 199–259.

Bohak, G. 2016. 'The diffusion of the Greco-Egyptian magical tradition in late antiquity', in I. Rutherford (ed.), Greco-Egyptian Interactions: Literature, Translation, and Culture, 500 BCE–300 CE. Oxford: Oxford University Press, 357–81.

Bonwetsch, G. N. 1897. Die apokryphen Fragen des Bartholomäus. Nachrichten von der königlichen Gesellschaft der Wissenschaften zu Göttingen. Philologisch-Historische Klasse. Göttingen.

Budge, E. A. W. 1888. The Martyrdom and Miracles of Saint George of Cappadocia. London: D. Nutt.

Canart, P. 1982. 'La collection hagiographique palimpseste du Palatinus graecus 205 et la Passion de S. Georges, BHG 670g', Analecta Bollandiana 100: 87–110.

Crum, W. E. 1934a. 'Magical texts in Coptic', Journal of Egyptian Archaeology 20: 51–3.

Crum, W. E. 1934b. 'Magical Texts in Coptic II', Journal of Egyptian Archaeology 20: 51–3.

Crum, W. E. 1939. A Coptic Dictionary. Oxford: Clarendon Press.

Dieleman, J. 2005. Priests, Tongues, and Rites: The London-Leiden Magical Manuscripts and Translation in Egyptian Ritual (100–300 CE). Leiden: Brill.

Grosjean, P. 1954. 'Les vingt-quatre vieillards de l'Apocalypse, à propos d'une liste galloise', Analecta Bollandiana 72: 192–212.

Jördens, A., Kiyanrad, S. and Quack, J. F. 2015. 'Leder', in T. Meier, M. R. Ott and R. Sauer (eds), Material Textkulturen: Konzepte - Materialen – Praktiken. Berlin: De Gruyter, 323–35.

Kaestli, J.-D. and Cherix. P. 1993. L'évangile de Barthélemy d'après deux écrits apocryphes. Turnhout: Brepols.

Kropp, A. M. 1930-1. Ausgewählte koptische Zaubertexte (3 vols). Brussels: Édition de la Fondation égyptologique Reine Élisabeth.

Love, E. O. D. 2016. Code-switching with the Gods: The Bilingual (Old Coptic-Greek) Spells of PGM IV (P. Bibliothèque nationale supplément grec 574) and their Linguistic, Religious, and Socio-cultural Context in Late Roman Egypt. Berlin: De Gruyter.

McCown, C. C. 1922. The Testament of Solomon, Edited from Manuscripts at Mount Athos, Bologna, Holkham Hall, Jerusalem, London, Milan, Paris and Vienna. Leipzig: J. C. Hinrichs.

Michl, J. 1962. 'Engel I–IX', Reallexikon für Antike und Christentum 5: 53–258.

Mirecki, P., Gardner, I. and Alcock, A. 1997. 'Magical spell, Manichaean letter', in P. Mirecki and J. BeDuhn (eds), Emerging from Darkness: Studies in the Recovery of Manichaean Sources. Leiden: Brill, 1–32.

Mitthof, F. 2007. Griechische Papyrusurkunden kleineren Formats. Neuedition. SPP III2 119-238: Schuldscheine und Quittungen. Vienna: Verlag der Österreichischen Akademie der Wissenschaften.

O'Connell, E. R. et al. (2016–). The 'Hay cookbook' of Coptic spells and associated ritual handbooks on leather. Available at: www.britishmuseum.org/research/research_projects/all_current_projects/the_hay_cookbook.aspx [last accessed 1 August 2018].

Richter, T. S. 2015. 'Magic', in C. Fluck, G. Helmecke and E. R. O'Connell (eds), Egypt: Faith after the Pharaohs. London: British Museum, 188-95.

Wills, B. et al. (forthcoming). 'Conserving, analysing and studying the "Hay cookbook": Revelations from ancient "magical" texts on leather', in Postprints of the 17th Seminar on the Care and Conservation of Manuscripts, University of Copenhagen.

Abbreviations

Trismegistos = Trismegistos. An interdisciplinary portal of papyrological and epigraphical resources. Available at: www.trismegistos.org [last accessed 1 August 2018].

P.Kellis V = Gardner, I., Alcock, A., and Funk, W.-P. (1999) Coptic Documentary Texts from Kellis 1. Oxford: Oxbow.

P.Lond.Copt. I = Crum, W. E. 1905. Catalogue of the Coptic Manuscripts in the British Museum. London: British Museum.

P.Oxy. XLII = Parsons, P. J. 1974. The Oxyrhynchus Papyri 42. London: The Egypt Exploration Society.

Suppl.Mag. I = Daniel, R. W. and Maltomini, F. 1990. Supplementum Magicum 1. Opladen: Westdeutscher Verlag.

Papers presented at BEC 4 not included in this volume

Identifying the painting from Tomb 100 Hierakonpolis
Mohamed Abdel-Rahman, Ministry of Antiquities

What is Old Egyptian? The grammar of Old Kingdom documentary texts
Victoria Almansa Villatoro, Brown University

Regional diversity and use of mummy labels
Adrienn Almásy, British Museum

Blazing bull, rejoicing pillar: symbolism and imagery of the moon in the temples of Graeco-Roman Egypt
Victoria Altmann-Wendling, LMU München

What can we learn from the turnover of workmen at Deir el-Medina?
Jean-Christophe Antoine, University of Saint-Etienne

Reconstruction of a forgotten burial form: early travellers, early Egyptologists and the 'mummy pits' of ancient Egypt
Tessa Baber, Cardiff University

Report on the current University of Hawaii fieldwork at the Graeco-Roman city of Tell Timai in the north-eastern Nile Delta
James E. Bennett, Independent scholar

Investigating the effectiveness of an archetype digital framework for characterising and differentiating 'hands' of scribes / draughtsmen who painted hieroglyphs
Elizabeth Bettles, Universiteit Leiden

Tomb security in ancient Egypt from the Early Dynastic Period to the Third Dynasty
Reg Clark, Independent scholar

The high priest of Min and Isis in Akhmim and chief architect Nakhtmin: a new perspective on his career and tomb
Marion Claude, Université Paul-Valéry Montpellier 3

A catalogue of errors? The documentation of Egyptian mummy dissections over the last 200 years
Jenefer Cockitt, University of Manchester

A curious fragment from the Oxyrhynchus Papyri Collection
Daniela Colomo, University of Oxford

Self bows: a 'simple' misnomer and the complexity of a bent stick
Samantha Lauren Cook, University of Liverpool

Coptic documents from Nubia on leather in the British Library
Jennifer Cromwell, Manchester Metropolitan University

The KNH Centre and the future of UK Egyptology
Rosalie David and Anthony Freemont, KNH Centre, University of Manchester

Amun and his wives: ritual activity at Karnak
Ilaria Davino, Sapienza University of Rome

The proximity factor in the Egyptian government of the southern Levant during the Amarna Period
Francesco De Magistris, University of Oxford

'The vile chief of Ḥatti as captive': topographical lists as a source for Egypto-Hittite contacts
Marco De Pietri, University of Pavia

A bridge between archaeology and science in studying and conserving Tutankhamun's hassock
Nagm El-Deen Morshed Hamza, Grand Egyptian Museum

From blocks to tomb-chapels: documentation and reconstruction of 246 stone blocks for display in the Grand Egyptian Museum
Nagm El-Deen Morshed Hamza, Grand Egyptian Museum

Pepper pots of the pharaohs: Cleopatra's Needle obeliskiana and ephemera
Chris Elliott, University of Southampton

Egyptian society through woodcraft: TRACER project results and perspectives
Gersande Eschenbrenner-Diemer, University College London

Cenotaphs of gods in ancient Egypt
Dina M. Ezz El-Din, Alexandria University

Late Dynastic and Early Ptolemaic material culture from the Western Delta of Egypt
Urška Furlan, Centro Archeologico Italo-Egiziano / Slovene Ethnographic Museum

Papyrus for the people at the Petrie Museum
Anna Garnett, University College London

The lost pyramids at south Saqqara
Afifi Ghoname, Ministry of Antiquities

P. BM EA 10252 + 10081: a handbook for the performance of the Khoiak-festival in the Temple of Karnak
Ann-Katrin Gill, Museo Egizio, Turin

The EES and the future of UK Egyptology
Cédric Gobeil and Margaret Mountford, Egypt Exploration Society

A heap of sand: constructing cosmogonical landscapes in ancient Thebes
Angus Graham, Uppsala University

Biography of the objects: dialogue between Egyptology and sciences
Christian Greco, Museo Egizio, Turin

ḏt and *nḥḥ*: concepts of existential dualism in pharaonic ideology
Steven Gregory, Birmingham Egyptology

The creation of a database of Egyptian wine jars from the Pre-dynastic to the New Kingdom
Maria Rosa Guasch-Jané, Sorbonne University

Forgotten treasures: collecting ancient Egypt at the Victoria and Albert Museum
Benjamin Hinson, Victoria and Albert Museum

Cylinder seals in Upper Egypt: the cases of five Mesopotamian seals found in some Pre-dynastic Upper Egyptian graves
Federica Iannucci, Sapienza University of Rome

Hidden in plain sight: the cycle of life and death in purification scenes after 238 BC
Konstantin Ivanov, University of Copenhagen

The courtyard of the Temple of Thutmose I at Qurna
Jadwiga Iwaszczuk, Polish Academy of Sciences

'It is a pleasure to me to think of gathering little things however small for the poor old museum': travellers and antiquarian collectors' contributions to Irish Egyptology
Emmet Jackson, Exeter University

Iron in ancient Egypt: origins, processing and cultural implications
Diane Johnson, University of Exeter

The day in the date of Hatshepsut's oracle from the Chapelle Rouge
Ewa Józefowicz, Polish Academy of Sciences

'Egypt is getting a hold on the imaginations of Norwich'
Faye Kalloniatis, Norwich Castle Museum

The coronation scene above the entrance to the Southern Room of Amun in the Temple of Hatshepsut at Deir el-Bahari
Katarzyna Kapiec, University of Warsaw

Exchanging the divine: deities as travellers in Late Bronze Age Egypt and the Near East
Grigorios Kontopoulos, University of the Aegean

The Manchester Museum collection of human mummies
Robert Loynes, University of Manchester

The King and I: An unusual private / royal Ramesside statue in the National Museums Scotland
Margaret Maitland, National Museums Scotland

Persian Period Papyri from Herakleopolis in the British Museum
Cary J. Martin, University College London

Loss of heritage in the 18th Dynasty mining region of the Gorgod Hills between Soleb and Sesebi
Iain McLean, Independent scholar

Those who left their mark on Egypt: an introduction to travellers' graffiti, digital recording and conservation
Lee Robert McStein, Independent scholar

The cultural landscape of status and wealth in the Third Intermediate Period
Edward Mushett Cole, University of Birmingham

The SIGSaqqâra Project: about online publishing
Éloïse Noc, Université Paul-Valéry Montpellier 3

A family set in stone? Reinterpreting family groups through a statuette at the Ashmolean Museum (Oxford)
Leire Olabarria, University of Oxford

The four Sons of Horus portrayed as the *ba* of the deceased
Joan Padgham, Independent scholar

Re-examining the false door of Hemi-Ra from the Fitzwilliam Museum, Cambridge
Melanie Pitkin, Fitzwilliam Museum, Cambridge

The darker side of creation: the role of inimical forces in the Pyramid Texts
Joanna Popielska-Grzybowska, Polish Academy of Sciences

Understanding divine interaction: the 'hand of the god' and the 'arms of the god'
Daniel Potter, National Museums Scotland

The Oxford Expedition to Elkab: a study of Late and Graeco-Roman Period inscriptions during fieldwork seasons 2016-2018
Luigi Prada, University of Oxford

Composing communities at the dawn of history: creativity, rituals, and minds
Emanuele Prezioso, University of Oxford

Musical instruments and their use in Roman and Late Roman Egypt
April Pudsey, Manchester Metropolitan University

The personification of cities in Graeco-Roman temples
Mohamed Ragab Sayed, Minia University

Talking to god: facework, social rituals, and the Late Ramesside Letters
Kim Ridealgh, University of East Anglia

'Take a wife when you are twenty years old...': an exploration of evidence for non-royal consanguineous marriage in ancient Egypt
Joanne Robinson, University of Manchester

The Amduat: mapping the Theban landscape?
Peter Robinson, Independent scholar

Egyptian prehistory on the global stage: raising the profile of Egypt's earliest heritage
Joanne Rowland, University of Edinburgh

Power, prestige, and performance: examining the textual self-presentation of viziers in the 18th Dynasty
Ellen M. Ryan, Macquarie University

New technology, new diagnoses: the evolving knowledge of disease in ancient Egypt
Lisa Sabbahy, American University in Cairo

Funerary private religion during the Amarna age
Valentina Santini, Museo Egizio, Turin

Clever in the past, mindful on the morrow: remarks on archival work in the 18th Dynasty
Jakob Schneider, Humboldt Universität Berlin

Gendered perspectives on Abu Simbel: negotiations of decorum and agency in the Small Temple of Nefertari
Edward Scrivens, University of Oxford

Evaluation of Reflectance Transformation Imaging (RTI) suitability for the study the surface morphology of ancient Egyptian materials
Islam Shaheen, Grand Egyptian Museum

The nature of the necropolis of the Valley of the Kings during the 18th Dynasty and its relations to the other cemeteries of western Thebes
Daniel Soliman, University of Copenhagen

An analytical characterization of gold leaves of the fourth (innermost) shrine of king Tutankhamun
Eman Taha, Grand Egyptian Museum

Demotic voices and narrative structure
John Tait, University College London

Absent pottery and the change of funerary practice in Tarkhan-Kafr Ammar in the 3rd millennium BC
Tian Tian

The Western Delta through private documentation and sacred geography: the specific sacerdotal titles and the MAP project
Elena Tiribilli, Durham University

Bolton's Egypt: 140 years of philanthropy and display
Ian Trumble, Bolton Library & Museum Services

Sensory experiences in the temple: the significance of statue inscriptions and their placement
Jennifer Turner, University of Birmingham

3D modelling for the dissemination of archaeological data: the virtual reconstruction of the Sacred Animal Necropolis north of Saqqara
David Vacas-Madrid, Independent scholar

Prisoners of war in New Kingdom Egypt: an historical overview
Marta Valerio, Université Paul-Valéry Montpellier 3

Insights into the manufacture of Graeco-Roman funerary masks
Marie Vandenbeusch, The British Museum

Possible reasons for the poor nutritional health of the non-elite residents of the city of Amarna, New Kingdom Egypt
Keith White, University of Manchester

Affordances and entanglement: a new perspective of the sacred landscape of Late Period / Early Ptolemaic North Saqqara
Scott Williams, Cardiff University

Mortars used for construction in the Great Pyramid of Giza
Franc Zalewski, University of Rzeszów

Thinking about materialities and identities: how to approach unprovenanced objects
Katharina Zinn, University of Wales: Trinity Saint David

Posters presented at BEC 4

The Griffith Institute Archive's new online catalogue
Francisco Bosch-Puche, Griffith Institute, Oxford

Unwrapped learning: open educational resources on Egyptology
Ryan Metcalfe, University of Manchester

The building phases of the Sphinx Temple, Giza
Colin Reader, Independent scholar

The ritual topography of hour 7 of the Amduat
Peter Robinson, Independent scholar

The integrated documentation and archaeometric study of
Tutankhamun's shields
Islam Shaheen, Grand Egyptian Museum

Female figurines of the Middle Kingdom and Second Intermediate Period:
truncated (type 1) figurines
Angela Tooley, Independent scholar